D0962490

Bureaucratizing the Muse

Bureaucratizing the Muse

Public Funds and the Cultural Worker

Steven C. Dubin

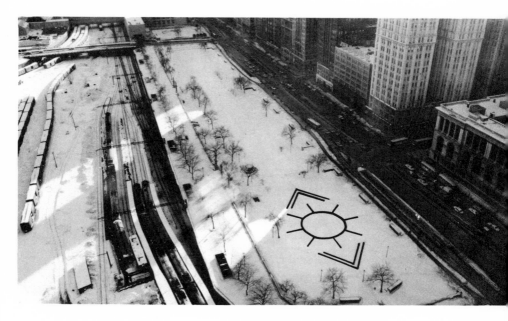

The University of Chicago Press • Chicago and London

Steven C. Dubin is a lecturer in sociology at State
University of New York, Purchase.

Photo on title page: *Good Prospects,* environmental art for
Whitney Halstead, 1979. Blue and yellow pigment in
snow. Artwork and photograph by Janet Sullivan.

The University of Chicago Press, Chicago 60637
The University of Chicago Press, Ltd., London

© 1987 by The University of Chicago
All rights reserved. Published 1987
Printed in the United States of America

96 95 94 93 92 91 90 89 88 87 5 4 3 2 1

Library of Congress Cataloging-in-Publication Data

Dubin, Steven C.
 Bureaucratizing the muse.

 Bibliography.
 Includes index.
 1. Federal aid to the arts—United States.
2. Art patronage—United States. I. Title.
NX735.D8 1987 306'.47 86–30862
ISBN 0–226–16748–8

Our status is backed by the solid buildings of the world, while our sense of personal identity often resides in the cracks.

Erving Goffman, *Asylums,* 1961

You can't put a black button on a white dress or a white button on a black dress.

Sarah Dubin, 1983

Contents

List of Tables

Acknowledgments

The novelist Anne Tyler once mused that personal relationships are like parking lot accidents where the fender of each vehicle carries away with it some traces of paint from the other; a sign is recorded, tangibly denoting the contact. This is as apt a metaphor for intellectual relationships and the mutuality of influences. Discounting a few major collisions, completing this project has been distinguished by encounters more like good-natured bumper car jostling than the willful destructiveness of a demolition derby. And I'd like to think that I've carried away many indications of such meetings, in addition to having had an impact of my own.

What I have often experienced as a solitary pursuit has actually been a collective endeavor to which many people have contributed. In fact, one of the few advantages of becoming a "gypsy" academic is the multiplication of locales where personal and professional relationships can be developed, which to some degree explains the magnitude of my debt.

Howard S. Becker, Wendy Griswold, and Paul Hirsch helped to nurture this research in its earlier form as a dissertation at the University of Chicago. As a committee they willingly provided support when I needed it, criticism when it was deserved, and the opportunity to work independently when it was absolutely essen-

tial. I am also grateful to Bob Gottlieb and Ken Burkhart for their assistance in gaining entry to the Artists-in-Residence program and to Joyce Bolinger for allowing me to forge a position wherein I could accomplish a great deal of my "own work."

Others have offered intellectual support and stimulation, comradeship, emotional relief, or a combination of these valued goods, comprising a *mishpachah* that transcends institutional and geographical boundaries. I'd especially like to acknowledge Nachman Ben-Yehuda, Carol Boyer, George Chauncey, Lynn Egan, Kai Erikson, Eric Hirsch, Lester R. Kurtz, Sarah E. Lauzen, Ilona Lubman, Milton Mankoff, Stuart Michaels, Rita R. Rousseau, Barry Schwartz, and Gary Schwartz in this regard. In addition, I'm grateful to Dr. Regina Casper; more than anyone she was responsible for getting this particular turtle off his back and inching toward completion.

Ken Burkhart of the Chicago Office of Fine Arts was very generous with his time and expert eye in helping to locate AIR photodocumentation, as was Laura Linard of the Special Collections division of the Chicago Public Library. In addition, Janet Sullivan patiently looked through hundreds of her slides with me in order to choose several images. All of the photos were taken by photographers in the AIR program; the individual photographers have been given credit wherever possible, but exact identification could not be established in all instances.

Finally, this book is a product of the very satisfying years I spent in Chicago. And what other city could offer the cultural complexity that is reflected in such zany decisions as trying to expand upon Picasso's vision by topping off his monumental public sculpture with the cap and headband of local winning sports teams in 1985 and 1986? In addition, my life in Chicago was considerably enriched by Esther and the late Max Portnoy, and it is to them that this book is dedicated, in gratitude for their love and the extraordinary examples of their lives.

Introduction

The world of art is one in which neutrality is not expected. Everyone is entitled to an opinion, their specific expertise notwithstanding. President Truman's assessment of a painting included within a U.S. exhibit which would be circulating abroad—" . . . if that's art, I'm a Hottentot"[1]—makes it clear that the evaluation of art and artists is contested territory. There are problems of definition: What is to be studied, product or producer, process or result? And there are jurisdictional problems: Who should be mandated to conduct studies and under the auspices of which academic discipline[s]? For researchers in this domain the difficulties are manifold, arguments rife, and boundaries defensively guarded by opposed explanatory schemes. Individual and collective egos are routinely placed on the line when artistic studies are presented.

Not too surprisingly, the study of art and artists is an area which also generates the issuing of manifestos and the sounding of clarion calls. Susan Sontag promoted just such a call to (non-) expository action in 1964. "In place of a hermeneutics," she declared, "we need an erotics of art."[2] This directed attention away from understanding content and toward the feeling and experiencing of artistic works. Such a position correspondingly advocated directing attention away from understanding the actual conditions under

which art is produced and away from those producing it. In light of a more recent and rather unintentional coalescence of efforts on the part of governmental agencies, academics, and artists themselves to focus on artists as workers—more similar than dissimilar from other groups[3]—the aforementioned approach now seems ill-conceived at best, reactionary at worst.

The present study builds upon contemporary social science efforts to understand artists and the conditions relating to the production of art, drawing especially from the fields of organizational theory[4] and the sociology of culture. The experiences of artists within an actual organizational setting will be central, complemented by an examination of what kinds of production were possible for them. Much of the material on which this book is based was gathered during my fieldwork experiences in Chicago's CETA-funded[5] Artists-in-Residence program (AIR) from 1978 to 1980. This program was sponsored by the Chicago Council on Fine Arts (CCFA) and employed 108 artists in nine artistic fields: dance, film, music, photography, theatre, video, visual and graphic arts, and arts administration. The primary emphasis of the program was to provide public service to areas that typically had limited access to such resources: schools, childcare centers, and senior citizens' homes. AIR was one of the largest CETA-arts beneficiaries in the country and as such exhibited all the problems and successes of this alliance between government and the arts.

There have been only two large-scale commitments of public support directly to artists within this century: the Works Progress Administration (WPA) projects of the 1930s and the more recent CETA-arts projects. An observer in 1937 noted that federal support of artists had allowed them to leave their bohemian environments, which were as much psychologically as spatially located.[6] A prominent art critic who was a WPA participant later reflected similarly that the most important aspect of these projects was not what was actually produced, but rather the contribution they made to the professionalization of the art world.[7] In each case a decrease in marginality was noted, with a corresponding affirmation of "a new social basis for art in American society."[8]

However, assessing the marginality of an entire group is an extraordinarily difficult and elusive task. This is especially the case when the basis for recognition in the art world splits off a few exceptional examples from the majority of participants. To the former flow great rewards; to the latter group, comparatively little is offered. What the WPA and CETA arts projects unmistakably pro-

vided was a respite from the typical problems of managing an artistic career, a suspension of immediate pressures. While this may have allowed some individuals temporary relief, the degree to which these programs actually altered the overall structure of the market situation for artists is much more open to question. And correspondingly, the degree to which an occupation can professionalize outside of the establishment of ongoing work structures would seem to be significantly limited.

What *is* clear is that the commitment to fundamentally altering market conditions for artists has been both hesitant and intermittent at best. At worst, it has drawn the wrath of those determined to force artists to remain largely unprovided for. A peculiar reaction surfaces when concern for artists is concretely expressed. For example, a 1980 editorial in a major metropolitan newspaper concluded that "somehow, the arts will survive those who worry about their having a future."[9] And a national business magazine voiced a decided preference for "passing the hat" as a more appropriate means of supporting the arts than the continued commitment of CETA funds.[10] Furthermore, the conjunction of government money with public display greatly expands the audience to which an artist is answerable and generates predictably negative appraisals.[11] The products of such schemes *in general* provide a convenient target for criticism, whether they be murals in 1930s small-town America[12] or contemporary artworks in New York, Chicago, or New Haven.[13] An adversarial relationship often develops, with artists sensing they are being unjustifiably directed and recipients of such goods feeling that something is being unfairly imposed upon them. Such sentiments gradually gained sufficient strength to reverse the flow of support which recognized and attempted to meet artists' needs in what turned out to be a relatively brief period from 1975 until 1981.

The central purpose of this study can be summarized as follows: a multimethod social science approach will be used to examine the establishment, growth, and development of an organization using public monies to provide employment for artists. Although initially tailored to meet the perceived needs of this occupational group, the increased bureaucratization of this program heightened its short-term survival capacity but decreased its sensitivity to the needs of its personnel and deflected attention away from its originally established goals. There will be a focus on two distinct levels throughout: the themes of survival and adjustment pertain to both the artists and to their sponsoring organization. For

the artists, adjustments to the distinctive demands of this organization were necessary. For the organization itself, adaptations to the claims of innumerable parties in the surrounding environment were required, be they economically, politically, or artistically based.

A number of interrelated questions most directly concern the program artists. For example, to what extent did artistic and bureaucratic imperatives mesh, and to what degree did they come into conflict? Further, were the artists willing to submit to the process of being developed into "cultural workers," that is, professionals trained to adapt to the exigencies of the contemporary market? And finally, artists from different fields brought with them a range of distinctive cultures and types of social organization; the degree of compatibility between artistic strategies and programmatic priorities led to the acceptance or rejection of the organization's goals, had consequences for the artists' perceptions of their professional career progress, and had aesthetic consequences for the material they produced.

One issue was paramount on the organizational level of analysis: How and why did a distinctive organizational character develop? Among the more important factors was the unusual nature of the personnel around which the program was shaped, which necessitated incorporating a markedly non- or antirational element into a rational form of organization. In addition, there were the changing political fortunes of the sponsoring CETA program as a whole, providing a problematic environment. Whose concerns were most effectively voiced and subsequently heeded by AIR: external parties pressing for rationality and demanding displays of legitimacy or internal ones calling for artistic space and flexibility? As we will discover, a gradual conservatism of purpose replaced the initial support for openness and experimentation as the concern for survival and organizational perseverance became predominant.

A primary working assumption is that CETA artists were subject to certain kinds of constraints, just as they would be had they been employed under any alternative production arrangement. Determining the specific kinds of social controls embedded in this organizational structure is a way of evaluating how decisions made on a more macro-level were actually experienced by these artistic workers. Such has been the impetus for innumerable historical and social-scientific examinations of the position of artists under various patterns of patronage;[14] here one of the most important contemporary forms of artistic patronage can be similarly investigated

by looking at real individuals and situations, rather than addressing such concerns in the abstract. In fact, there has been a great deal of speculation about the nature of artists and their work.[15] However, an important question to pose is, "To what extent are certain attributes of artists either intrinsic to these individuals or the consequence of social structural arrangements (and secondary adjustments to them)?" By grounding the present study within an organization, and one which specifically designed many of its features in deference to the needs of this group, the collective, social bases of artistic production can be examined in a manner which has only infrequently been accomplished.

1

The Sociocultural Context of CETA-arts Projects

No one has outdone Dickens in capturing both the sense of promise and the problematic, the enthusiasm and the suspicions of a particular cultural milieu. His phrase "It was the best of times, it was the worst of times" was intended to record the incongruities of life in revolutionary France. And yet he capsulized the intersection of societal processes and their differential impact in a way that accurately describes other times and locales as well. It will be possible in this chapter to broadly outline some of the major social, economic, and cultural trends which helped form the environment in which CETA-arts programs developed. While this time period (from 1975 to 1981) is generally characterized as a quiescent one, it was not without its contradictions and dissonant tendencies. The goal here is to be suggestive of these, not definitive. The problem is that of the central point of the Japanese movie *Rashomon*—each observer of the same set of events would likely issue a different report. With this caveat in mind, some of the general conditions in which CETA-arts programs were embedded will be examined. In addition, the overlay of some influences distinctive to Chicago will likewise be considered.

The period of CETA-arts involvement was one of economic boom and bust. Depending on the sector of the economy there

was either growth or retrenchment, optimism or despair. In significant ways the arts flourished while other activities languished. Particularly important in the support of these pursuits were two previous developments: the establishment of the National Endowment for the Arts (NEA) in 1965 and the subsequent channeling of funds to state arts councils. When the NEA started offering matching grants to these agencies in 1967, twenty-two states had already organized such bodies. Just five years later, every state had established similar organizations.[1] While these agencies have never gotten much support relative to other concerns, they were tremendously important in establishing a climate in which the arts were deemed important. And, they dispersed financial support that could mean the difference between an artistic group's life and death, albeit meager in real dollar terms.

There has been, then, a gradual growth in the demand for artistic products and activities. Such societal-wide factors as a growth in real income, an increase in education levels, and the greater availability of leisure time have all contributed to the increased valuation of these pursuits. Thus a 1975 report by the National Committee for Cultural Resources documented an increase in the number of individuals in artistic fields, an expansion of the number of performing companies and community art centers, and an increase in museum attendance.[2]

This activity begat new schemes, new partnerships, and new working definitions. One of the principal ways this was evident was in the increased number of alliances between the business and art communities; each was seen to have something of value to offer the other. In 1979, for example, the Small Business Administration held conferences entitled "The Business of Art and the Artist." The underlying rationale was that artists could be the last (and the smallest) independent businessmen. As such, they could profit from the development of business acumen. Similarly, academic programs sprang up in arts administration to formally train business managers for arts organizations.[3] A previously unmentionable aspect of artistic pursuits—the making of money—was being formalized and discussed in relation to a wide range of artists, not just celebrities. Art was consequently described by a Chicago Council on Fine Art's administrator as "the perfect capitalistic endeavor, strictly supply and demand; when I write 'artist' on my tax form, nothing special happens. The Internal Revenue Service considers me a small businessman, just like any other small businessman."[4] In addition, schemes that might have been dismissed

as mere fantasy in other times were instead adopted as inspired designs. In 1979 the Museum of Modern Art in New York negotiated for the payment of $17 million for the air rights over its property to allow the construction of a residential building, thereby providing income needed for its own continued growth.

Expansion seemed to be the order of the day; "explosion" was not considered too enthusiastic a term to describe the contemporary art scene. In Chicago, for example, the proliferation of dance and theatre groups was frequently discussed. And as one article noted,

> Gone . . . were the days when seeing a locally produced show meant crawling up to an unheated loft to sit on the floor and watch "experimental" theater. Maturity has brought stabilization during the last two [years] . . . companies that formally were moving like gypsies from one empty space to another every time they wanted to perform have undertaken . . . renovation[s] and [have] settled in to develop audiences and business in their own neighborhoods.[5]

The availability of CETA funds was frequently cited as a primary factor contributing to this effervescence of artistic activity. However, optimism was quickly counterbalanced by the intrusion of some less encouraging signs. Several reports identified the shaky foundation on which hopes had been built: the withdrawal of certain funds revealed how precarious and dependent the operation of many of these new organizations were.[6] As one news article declared, "It has been a year of big numbers and great expectations, of unresolved issues and lowered possibilities."[7]

Economic problems confronted other sectors of the economy as well. The unemployment rate and other indices of the economy's ills were reported with increasing frequency from 1979 onwards. While public images of economic health were promoted, many private doubts were maintained. Reflecting (or possibly predicating) such discrepant views was a revelation that the president had publicly issued the forecast of an unemployment rate which was in marked contrast to higher figures privately kept.[8] However, regular reports of weekly increases in jobless claims and huge crowds of job-seekers forming at work sites at the announcement of openings testified to the severity of economic conditions in a clear manner.[9]

It is important to understand that the expansion and subsequent curtailment of CETA-arts funding in this period merely tele-

scoped similar events occurring in relation to other groups rather than demonstrating a different developmental history. It was only after many other constituencies had previously received public funds that the arts were finally recognized in like manner; in a fundamental respect they benefited from a momentum of forces already under way. However, due to the combination of this relatively late recognition, worsening economic conditions overall, and a significant political realignment as a result of the 1980 election, the arts enjoyed the advantages of increased support for only a relatively short period of time.

The precedents set by Depression-era conditions were frequently invoked as a reference point in matters during this time. What happened in the 1930s became the baseline by which the severity of contemporary events could be calculated; unemployment figures as well as other indices of economic well-being were compared to what had previously been measured. "The average family in the Chicago area," it was reported, "spends ten percent more of its income on necessities than it did in the Depression," according to a newspaper article whose headline declared that consumers were "harder hit" than in 1935.[10] Similarly, plant closings and their effects upon local areas were recalled as echoing past events. A prolonged heat wave in the summer of 1980 was described in Dust Bowl terms. And certain images were reworked to mock their original intent: while selling apples on street corners previously symbolized the collapse of the economy, the use of five-cent apples as centerpiece decorations at a bankers' convention in Chicago in 1980 was a collective attempt to deride and diffuse rumblings about impending economic doom.

The collective memories of the relief programs undertaken in the 1930s were similarly available for comparative purposes, and the records of these programs could also be variously recalled. On the one hand, the precedent of large-scale work programs was used to justify contemporary undertakings. Although the inclusion of artists within these early programs reflected the pervasiveness of the economy's ills and not a well-developed commitment to the needs of this occupational group, the precedent was used to support the regeneration of such projects. On the other hand, the record could also be used by critics of the increased intervention into economic matters. Here the efficiency of such efforts was called into question, with the arts components often singled out for particular disapproval. Increased federal spending might be ill-advised, but editorial commentators frequently considered the

funding of the arts to be ridiculous: "We can't quarrel with . . . [the] conclusion that paying people for doing something (even producing alleged art) is better than paying them for nothing. But when it comes to being productive, no federal jobs project, including CETA, will ever be able to compete with private industry."[11] While these work efforts might be presented as art, implicit in this statement was a reluctance to accept what was being produced under government sponsorship as such.

A passage within one of the best-selling novels of this period also raised questions about what art is and what it should do:

> "Art doesn't help anyone," Garp said. "People can't really use it; they can't eat it, it won't shelter or clothe them—and if they're sick, it won't make them well." This . . . was Garp's thesis on the basic uselessness of art; he rejected the idea that art was of any social value whatsoever—that it could be, that it should be. The two things mustn't be confused, he thought: there was art, there was helping people. The messes came when certain jerks attempted to combine these fields.[12]

Cultural currents which underwrote fantasy and introspection predominated in the late 1970s to the relative diminution of social and political themes. *Annie,* a major theatrical hit, was described as "a shamelessly endearing and sentimental fantasy about hope"[13] Apparently, though, this musical recreation of hard times was the way many people were most comfortable in remembering the Depression years. As further noted, this play "seems to have found an American hunger for some pure-spirited news."[14]

Similar observations were made by other important figures in the art world. Joseph Papp, the noted theatrical producer and director, decried an evasiveness about the sense of a real world existing outside the purview of contemporary plays: "Now, plays seem to be written in somebody's room instead of life. I think of Hamlet's quote about 'this distracted globe.' He meant his own mind and the theater, but he also meant the world. . . . There's a strong conservative trend in the country. Revivals. Middle-of-the-road drama. Business has never been better on Broadway, which is great for the economy but not necessarily good for the theater."[15]

The CETA era was actually sandwiched between a period of introspection and widespread artistic withdrawal from social and political concerns and a period when critical work increased and an oppositional culture began to gain strength. The 1970s, it has

been noted, "represented the culmination of artistic weariness."[16] However, this period was followed by a time when engagement started to become less the exception and more the expected occurrence. And this was not only demonstrated by artists' participation in various pro-peace and anti-imperialist causes, but surfaced in more mainstream cultural endeavors as well. Critics observed that new Broadway plays with major political components were being produced alongside musicals in the 1980s and that the businessman as con artist was becoming a noticeably predominant figure in these shows.[17] However, CETA-arts involvement ended before this transformation, and CETA artists plied their trades in a markedly nonideological and acritical time.

Artists in general could not ignore this predominant climate of opinion, and those who were the recipients of public support had a heightened awareness of what was currently acceptable as art because of their employee status. Added to this for the CETA artists under consideration here were cultural components peculiar to Chicago. Nelson Algren's appellation for the city as being "on the make" has stuck; it connotes a brashness and toughness which pervades many spheres of action. As he further declared, " 'If he can get away with it I give the man credit,' is said here of both bad poets and good safeblowers. Write, paint or steal the town blind—so long as you make your operation pay you'll count nothing but cheers."[18]

Thus the criteria according to which art might be judged in Chicago could include savvy as much as the refinement of skills, economic success as much as aesthetic development. And since the activities of these public service artists were often used to represent this city, its general image had to be contended with in a creative manner. For example, Chicago's reputation for violence and political corruption has been long-standing and widely diffused. This is so much the case that Europeans were reportedly shocked and fascinated by the election of a female mayor in Chicago in 1980; as noted by several representatives of the British media, Chicago is "a world symbol of masculinity."[19] In addition to this general milieu of a free-for-all, there was also a sense of political turmoil distinctive to this time period. A suggestion by the local columnist Mike Royko seemed particularly apt—he proposed that the city's motto of "Urbs in Horto" ("city in a garden") be changed to "Ubi Est Mea?" ("where's mine?") to publicly document the corruption which reputedly permeates the city's day-to-day operations. These, then, were just some of the pervasive themes and

symbols Chicago's CETA artists had to accept as givens in their own activities as producers of symbols.

The AIR participants came to their positions subject to the influences of a number of prevailing ideas and trends. They were painfully aware of then-current economic realities, as were others in the population at large. As artists, they were susceptible to the authority of predominant thematic concerns. As CETA employees, they were subject to specific sets of regulations and to the scrutiny of both proponents and detractors of the program as a whole. And as city-sponsored employees, they were accountable to the specific demands of agencies for whom they were providing services and for which they were often taken as public representatives.

This discussion was not intended to be inclusive, but merely to provide some indication of the factors which formed a backdrop for CETA-arts programs and their participants. Most of these elements will be discussed in greater detail in subsequent chapters, which can be summarized in the following manner. Chapter 2 examines interpretations, both those made by and about AIR and other CETA-arts programs. How CETA was broadly interpreted to encompass artists, the manner in which regulations were translated, and the distinctive ways the AIR program rendered its definition of office procedures are each considered. Additionally, a variety of public responses will be examined. In chapter 3, explanations are offered. That is, what ideological rationale was developed to consider artists as workers rather than as special individuals? And further, what sets of explanations were assembled to justify the development of public service programs to supposedly address their particular needs? Chapter 4 describes the process of choosing participants, who was chosen, and the evolution of an operational format over time. In other words, who were the Artists-in-Residence, and what were they employed to do?

The primary focus in chapters 5 and 6 is on AIR as an organization. Organizational character and how it was refined in response to a number of factors is examined. The nature of the clientele with which AIR was working, unique features of CETA regulations, and various constituencies and events in the external environment which created uncertainty for the program are all discussed. Likewise, the progression from a defensive to a more offensive stance and an increased emphasis on organizational survival are considered.

Chapter 7 is the first of two chapters which pertain more exclusively to the artists' experience of their AIR tenures. The con-

flict between artistic and bureaucratic standards is examined, expanding the previous discussion of AIR in ideal-typical terms; how the bureaucracy "felt" to its participants is most important here. Further, the artists' perceptions of their career stages and self-evaluations of professional ability and progress are discussed. And finally, their degree of receptiveness to being molded into cultural workers is considered, particularly as this related to the preexisting realities of the market situation for artists.

Chapter 8 continues the focus on the adaptations of the individual artists. Four distinct ways are examined in which they defined themselves within a significantly limited role, given that they could have little stake in the program as an ongoing concern. Considered in turn are the fundamental separation of AIR duties from their "own work"; the failure to develop a sense of community within the program; the lack of collective definitions of their fate as employees or as artists more generally; and the thematic concerns of AIR-produced artworks. The impact of organizational structure on individual behavior was paramount in these respects.

In chapter 9 the format switches to the presentation of three case studies, focusing on AIR's gradual definition of what it meant by public service art. Special attention is given to the coalescence or conflict between latent artistic cultures and AIR's manifest culture. Those individuals, artistic disciplines, and programmatic units that either successfully or unsuccessfully interpreted this working definition are each discussed here.

Chapter 10 investigates the distinctive forms social control of creative endeavors has assumed under government sponsorship. The gradual supplanting of explicit censorship by implicit controls is identified as resulting from the refinement of the bureaucratic structures under which these artist-workers have been employed. The social uses to which these artists and their products were put are also studied in order to determine what they had to provide in exchange for monetary support.

2

CETA and Artists: An Unexpected Alliance

CETA, the acronym for the Comprehensive Employment and Training Act, has come to stand for much more. To many minds, it alternately spelled boondoggle, political plum, or opportunity. Estimations of the program depended upon a number of factors: the distance of one's own position from that of need; preconceived political and philosophical notions; or, access to obtaining or dispersing those positions. CETA came to represent either the best or worst of governmental efforts to attempt to redress social inequities or to induce social change. As the source of support for the program under study here, it is important to examine the history, development, and scope of CETA to understand both how artists came to be adopted by this sponsor, as well as to determine to what extent projects of the same lineage shared the characteristics of their parent.

Strange Bedfellows: The Variety of CETA Participants

CETA-sponsored workers were engaged in a wide range of situations in the 1970s, especially as subprofessional support personnel. They were employed, for example, as teacher aides, library aides, and in auxiliary police functions such as directing

traffic, manning school crossing stations, and answering emergency phone lines. These funds were also targeted in certain instances to serve the needs of specific groups or communities. Such CETA programs trained prison inmates about to be paroled, encouraged and enabled disadvantaged school dropouts to return for job training, and provided on-site training for community residents in the rehabilitation of housing stock in declining neighborhoods. In addition, CETA workers assumed some surprising roles—at one time one-half of New York City's zookeepers were CETA trainees, a controversial innovation which nonetheless enabled a troubled municipal service to continue.[1]

The attention generated by unusual activities caused CETA's proponents to adopt a markedly defensive stance; exposés of fraud, mismanagement, political abuse, and conflicts of interest appeared in the press with regularity. The enormity of the program explains to some extent the number of critical responses to it. However, the vehemence of such attacks strongly suggests that the *idea* of CETA was anathema to some and that there was a special delight to discovering the ways it had supposedly erred.

Criticisms of the program developed along several lines. First, charges of mismanagement and improper supervision were common. As a result, local as well as federal investigative bodies, most notably the General Accounting Office (GAO), examined accusations of "ghost" employees, overpayments, the falsification of records, and the failure to provide sufficient amounts of work for trainees.[2] Second, widespread documentation demonstrated that political patronage usurped the program's original mandate. In many cases economic need did not determine who got CETA positions as much as who you knew, how much political clout they had, and what you were willing to do for them. Numerous probes by newspapers detailed the importance of such extra-economic factors in initially securing and then keeping jobs.[3] And third, the most consistent criticism of the program also revolved around the deflection of its original mandate, namely, the use of CETA funds to pay the salaries of regular city employees rather than to create new jobs for the unemployed. Estimates of the prevalence of this practice (known as substitution) were as high as forty percent of all CETA hirings.[4] Substitution was strongly criticized in Chicago where the legendary political machine and its patronage system were given a monetary shot in the arm by the use of federal funds.[5]

This provided the basis for broader commentary in the national media which regularly conveyed a negative image of the

program. Some of this response was in publications whose reputations for sensationalism and simplification both attract as well as repel large numbers of people: *The National Enquirer, Reader's Digest,* and *People Magazine.* Critical articles also appeared in such publications as *Newsweek* and *Fortune,* however. Common to all this press coverage was the image and the word "ripoff" or some synonymous term. While this was perceived to be a constant media assault, there were occasional articles that did not communicate negative appraisals. In these unusual instances CETA programs expressed relief over the "fairness" with which examples were chosen and their programs assessed.

The activities of CETA-sponsored arts programs were cited in the critical reports almost without exception. These programs were a visibly exposed flank of a large animal increasingly judged to be overfeeding at the public's expense. This was so for a number of reasons: (1) CETA-arts activities were very public in nature; (2) there was a general failure to understand how they were incorporated within the CETA program; and (3) historically, artists have not been considered as workers with economic needs. Therefore, it is not difficult to understand conservative commentator James J. Kilpatrick's portrayal of CETA as a metaphor for untold numbers of problems: it "continues to provide," in his words, "a prime example of much that is wrong in government today."[6]

CETA-sponsored arts programs therefore were both judged by and contributed to appraisals of the program as a whole. The predominant climate of opinion held that CETA was a program readily available for abuse and adaptation to questionable pursuits. Reflecting this, a highly satirical article entitled "While You're Up, Get Me a Grant" queried "if there's a CETA symphony (and there is), why not a CETA airline ('We're earning as we're learning') or a CETA baseball team . . . "[7] The implication was that if CETA funds could be used in support of the arts, more absurd applications would hardly be noticed. This sentiment also surfaced in a comic strip appearing soon after the defeat of Chicago's incumbent mayor in a primary election. "Well," stated one character, "the future looks good for Michael Bilandic . . . He'll be eligible for a CETA job."[8]

CETA-sponsored arts programs developed and matured against such a turbulent background. The administrators and participants in these programs were ever aware of the probability of critical scrutiny, thus forcing them to operate in a highly uncertain and hostile environment. Accordingly, caution was good counsel;

justifications were readied for anticipated attacks; and defensiveness was practically a reflex action on a day-to-day operating basis. In order to understand such conditions, closer examinations of both the CETA program as a whole and the arts components in particular are necessary.

CETA: History and Development

CETA burst upon the economic and social scene in December 1973. The commitment of public monies to subsidize jobs had occurred previously in such magnitude only in the Works Progress Administration (WPA) programs of the 1930s and various employment programs initiated in the 1960s in the spirit of "a new frontier" and "the great society." Unemployment was at a low level at the time of CETA's initial implementation, standing at less than three percent. The emphasis was therefore on the long-term structurally unemployed individual,[9] and the goal at this time was to improve the employability of relatively untrained workers. A high percentage of those enrolled were the poor, the young, minorities, older workers, migrant farm workers, and Native Americans,[10] and it was this population that became most commonly associated with the program in the public mind.

However, when unemployment greatly increased in the next year, attention turned to a new concern: the provision of countercyclical public service employment (PSE). The countercyclical objective was markedly different from the goal of trying to redress the inequities various groups had experienced in gaining access to the rewards of the marketplace. The goal here was the creation of temporary jobs in the public sector to counter rising unemployment and help the system regain a collective sense of balance. And, the beneficiaries of this aspect of the CETA program were quite different, tending to be older, better educated, and less disadvantaged.[11] CETA alternately acceded to the concerns of one target population, one set of economic conditions and type of social commitment, and then another.

After its first year, CETA's "overriding objective" was decentralization for the sake of giving local governments greater flexibility in their programming.[12] However, this emphasis brought about the problematic aspects of political patronage and substitution and a great deal of the adverse public reaction. Attempts to remedy this situation resulted in the passage of the Emergency Jobs Programs Extension Act (EJPEA) in 1976, the pri-

mary goal of which was to undertake short-term projects under the sponsorship of not-for-profit agencies that typically would not be undertaken in the private or public sector. The countercyclical thrust of the program was thereby strengthened, but its inability to deal with the problems of substitution and the maintenance of regular governmental activities continued apace.

The final major reorientation of the CETA program of concern here was the CETA Reauthorization Bill passed by Congress in 1978. While continuing to allocate funds for the program, this bill also attempted to deal with the nagging problem of substitution. As a result, eligibility requirements became more stringent to increase participation of the disadvantaged; the maximum participation time was reduced to expand the number of eligible persons who could enroll in the program; and the *temporary* nature of the program was reemphasized. CETA Public Service Employment was a major target of the retrenchment of government programs initiated by President Reagan in January 1981 and no longer exists.

Each of these aforementioned developments and their associated sets of regulations provided new sets of parameters within which participating units had to adjust their goals, needs, and sense of priorities. Over time there was a shift away from concern with those who were structurally disadvantaged (a great interest in the 1960s), to the unemployed generally. Further, there was a shift away from classroom instruction to on-the-job training and therefore away from preparation for economic self-sufficiency to subsidized employment.[13] The provision of CETA-sponsored arts positions paralleled major programmatic shifts. Titles II and VI most consistently funded arts positions, and they accounted for twelve percent and fifty-four percent respectively of all CETA positions by 1978,[14] dramatically illustrating the primary emphasis upon public service employment.

Title II was intended to serve the economically disadvantaged (a structural approach), while Title VI was intended for countercyclical employment. The inclusion of artists under both of these programs reflected the distinctive nature of their market situation. Artists can be considered among the structurally unemployed, given the extreme mismatch between the number of positions available and the number of individuals wanting them; employment *qua* artist is not often available, as will become apparent when the employment histories of AIR participants are discussed. Artists additionally suffer from cyclical unemployment. They often work at marginal jobs in order to support their artistic pur-

suits, and competition for these positions becomes more acute in bad economic times. Artists' needs therefore straddled the twin emphases of the CETA program.

Funded by Title VI, AIR tackled both countercyclical and structural issues, which set up perplexing internal contradictions. For example, AIR was clearly addressing the countercyclical concern of providing short-term employment to highly trained individuals; yet it concurrently purported to train them, a structural concern. However, AIR did not suggest that it was in the business of transmitting and developing artistic skills. Rather, it stressed the adaptation and packaging of already acquired skills to real market situations, the development of modern workers or "corporation men," if you will.

Resistance from the artists would not be called out by the countercyclical objective—here economic relief was promised, with a minimum of obligation implied. In contrast, the structural emphasis carried a different set of objectives which could provoke opposition. Artists displayed a range of receptivity to being molded into specific kinds of workers. Some who clung to a romantic, individualistic notion of what it means to be an artist rejected these efforts strenuously. Others resisted to the extent that they felt they would have to return to a market structure which was essentially unchanged and which was not supportive of their particular needs. Still others, however, defined this employment opportunity as just that, an opportunity to develop specific work-related skills and concurrently refine their artistic capacities. Here the fit between individual and program objectives was the most comfortable.

The inclusion of the arts under the CETA mandate demonstrates that groups different from those attracting most of the attention in the preceding decade were also seen to have legitimate needs. In many ways old threats had diminished, and new groups and concerns entered into the forefront.

How Will It Play in Peoria (or Chicago)?

The lack of fit between intentions and reality and the ironic space between official policy and everyday operating procedures have long delighted social scientists intent upon discovering the "whole story," the proverbial "larger picture." The various alterations in CETA regulations provide fertile ground for just such poking around. Not surprisingly, each new policy or program emphasis called out interpretations and readjustments on the part of local

Table 2.1 *Intentional and Unintentional Results of CETA Regulations*

Regulation or Emphasis	Intention	Unintentional Result
Create unique positions	Avoid substitution	Decrease ability to directly transition into private employment
Lower wage rates and tighten eligibility requirements	Make CETA less competitive, private employment more attractive; increase participation of disadvantaged individuals	Programs seeking to maintain certain standards of performance such as artistic quality find pool contracted; local program goals conflict with national programmatic goals
Limit maximum participation time of employees	Reduce substitution; increase the number of individuals served; increase "multiplier" effect of more people transitioning into private employment, stimulating more jobs	Interfere with continuity of performance ensembles and artistic direction

projects. What is surprising is that CETA policymakers on the national level were not able to more adequately anticipate the organizational imperatives of local working units which conflicted with their original intentions. For once CETA projects came into existence they often developed according to a logic of their own; their distinctive needs and demands brought out contention with some regularity. A small sample of such conflicts will highlight the kinds of problems resulting each time the program as a whole changed (see table 2.1).[15]

The bugaboo of CETA was the specter of substitution; its mention sent investigators readying their tools of examination and program sponsors to readying explanations. Many regulations were enacted and refinements were attempted in anticipation of heading off such inquiries. For example, the order to create new positions

rather than have CETA workers fill already established slots was certainly in response to the substitution problem, but the more unique the project, the less likely it was that participants could be directly transitioned into private employment.[16] In the case of the AIR program, artists placed in assistant-level positions in city agencies (e.g., as program and production assistants) could be absorbed rather easily into permanent places when their CETA tenures expired—a feather in AIR's cap. However, a majority of the projects AIR developed were directed by the imperative to provide largely unavailable services to largely unserved audiences. When most artists left the program they may have had more experience, but comparable positions did not exist for them in the private sector. Therefore, AIR had to balance the necessity to provide a successful rate of transition to permanent employment with the demand that their services not overlap with what would already be available without CETA's support.

A second example involved tighter eligibility requirements and various proposals to lower the maximum wage rate of participants by the 1970 Reauthorization Act. The intent of these changes was to make CETA a choice of last resort in relation to private industry and to increase the participation of those individuals who were the most disadvantaged. However, this assumed that jobs indeed existed in private industry. In the case of artists this was largely untrue, so that all that was accomplished was a constriction of AIR's potential employee pool. Here the conflict developed: AIR wished to provide not only employment, but the production of art according to standards of judgment existing beyond the scope of any CETA regulations. As a result, the locally developed organizational desire to maintain certain standards was undercut by decreasing the number and the range of participants from whom the program had to choose.

As a final example, the regulation that placed a limitation upon the maximum participation time was lowered from two years to eighteen months in 1978. This measure was intended to reduce substitution by funding positions for a shorter period of time, as well as to increase the number of individuals who could secure a position. However, such a change was disruptive to a project desiring continuity of performance. More frequent changes in personnel meant difficulty in sustaining ensembles of artists and in providing artistic direction by individuals who were skilled in their own disciplines as well as in negotiating the organizational order.

In the alliance between CETA and artists, the problem was

having to serve two masters: the demands of the CETA program as a whole and the imperatives of artistic standards. And each insisted on Herculean efforts to serve its needs while minimizing acknowledgement of the other's demands. We have not, however, as yet examined how this alliance came into being.

Bringing in the Artists

CETA-arts involvement did not emerge fully formed from the collective heads of Department of Labor planners in Washington. Rather, local projects developed somewhat independently in a number of areas, word of the possibility of such programs spread, and a much more specialized effort was gradually mounted to promote and coordinate these endeavors. The first CETA-funded jobs program for unemployed artists was established in San Francisco in 1975. A widely circulated videotape documenting these activities in several instances became the catalyst to similarly channel monies in other communities. Artist-oriented projects initiated by a few resourceful individuals in scattered locales gradually became an identifiable segment of the overall CETA effort. As a result a special CETA-arts coordinator was appointed to the Department of Labor early in 1979, and conferences organized around the special concerns of this group of CETA beneficiaries were convened in major cities in 1979 and 1980. Even before these transpired, however, a strategy to tap into the reserves of CETA funds had been devised. In a regularly issued newsletter on federal economic programs and the arts, the National Endowment for the Arts offered the following advice to arts groups on how they could resourcefully utilize CETA:

> It should be noted that prime sponsors have considerable authority and flexibility in the local interpretation of CETA rules. They cannot, however, be sensitive to the needs and peculiarities of arts groups unless these are specifically defined by the organizations themselves . . . You can play a significant role in determining how the rules are established for your own activities, and you should do so.[17]

The word was out: CETA was available and it was adaptable. At the time of the first national CETA arts conference in 1979, support to this occupational group was estimated at as much as $200 million, maintaining 600 projects in approximately 200 locations. CETA had become the largest funding source for the arts in the

United States, exceeding even the expenditures of the National Endowment for the Arts.[18] This was the case even though the creative arts component accounted for a mere two percent of the public service employment (PSE) positions under Title VI.[19]

The history of CETA-arts involvement in the city of Chicago paralleled these trends. The first such commitment was in the summer of 1975 when the Mayor's Office of Manpower[20] funded a request by the Chicago Commission on Cultural and Economic Development for $50,000 to mount a "Festival of the Arts." Later that year $1.1 million from "salvage" or previously uncommitted funds was earmarked for the Transitional Work Experience program (TWE) for paying the salaries of 176 artists and arts-related workers within private, not-for-profit agencies. This program was renewed and expanded the next year: $1.5 million subsidized 203 workers in cultural areas. The director of this program was aware of the similar use of CETA funds in San Francisco through their videotaped documentation, and it was this knowledge which helped shape TWE as well as its successors.

In the spring of 1977 the title which supported TWE was significantly reduced and the program ended. At the same time, however, President Carter championed an expansion of the counter-cyclical components of CETA. Because of the relative success of TWE (it was estimated that sixty-six percent of its participants moved into private sector jobs) and because the number of arts organizations had greatly increased in the city due to the availability of CETA support, the union between the arts and government funding continued. In the fall of that year more than 350 artists were employed by not-for-profit agencies in Chicago at the cost of $2.7 million and an additional $1.2 million was earmarked to begin the AIR program, with the initial planning being the responsibility of the same person who had directed TWE. The screening and hiring of the artists and the solicitation and final selection of project proposals were done with only two months' lead time.

AIR completed three years of programming at the same level with funding for 108 positions. In each of the years from 1978 onwards, however, the funding for not-for-profit organizations was steadily decreased. AIR was also threatened with such cuts repeatedly but managed to escape them until 1980. At that time a hiring freeze was imposed so that when artists left the program their positions could not be refilled; in October 1980 the program stood at the reduced level of sixty-five positions. New artists were not hired from that time forward, and selection panels were no

longer convened. With the anticipation of CETA's demise, AIR managed to secure federal community development funds and changed its name to the Community Arts Development Program (CAD) late in 1980. The name change signaled a fundamental shift in orientation. Rather than employ artists, CAD gave grants to support artist-initiated projects in specified communities. When the tenure of the remaining AIR artists expired on 1 October 1981, CAD completely supplanted the AIR program. CETA funding for the arts therefore came and went with relative speed.

While the funding for AIR was obtained from a centralized source for CETA funding in the city of Chicago as a whole, it was channeled through another city department, the Chicago Council on Fine Arts (CCFA). CCFA was established in November 1976, and less than a year later it had undertaken three major projects: a survey of the nature and scope of arts activities in the city, a survey of the volume of corporate support of the arts, and AIR. These first two projects demonstrated an interest both in assessing the contribution of cultural activities to the economic *and* nonmaterial well-being of the community, as well as determining what the community (especially the business segment) did to sustain these efforts. AIR came into being in the company of sister projects at a time when linkages between the arts, the community, the business community in particular, and the expansion of funding were being examined concurrently.

The three individuals who held the post of CCFA director during AIR's existence should be noted, for each provided important connections between AIR and other city agencies and offered varying degrees of support for continuing the program. CCFA's first director remained at the post for less than a year, but it was the year in which planning for AIR began, and her support of this nascent project was substantial. Perhaps more important than her support while she was in office, however, was what she could offer in a more informal role. She resigned her post to marry the mayor and quickly enlisted him as an ally of the program. AIR had its own emissary to the center of city government, providing an unanticipated (and quite valuable) political base of support.

The second director brought another important set of connections. The person who had been responsible for planning AIR was pulled into the directorship of CCFA just as AIR was becoming a reality. Not only was she naturally sympathetic to a program she had just designed and had intended to lead, but her previous experience had been in the Office of Manpower, the CETA prime spon-

sor. AIR therefore had the benefit of her expertise in dealing with the agency it was dependent upon for continued funding. Other CETA-sponsored arts programs had to develop contacts and understandings with this office independently and in a relatively blind manner, while this important prior association gave AIR a competitive advantage in relation to other groups also seeking support.

This director, the previously cultivated connections, and AIR's favored position were all lost in August 1979 through the housecleaning which followed the election of a new mayor. The new director brought with her a sympathy toward more established cultural organizations (e.g., museums, symphonies, and opera companies) on whose governing boards she had done volunteer work for years. Further, her initial commitment was to the national rather than the local art community. Soon after assuming office, for example, she personally sponsored a benefit for the Kennedy Center for the Performing Arts in Washington, D.C., raising more money than CCFA's entire yearly budget. This move was criticized as abandoning CCFA's commitment to a wide range of local community arts programming and thereby using the arts as political capital.[21] The emphasis shifted, then, from identifying and mobilizing business and other sources of funding for the support of a variety of local cultural endeavors to the national political arena and to "cultivation" of a decidedly different sort.

Artists Sitting at Desks

When visitors came to the Artists-in-Residence office, what would they have likely observed?

If an office conjures up images of orderliness, regulations, and businesslike formality, there was a serious question as to whether there was any overlap between these ideal-typical characteristics and the rendering offered by AIR's first office space. Immediately striking the observer would be the amount (as well as the noise volume) of activities being conducted within what was essentially one large area. The first office was located on the 24th floor of a high-rise office building in the northwest part of Chicago's Loop and was used during the initial eleven months of the program. The secretarial staff collectively occupied a separate area of the space, and the director and assistant director each had a private office with a door. However, other administrative staff and any artists wishing to use the office facilities to conduct business of any kind shared the remaining area. The desks, telephones, and other types of equipment that were available were generally insuf-

ficient to meet the demand for them, even though the space hardly could have supported anything more than it already held.

The office was generally a flurry of activity. And visually, it was just as busy—movie and theatrical posters adorned some of the walls, press clippings covered the entire length of another, and at various times desks were piled with costumes, musical instruments, brochures or programs for upcoming events, and numerous kinds of art supplies. The smallness of the area relative to the amount of activity conducted there contributed to a *gemeinschaft*-like milieu where everyone seemed engaged in communal activities, and everyone definitely knew everyone else's business. However, the flowering of individual styles and the types of activities which were undertaken were clearly drawn from and nurtured in a more *gesellschaft*-like environment.

The elevator operators developed a sixth sense about who was going to the 24th floor. They quickly learned to successfully read the cues given off by those coming to the AIR office that distinguished them from most others in the building. The easiest to spot were those who carried equipment marking them as artists. With some small amount of practice, however, it would be relatively easy to identify the artists without the assistance of such obvious accoutrements. "Costumes" rather than clothing might better describe the manner of dress of some of the artists. Commonly seen were bright, sometimes wildly contrasting colors; vintage clothing from various eras; and appearances ranging from exotically formal to casually disheveled—yet all were assembled in a self-conscious manner. These artists were not, to reiterate, typical of most people working in a downtown office building in Chicago.

AIR moved to a building in the central portion of the Loop overlooking the State Street Mall just prior to the beginning of the second program year. The new office was a striking contrast to the old one and also much larger. It was rented as raw space and then designed in consultation with the administrative staff. The number of private offices increased, and other work areas combined an air of informality with a sense of privacy. Partitions demarcated spaces for no more than two or three individuals. The partitions were erected in an arrangement of ascending heights throughout the office, with not even the tallest reaching the ceiling. Each space was thereby separated from the others, but it was easy to talk over the tops of these panels, and each cubicle opened into a common corridor and had no door.

This environment was generally more conducive to the effi-

cient execution of duties. In addition, an attempt was made to regulate the clutter distinctive to the previous office by requiring the approval of one of the assistant directors before anything was displayed on the walls. Yet even with such restrictions the office developed a distinctive look. For example, the aforementioned panels were painted bright designer colors, carefully matched for a harmonious effect. And, the prescreening rule quickly broke down as individuals installed large pink plastic flamingos, pictures, posters, and artifacts in their own work areas. Personal style and decorative impulses could not be legislated out of existence.

The move to the new facilities was differentially evaluated. The accentuated sense of space, newness, and privacy was welcomed, especially by those who had to be in the office every day. As the AIR director noted the first week of the 1978–79 program: "Hopefully we are squared away. I can't believe that we are finally settled. I love my new office and feel as though I have been taken out of a strait jacket. With a few minor skirmishes, the senior artists are settled in desks and we will all be moved in by the end of the week."[22]

In contrast, there was also a feeling of loss over the shared sense of working together that the old physical surroundings had necessitated. Much as contemporary drama and fiction record the disequilibrium felt by urban ethnics who strive to succeed and escape the old neighborhood only to later lament the absence of familiar sounds, smells, and activities in their new environments, some artists expressed the concern that something intangible had been lost in this move. The reaction of artists not on the administrative staff was particularly telling. One visual artist felt overwhelmed and alienated—not only were there the increased number of private workspaces, but each desk was equipped with a phone having a multitude of buttons! In actuality the number of general phone lines had not changed, and the old phones were similarly equipped; however, he was convinced this was an index of the increasing formalization of the office. Additionally, he was informed that each deskholder had been assigned an interoffice communication line number, so he or she could be informed of incoming calls. Again, because he remembered that anyone's attention could be attracted by shouting or waving in the old office, this type of formality destroyed his sense of how the office had previously operated. Although as a visual artist he made minimal use of the office (for occasional meetings and picking up paychecks, for example), the sense of displacement and loss he expressed was enormous.

AIR sustained its unusual physical environment largely because its facilities were separate from its sponsors. This uniqueness was matched by office routine and procedure. There was a casualness and informality that contrasted with other city offices and with other bureaucracies more generally. Despite reactions to the contrary, the office could hardly be characterized as tightly structured, hierarchical, or bureaucratic. The program consciously developed this atmosphere because it wished to be responsive to the needs of its artists as it perceived them and did not want to put them off so totally that *no* control could be exercised. Thus what seemed to be an organization lacking much of a discernible structure had been strategically developed as a minimal one its designers felt would best meet the needs of these employees.

This basic characteristic of the AIR office was most evident at a particularly critical moment. A great deal of suspicion and insecurity arose when a thief began operating within the office. Many practices had to be closely regulated so as to limit individuals' access to valuable resources; for example, private offices became locked storage facilities for expensive equipment, restrictions were placed on who could be in the office at what times, and distribution of paychecks was more tightly supervised.

The response to this crisis was not just annoyance at these inconveniences, but also one of anger and resentment that the atmosphere of trust and informality had been breached. These feelings were especially evident for the director who responded by issuing a memo and convening a staff meeting, both of which were permeated with a tone of personal disappointment and violation. The memo stated in part:

> This is very unsettling not only because of the losses of personal and office property but because it is damaging to the sense of trust we have all shared to this point.
>
> In analyzing the pattern which has emerged from the incident when the property was taken, I have regretfully come to the conclusion that the person stealing is in our office.
>
> I am instituting a number of security precautions. . . . These procedures are inconvenient to all of us and they further complicate our operations. However, I feel that I have been forced to institute them to protect our office and personal property and staff morale.[23]

There was the sense that even if this situation were successfully resolved, the office would not and could not revert to its previous procedures. As the director declared in the meeting, "People like

us who are creative are unable to work under such security pre-cautions."

This crisis did remain unresolved; the thief was never identi-fied, and the incident had a long-term impact. For while the desire had been to offer a singularly unique (i.e., nontraditional) office atmosphere in which creativity would flourish, this forced the ad-ministrators to exercise authority and act in a more typically bu-reaucratic way. This fundamental challenge to the organization clarified its boundaries and necessitated a response revealing a ca-pacity to act that had been largely unexpressed previously.[24]

With some sense of what the organizational setting of the office was like, we can proceed to examine crucial assumptions underlying AIR's operation.

3

Explanations and Justifications: The Artist as Worker, The Program as Employer

> The self-image of the insurance salesman as a fatherly adviser to young families, of the burlesque stripper as an artist, of the propagandist as a communications expert, of the hangman as a public servant—all these notions are not only individual assuagements of guilt or status anxiety, but constitute the official interpretations of entire social groups.[1]

Artists are an enigma; they challenge many of the accepted notions of what it means to be members of a professional group in this society. On the one hand, they tend to undertake an extended period of formal training, maintain affiliations with professional organizations, and develop a strong sense of identification with their chosen fields. On the other hand, they are subject to a number of highly contrasting trends. Their rates of unemployment and underemployment are marked, their income and the status they are accorded is low, and the degree of control and predictability they have over career lines is low relative to other professional groups.

Adding to a complex situation has been the presence of a unique aura surrounding the role of the artist. In part imposed by society and in part actively reinforced by artists themselves, a romantic notion has existed which fails to recognize the problems artists face as workers. By picturing artists as ascetic characters, entrenched in garrets and able to survive by means of the self-satisfaction deriving from their work alone, their unusualness has been emphasized while the similarities they share with other groups have been overlooked.[2]

In the very recent past, however, governmental agencies, ac-

ademics, and artists themselves have established a nascent yet distinct trend to describe artistic roles, their incumbents, and activities in ways similar to other groups. In their family and household characteristics, for example, artists tend to be somewhat different from the general population, but the differences are not dramatic; more significant contrasts can be noted *between* artistic groups themselves.[3] The attempt to "overcome false ideas and romantic notions that developed through popularization of individual and often atypical cases"[4] has dictated asking questions which previously seemed irrelevant to artists and their position in society.

Additional indices suggestive of this trend can be found in the tendency to see artists as subject to the same institutional and structural constraints as others in society;[5] an increased emphasis on the artist as grounded within a network of producers and production constraints rather than being socially isolated;[6] the additional stress placed upon the contributions of artists and their creations to the economic well-being of communities;[7] and finally, the recasting of artists as workers with typical, not atypical problems.[8] CETA-arts programs were spawned by similar ideas and relied upon similar arguments when they explained their mandate, described their activities, and specified who they were working with and toward what ends.

The Artist as Worker: An Ideological Rationale

The individual rip-offs reported in relation to CETA projects were not particularly surprising. Within the maze of regulations and procedures which accompany such programs there are plenty of blind corners which offer protective cover to execute what some would term a scam. However, they do tend to provoke outrage: "Artist Rakes in Your Tax $$ with Weird Sculptures," proclaimed a *National Enquirer* article on an AIR participant.[9] What this individual claimed to be "environmental sculpture" her critics instead saw as merely stacks of tree branches, piles of sawdust, or trails of pigment in the snow (see fig. 1). But even in regard to the most conventional types of art production within AIR and other CETA-sponsored arts projects, many segments of the public believed that what would be termed a scam on an individual level was being perpetrated instead on a collective basis. Since artists were often considered to be questionable recipients of public support, by what alchemy were these individuals transformed so that CETA prime

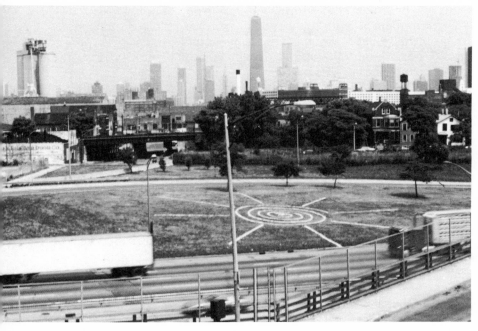

Figure 1. This environmental sculpture entitled *The Sun/Serpent* was executed with sawdust on a grassy area alongside an expressway and is framed by a familiar section of the Chicago skyline in the background. Photograph by Janet Sullivan.

sponsors were willing to acknowledge their needs, at least for a time? In other words, what ideology was constructed to justify the inclusion of a somewhat special group within the ordinary boundaries of public service employment?

As if to magically provide the key to success, the phrase "artist as worker" resounds throughout the official statements of CETA-sponsored arts projects. Artists were cautioned to deemphasize those elements that would distinguish their work habits, productions, life-styles, or standards of judgment as anything extraordinary. "Define yourselves in such a manner," artists seemed to be told, "and support can be yours." The alchemy which "transformed" artists into CETA workers was a rearrangement of components as much as anything else; the metamorphosis was less magical than strategical.

The tendency to "normalize" this group of individuals and to present them in quite conventional terms has involved tremendous problems. The enormity of the change implied in this concept was reflected in the following statement from the sourcebook of the first national CETA-arts conference:

> . . . the advisory group members identified as a critical issue facing artists in this society: that artists are not perceived as workers. The advisory group suggested that this perception is a major obstacle in obtaining Prime Sponsor support for Arts programs. They recommended that a well-known professional artist, speaking from the perspective of personal experience, describe the training, discipline, dedication, and hard work necessary for professional success in the Arts.[10]

The fact that CETA-arts organizations concluded that they needed to supply sufficient grounds to warrant support in such a way says more about the hostility and disbelief of the environment they were confronting than it does about anything intrinsic to artists or artistic pursuits.

There is a corollary to this idea of artist as worker: for if he or she works, of what use are their efforts and products? Art production increasingly has been touted as contributing to the economic well-being of communities, and the relationship between the art and the business communities has been explored with great interest. It can be argued that CETA support of the arts was the culmination of a process whereby art has been treated as a consumer good. As a result, both artists and what they create have lost much of their sacred nature and are becoming recognized as an important economic force.[11]

This position can be detected in the arguments of Jeremy Bentham. In his *Theory of Legislation*[12] he discussed the importance of arts activities to business; by attracting foreign visitors, an active art community can encourage the expenditure of large amounts of "tourist dollars." Yet Bentham's view could not boast of as many advocates in the past as it has in recent years. For example, a Rockefeller Panel Report on the performing arts in 1965 had much the same emphasis—treating the arts as big business, looking at their impact on communities, and assessing their potential contribution to business (e.g., making it easier to attract employees).[13] These themes were echoed by a report on the contributions of the

arts to the economic and social well-being of New York City which cited the development of Lincoln Center and the settlement of large numbers of artists in SoHo as critical to the increased prosperity of surrounding areas.[14] The role of the arts as economic "multipliers"—they generate returns on each funding dollar—is now emphasized. It was this latter point that was cited in justification of such programs as CETA in general. By publicly funding certain activities, the participants could move from being tax consumers to eventually becoming taxpayers.[15]

The contributions of the arts and cultural activities to communities are variously calculated, but such attempts are increasingly made. In Chicago, the amount of both direct and indirect contributions was estimated to be about $47 million each year according to a CCFA report.[16] And to guarantee the maximization of these contributions, groups such as the AFL-CIO have emphasized that the continued underutilization of the training and abilities of performing artists severely curtails the potential economic gain of the nation as a whole.[17] Many contemporary proponents of the arts do not present these as luxury goods; rather, expansion and contraction of public support are increasingly considered as gains and losses for the welfare of communities as well as for individual artists.

Significantly, economists have previously argued with quite a different emphasis; they have pointed to the extraordinary nature of artistic pursuits and yet have been able to call for public support as well. A frequently cited study argued for support of the arts because certain distinguishing features such as the labor-intensive nature of such work result in an "earnings gap."[18] That is, the arts cannot incorporate technological innovations in the same way producers of other goods can, so they fail typical market tests of success. These authors also enumerated a number of intangible contributions the arts make to society which makes them desirable and necessary.[19] Still other economists have argued that art is a "merit good," again exempt from the evaluative criteria applied to the production of other goods and services, and deserving public support *because of* its special nature.

A social theorist might propose the following: these arguments represent a rejection of a classic utilitarian orientation which would emphasize society's mandate as only providing the barest essentials (à la Adam Smith), in favor of a more positivistic approach emphasizing the priority of the state and its provision of a

wide variety of services for the health and welfare of its citizenry (à la Comte and Durkheim). However, because CETA support of the arts turned out to be relatively short-lived, it is difficult to accept it as being an index of general contours of society. It is instead more reasonable to argue pragmatically. Support of the arts initially came about because it was possible to plug into an already existing system to a small extent. Then, attempts were made to develop an ideological justification of such support in markedly economic terms, thus the "artist as worker" and a contributor to the economic health of communities (art can be "good business"). Finally, however, neither of these ideas commanded sufficient attention.

The explanation of the evanescence of CETA support of the arts from 1975 to 1981 rests on two basic factors. First, artists sought sponsorship by a program which was already being critically evaluated and which gradually developed a more defamed image. As the program as a whole steadily lost support, so, too, did its constituent elements. It is important to consider the history of CETA as a whole—*its* political economy—rather than to examine the relatively minor arts component in isolation.[20] And second, the promotion of the idea of artist as worker was inconsistent and struggled against longstanding images of artists in very different terms. As much as this ideological innovation was advanced, it was also continually qualified and its potential persuasiveness thus eroded. The catch phrase was often amended by "Yes, but . . . "; the ways in which artists could be seen as typical were enumerated, but their special needs and the ways in which CETA regulations seemed inappropriate to their situation were just as frequently highlighted. AIR reacted with remarkable swiftness to request special consideration or exemptions whenever new CETA regulations seemed inapplicable or burdensome to its staff. Since the image of artist as worker was equivocably presented by its proponents— those who had the most to gain by general acceptance of the notion—other audiences were also less likely to believe in it.

The development and promotion of this image did not occur in isolation from other assumptions but was embedded within a set of observations and pronouncements which comprised an implicit rationale for AIR's operation. These explanations held out promises to participating artists; likewise, they were meant to help others interpret what the program was purporting to accomplish. There was an attempt, therefore, to justify AIR to those both within and beyond its organizational boundaries.

The Program: An Implicit Rationale of Operation

"Definition of a Poet"
. . . Inability to hold any kind of "real" job
for more than nine months
(That's my record anyway.)[21]

This epigraph records a condition many young artists experience. While the writer notes that she has been relatively unsuccessful in holding a job, she also assigns responsibility for such a situation to some flaw within herself. Further, she makes a distinction between a "real" job and what she usually does. We have here the definition of a problem in individual, not social terms.

Of great importance is what drops out of consideration, however. The poet does not ask how many jobs exist for writers in our society; she does not question why it is that what she does is devalued, nor why the work she must find to support herself is considered more "real" than what she is the most skilled in doing. Further, she does not try to assess the relative probability of success, or even subsistence, in her chosen profession. She has instead internalized her failure as being her own responsibility and then alternatively laments and celebrates her condition as reflecting the way the world is and must neccessarily be.

AIR sought to alter such conditions. On the one hand, it hoped to enable its participants to experience success through being chosen for the program and being given the opportunity to actually work and be paid for what they had been trained to do. In this sense the aim was to stabilize professional identities, to confirm the artists' sense that what they valued was indeed of value, and to heighten their self-respect and self-assurance. On the other hand, AIR believed that their participants would so successfully respond to this new type of arrangement that the future expansion of such situations would be inevitable. That is, demonstrating to decision makers and the public at large that artists are useful, contributing members of the community—*given the opportunity*—such opportunities would necessarily continue to be underwritten. AIR therefore anticipated that its activities would stimulate changes on both the personal and societal levels.

Although AIR administrators never explicitly articulated a model of the changes they were promoting, a model can be abstracted from explanations which were regularly offered in discussions of policy and goals. This was a three-part process through

which "raw material" would be progressively refined into a marketable entity, a "cultural worker." By offering an alternative to the conditions of uncertainly peculiar to the situation of artists, both present rewards and future dividends were promised.

The Potential Pool

AIR administrators were aware that a large pool of individuals who considered themselves artists but who were unable to find suitable employment on a full-time basis existed. This knowledge came not only from a variety of sources they regularly consulted, but also from their experience with real artists and their travails.[22] It did not come as a surprise that the number of AIR participants who had been able to support themselves as artists in the year prior to their employment as CETA artists ranged from only 12.5 percent to 21 percent, program year to program year (see chapter 4). Further, in end-of-the-year surveys conducted in 1979 and 1980, only 42 and 47 percent of the artists, respectively, reported that they had ever been able to support themselves entirely by their art at any time prior to their involvement in the program. And of course, their CETA eligibility itself indicated the marginal economic level to which they were accustomed. Therefore, a fact revealed by a 1977 study conducted by CCFA is easy to understand. When queried about the obstacles they experienced in furthering their careers, artists in every field surveyed most often cited the inability to arrange for the provision of money for a fixed, one-year period.[23]

AIR proposed to redress the severity of these economic conditions by providing their participants precisely what artists have claimed to need, i.e., a regular salary. Chicago's AIR was deluged with qualified applicants when program slots became available, as were other major CETA-arts programs.[24] Because of this demonstration of need, AIR concluded that large numbers of artists wished to overcome their experience of both psychological and economic insecurity. These individuals had somehow maintained a primary identification as artists despite little or no confirmation of this through securing appropriate employment; the program therefore assumed that the provision of more desirable work conditions would greatly help these artists who had persevered become more confident of their professional abilities. However, ability had to be combined with a willingness to shed some of the work habits, attitudes, and idiosyncrasies which might have been more appropriate to their previous situations.[25] When so many individuals

presented themselves as disposed to such training, AIR administrators concluded that qualities typically associated with an "artistic temperament" might be secondary adaptations to structural conditions, not necessarily characteristics intrinsic to artists and artistic pursuits.

The Amplification of a Professional Identity

Beyond the basic uncertainty provided by economic circumstances, AIR sought to assuage the impact of other conditions commonly confronted by young artists. Individuals within this occupational group must routinely attempt to locate themselves within a field having evaluative standards which are contradictory at best, transient, provisional, and inexplicable at worst. "How good is my art and according to what standards?"—these are recurring questions, most generally with no ready answers. Further, the career situation young artists frequently experience reflects the same lack of explicitly articulated guideposts by which they might locate themselves. While these circumstances were understood to some degree early in the program's existence, the actual gathering of information on AIR participants confirmed these suspicions and contributed to the formulation of programmatic emphases.

AIR discovered, for example, that these artists frequently described their stage of career as being near the "beginning" end of the continuum, despite a large amount of formal training and a rather high median age. This was interpreted as evidence of the lack of a series of statuses between receiving professional training and becoming a professional practitioner.[26] Similarly, only one-third of the entering artists in 1978 and forty-one percent in 1979 felt they had completed formal training in their fields. Many stated that training was an "ongoing process," and one artist expressed her feelings in a way echoed by many others: "Training continues as long as one is a dancer—formal training is taking classes forever." With training being largely indeterminate, few opportunities seem to exist to allow young artists to gauge their position within their respective disciplines.

In response to these facts of artistic life, AIR anticipated providing several corrective features. First, one way these individuals could gain a sense of their capabilities would be by their selection from what was known to be a large pool of available applicants. Young artists would be aware of the scope of the competitive field by seeing the long rosters of those being auditioned

and interviewed. To be chosen, then, would be to have one's professional potential recognized. Second, by offering its participants the opportunity to increase their artistic *and* work skills, AIR proposed to provide what could be called a "status-sequence."[27] It is apparent that artists do not have the widely recognized progression through stages of development as exists in other professions, such as medicine. Being acutely aware of the large proportion of their participants who felt themselves to be in transitional circumstances, AIR sought to provide an intermediate stage of training which did not typically exist for artists. Program administrators reasoned that such an interim position might be provided more frequently once it had been successfully established. Artists then could be accorded a clearer sense of their place in a succession of stages comprising a career.

And finally, AIR proposed that it could amplify and stabilize the professional identities of its participants through the provision of what could be referred to as situations of "differential association" and "differential opportunity structures."[28] The former, with its emphasis upon social learning, assumes that individuals are influenced to act in specific ways when they are exposed to one set of definitions and justifications which predominates over others. AIR attempted to bring together individuals willing to discard idiosyncratic approaches to art and wanting to acquire the skills necessary to negotiate the execution of their work in relation to clients' needs and demands. This included learning to adapt abilities, present ideas in a coherent form, and develop an understanding of organizational procedure. All this was to be done in the company of like-minded individuals, with the attendant economic and social advantages emphasized over the insecurities connected to operating as an independent artist/entrepreneur. This aspect of the program was captured in what sounds strikingly like sage advice being imparted to those gathered around to receive the wisdom of the experienced:

> It should, by now, be clear that "making it" in either our program or the art world is a complex matter. It calls for more than talent. It requires more than persistence. It will not come, neatly wrapped, delivered to the doorstep. Rather, it comes disguised as time sheets and cross-town travels; as agency reps and distracted audiences; as frustration and the growing ability to surmount all inevitabilities.[29]

Additionally, there was the assumption that once trained, individuals must be allowed to perform in their new capacities. In

Cloward and Ohlin's words, "Roles, whether conforming or deviant in content, are not necessarily freely available; access to them depends upon a variety of factors. . . . To be prepared for the role may not . . . ensure that the individual will ever discharge it."[30] AIR undertook to provide such opportunities in several ways. First, it provided participants the (literal) occasion to perform their art, within the parameters of its definition of public art. Second, AIR attempted to develop positions for its participants in culturally oriented organizations (e.g., as exhibit and program coordinators) which would continue past their AIR tenures. Thus, there was an effort to train artists for those art-related positions which might already exist, with the additional hope that if the program operated successfully it would contribute to the increased development of such situations. And further, AIR intended to increase its artists' opportunities through encouraging the translation of their experiences into tangible professional credentials, for example, by acquiring union membership. To cite one instance, this could be expedited in the case of actors because AIR was an Actors Equity company. Since it had this status, nonunion AIR theatre participants were able to join their major professional organization with greater ease and under more favorable monetary arrangements than had previously been the case for them.[31] Their professional identities, as well as their opportunities, were thereby assumed to increase.[32]

The Production of Cultural Workers

The end product of this process was the production of cultural workers. This term referred to individuals with artistic training who had successfully learned to adapt their skills to the existing market, whose needs as workers could be as seriously acknowledged as those of other occupational groups, and whose contributions to the health and welfare of local communities would be considered of value and thus worthy of continued support. In the development of such individuals, AIR believed that certain characteristics commonly associated with artists would drop away. AIR's reasoning was therefore similar to that of many jobs programs for disadvantaged groups in the 1960s which assumed that subcultural adaptations had developed in response to specific structural conditions and would change when and if these latter conditions were altered.

It is practically a sociological truism that what can be under-

stood as secondary adaptations to structural conditions are often taken to be indications of psychological traits instead.[33] What is frequently located within troubled psyches can to a large extent be explained by social processes. In the case of artists, peculiar "personality" configurations are popularly assumed to exist,[34] including such characteristics as lack of responsibility, emotional immaturity, or highly individualistic and egocentric spirits. However, each of these attributes could likewise attest to the extreme inability to find employment suitable to one's training in these fields and the subsequent need to individually overcome structural difficulties. With the centrality of work in our culture and its relation to the development and maintenance of adult status and identity, it follows that groups for whom there are generally few opportunities would not receive a proportionate share of available economic *or* psychological rewards.

AIR recognized these aspects of the young artist's plight and proposed to provide the aforementioned alternative opportunities. It assumed that the artists would flourish within such an environment and that certain characteristics would quickly fade into the background while they responsibly met the challenge of these altered conditions. However, such assumptions were not reasonable if these same individuals could expect only a limited tenure within the program and if most were faced with returning to an unaltered set of structural conditions in the larger society. Further, even while supposedly protected from the uncertainties common to artistic careers during the hiatus provided by AIR participation, uncertainties facing the organization were necessarily experienced by the artists as well. In many ways the program replicated rather than supplanted unsettled and insecure situations. While AIR might have provided a context for the conversion of artists into cultural workers, it failed to offer sufficient evidence to convince many of its participants to thoroughly submit to this process. With little guarantee of societal change, how could they be expected to relinquish their skillfully constructed strategies of survival?

Before such important questions can be fully examined, however, it will be necessary to consider the processes of choosing participants, designing and implementing the program, and facilitating a fit between these elements.

4

Horses for Courses: Personnel and Programs

"They Don't Look Like Payrollers—But 107 Artists Are"[1]

The image of artists on salary is somewhat unfamiliar since they are often pictured as independent entrepreneurs. The image of "payroller," however, is even more discomforting—this implies someone may be receiving undue recompense for his or her services. AIR administrators were not burdened by much of this prejudicial baggage but instead confronted the very practical tasks of formulating a workable program and assembling personnel to staff their positions. From AIR's point of view there was an embarrassment of riches: large numbers of potential employees were available at bargain prices. This allowed the program to insist on high quality as well as a comfortable fit; style was as important as adaptability in this comparative selection process. From the artists' point of view, however, AIR was just one more example of a hopeful situation that was in fact a long shot. The odds were against them as usual, and a large set of contingencies governed any individual's chance of being accepted. In sifting through all these hopefuls, individuals would fall out of contention whenever it was clear they were lacking in any one of the qualities AIR valued. Here it was even more the case than is usual that artists would counter the question "What can you do?" with the reply "What do you need?" For what AIR wanted was ambiguously presented, and artists tried

to emphasize their own plasticity in response. Who, then, were the CETA-sponsored artists in AIR, how were they chosen, and in what capacities did they serve in order to earn their pay?

Few Are Chosen

AIR selected its participants from a pool of candidates who had met CETA eligibility requirements current at their time of application. Information announcing the availability of positions and describing the anticipated nature of this venture was released approximately two months prior to the start of the program. The general media, more specialized art-related publications, and arts groups and institutions all received and diffused this information, as did personal networks within the art community. In fact, this latter source proved to be quite important: during the second and third program years, new artists indicated that in more than one-half of their situations they received their information about applying for positions through such networks. Because of the success of this overall procedure, it was repeated using all these resources in the following years.

CETA eligibility requirements became considerably more stringent as AIR developed. In the first year it was only necessary that an individual be unemployed for a minimum of thirty days or be underemployed (that is, working ten or fewer hours per week or earning $30 or less per week). The required period of unemployment or underemployment was extended to a minimum of fifteen weeks for the second-year applicants. Additionally, eligibility was determined by meeting federal poverty income standards applicable to the person's family size. This was set at $3,140 per year for an individual and increased according to the number of family members. These guidelines remained essentially the same for the third program year.

The changes in eligibility requirements had an impact on both the size and nature of the employee pool. For example, artists often work in situations which do not provide a steady income. They are employed typically on a commission basis, on projects that have a definite completion point, in performances which end their run, or in short-term jobs outside their chosen fields to sustain themselves until more appropriate employment can be secured. At any given time large numbers of artists could probably meet the criterion of having been unemployed for thirty days. However, because many artists' incomes tend to be quite low,

being unemployed for a minimum of fifteen weeks would be less common; many individuals would have to obtain some type of work before so much time passed just to meet basic expenses. What initially had been a set of requisites largely coincident with artists' situations instead became increasingly exclusionary for this population.

Even among a group so accustomed to leading economically marginal lives, those gaining CETA eligibility under the more stringent guidelines attracted both wonder and doubt. Wonder, that anyone could survive being *that* marginal and doubt about the individual's ability either as an artist or in obtaining alternative employment. The question was then posed, "How useful is CETA in providing a large and rich pool from which to choose?"

This question was not merely speculative. Whereas more than 1,200 applicants were available for the initial 108 AIR positions, just over 400 individuals were certified as eligible for the forty positions being filled in September 1978. And while there were as many as twenty-eight individuals vying for the available slots in some artistic disciplines during the first year,[2] the competition was not so acute in subsequent years. In fact, the recruitment period for the 1979–80 program year had to be extended in order to establish a satisfactory pool; in some artistic fields openings would have still existed even if every applicant had been hired.

When these general eligibility requirements were applied to artists, some individuals not originally intended to be part of the CETA target population slipped past. Within the first year's group, for example, a glance at the roster of participants would reveal some of these short-term unemployed individuals living at very desirable addresses. In some cases these were artists who were between jobs at the time of their application to CETA but who were otherwise relatively successful at securing employment. In others, parents, spouses, or lovers contributed considerable support while at that time only the applicant's own income determined eligibility. Some special cases could be noted among those who entered the second year as well. One participant had completed a teaching contract and had found it unnecessary to work throughout the summer, while another had just returned from a *Wanderjahr* throughout Europe and was considering what to do to replenish exhausted resources. In the third year, however, the financial situation of AIR applicants closely approximated that of the typical CETA applicant.

Despite some interesting exceptions, the precarious state of

many of the artists' financial situations was reflected in relatively unstable and markedly nonluxurious living accommodations. As an interesting indication of this, a secretary explained why a new roster of participants had not been assembled and distributed several months after the beginning of the 1978–79 program: from the experience of the previous year, many individuals obtained phones and new apartments after entry into the program, necessitating constant revision to keep the record current. The attempt to compose a new list was therefore postponed until the initial impact of receiving a regular salary—and the opportunities it now provided—had somewhat stabilized.[3]

AIR frequently emphasized the special nature of its artists and its program to the state jobs services office which determined the eligibility of all CETA applicants. They were enacting the doctrine of the artist as worker, although with special provisos. For example, each year AIR obtained a waiver from the Department of Labor to permit the establishment of artistic review panels to select its own finalists. The typical procedure in CETA programs was that an agency requesting employees would be given the files of the first three applicants certified to be eligible in a given field. The requesting agency would lose a position if they did not make a choice from these individuals. As the New York City artists' project declared, however, they "[weren't] looking for the *fastest* artists, but rather the best artists."[4] AIR argued that only other artists were sufficiently qualified to recognize the subtleties of artistic accomplishment and promise: "A review process is necessary due to the competitive nature of artistic occupations. Panels are essential to the selection process because the mechanical skills of artists are secondary to qualitative factors which require trained experts to distinguish."[5] This reasoning was accepted, and the applications of *all* artists obtaining CETA eligibility were referred to and reviewed by AIR personnel, insuring the widest latitude of choice.

Further, a special application section was established each year during a specified time period to process applications by artists, and consideration was requested for their particular needs. As an example, one group of AIR musicians had been providing instruction to students within the school system. During the upcoming summer, however, their desire to perform as a more complete musical group required more diverse instrumentation and the addition of players. The interdependence of musicians was emphasized in an appeal by AIR's director to the Office of Manpower: "I am asking for special consideration so that we may enable our mu-

sicians to become more effective. . . . I was unable to hire a bassist and a percussionist . . . before the city's freeze on hiring was imposed. Thus, they [the then incomplete ensemble] are severely limited in what they are able to accomplish."[6] Approval was granted so that the services of those artists already employed could be fully utilized; it is unlikely that CETA employees in other occupational areas were so mutually dependent on one another's contributions to execute their own responsibilities.

While such specific incidents demonstrated that these applicants had atypical needs, their unusualness was more generally apparent by comparing them with others filing their applications at the jobs services office. The artists looked healthier, more self-assured, were more often Caucasian, and better (although sometimes rather idiosyncratically) dressed. The contrast was apparent to the trained or untrained eye; puzzled glances were often exchanged between other applicants who wished to know what business these particular individuals could possibly have there.

CETA-sponsored arts groups felt they had to request special considerations if they wished their products to have a degree of artistic integrity. But since CETA erected a structure which could only anticipate standard problems, arts groups could offer to assume responsibility for certain processing tasks to relieve the system of any undue strain these unusual cases might cause. Therefore, when AIR successfully petitioned to receive the credentials of all arts applicants and audition and hire according to its own standards and priorities, it guaranteed its operation as an artistic enterprise. It secured this right by claiming to expedite the task of the jobs services office, an approach encouraged by the NEA:

> You must . . . *control performance levels by setting your own artistic qualifications and standards* and by narrowing job descriptions to meet precisely the levels you require. It is perfectly legal to hire any CETA-eligible person for your job; you need not take those pre-selected by your CETA office. . . . Most prime sponsors are delighted to be relieved of this role, and most arts groups have been surprised by the numbers and abilities of professional applicants for their CETA jobs.[7]

Given this pool of candidates, distinctions had to be drawn, choices had to be made. To carry out this task, panels were assembled to review the applicants' files. Performing artists furnished summaries of training, experience, critical reviews, and personal statements; those working in other media supplemented

their applications with photographs, slides, films, or videotapes. Separate panels were convened for each artistic discipline and were composed of recognized artists recommended by the arts council (CCFA). One additional panel, the projects review panel, judged the merits of the various proposals from city agencies which hoped to sponsor AIR participants.[8]

For the first year's program a large proportion of the applicants were interviewed or auditioned. In succeeding years, however, a screening process limited those being called in for personal presentations to a much smaller (and more manageable) segment of the available pool. Those on the review panels had to balance two sets of criteria in making their choices. First, artists had to be adaptable to the projects which had already been designated for the year's agenda. These projects had been chosen as follows: (1) priority was placed on projects meeting the highest levels of public service (e.g., serving economically disadvantaged, serving the broadest number of people); (2) artworks such as murals, paintings, photography, and sculpture were to be placed in public spaces (e.g., reception areas, parks, schools, etc.), not private offices; and (3) jobs were to offer meaningful artistic experiences for artists.[9]

In addition, artistic quality had to be assessed. During the first year the panel members and AIR representatives negotiated and agreed to hire highly talented artists, even if a match could not be made between an artist and a slot in the program. However, in each subsequent year AIR provided panelists with a job description for every available position. Negotiation continued to take place between the panelists and AIR representatives, but to a lesser extent. As a result, individuals with impressive training and demonstrable skills could be denied positions because they did not fit into the design of the program. Classical musicians, for example, regardless of their financial need or expertise, were generally not incorporated into the program's structure.[10] A less accomplished and "less needy" musician, whose skills more clearly matched the program's needs, conceivably could be chosen instead.[11]

In acceptance letters sent to the artists chosen for AIR's second program year, the following selection criteria were listed: (1) public service orientation as demonstrated by experience or expressed interest; (2) quality of artistic achievement; (3) training and/or experience; and (4) appropriateness for positions established by city agencies for artists.[12]

Some of these criteria were more concretely defined than oth-

ers. Public service orientation was discussed but never concisely delineated. During the first year of the program, artists were encouraged to present their ideas of what public service art should be and to propose specific projects. The definitions of the artists and the definitions of the program, however, did not always dovetail. In fact, the space between these different interpretations provided the ground for later discontent. A member of the writing panel anticipated the development of such problems, offered observations on the selection process for the first year, and proposed changes for future hirings:

> It was clear from several of the applications that the writers themselves were unclear about what was expected of them; many outlined proposals for projects in their applications that in no way matched the available positions. It would have certainly made sense to make the list of positions available with the application form, although the shortage of time may have made that impossible. It was clear that many of the people we interviewed were taken aback by the jobs offered, although most were exceedingly willing to undertake anything on the list. [13]

Training and quality of artistic achievement could be more or less rank-ordered; "appropriateness," however, came to carry more weight. Several particularly vivid auditions attest to the relative importance of these different criteria. An American dancer who auditioned for the second year presented esoteric Tibetan temple dances, including the use of authentic costuming, native instruments, and taped musical accompaniment. After she had presented her first number and then talked about it, she was requested to give another example of her dance capabilities. When she began what appeared to the panelists to be a similar piece she was abruptly informed it was "Time!," and the audition ended. The panel thought it was laughable that she was trying to find a place in a public service art project with expertise in such an unusual area and would not consider including her in AIR. Another dancer also presented cross-cultural material, this time an African presenting material drawing on his own native themes. Here the panelists gave the individual one of its most enthusiastic responses, agreeing on his artistic accomplishment. They regretted, however, that the program could not be expanded to include artists with foreign interests and skills. And finally, another dance hopeful presented credentials indicating dual interests: he had just completed a B.A. in sociology and had expertise in

dance as well. It was clear from his interview that his education and past experiences qualified him in the public service area. When he auditioned, however, he demonstrated a free-form style of improvisation instead of presenting a polished piece. His performance was considered too self-indulgent and idiosyncratic, and the collective judgment was that he was not sufficiently accomplished artistically for the program's standards. Besides, the panelists were reminded, AIR required artists who were already trained, not those seeking training in a public service context.

Over time the likelihood of an individual artist's skills, interests, and temperament being adaptable to the program's structure came to be crucial in determining who would be hired. The tension between accomplished artistry and available positions was conveyed best in the statement of one administrator:

> "Horses for courses," that's what we play. Some horses are good on a turf and some can run on a dirt track; others are good on a half mile, some on a mile. So we don't just take the best writers because maybe our only opening is to teach four-year-olds poetry. So we've turned down people who were nominated for National Book Awards, people who would guarantee good writing, of national acclaim, because they weren't right for the one or two openings we have. Don't ever forget, "horses for courses."[14]

A Portrait of the Artist

The availability of so many qualified applicants raised questions about their previous situations: their training, past careers, and prior ability or inability to secure positions within their chosen fields. Accordingly, surveys were taken of all new artists who entered AIR in October 1978 and in October 1979. The following is based on tabulations of the results of those surveys, drawing from forty responses to the first survey (100 percent of the potential field), and sixty-three (out of a possible sixty-eight) responses to the second.[15]

The average age of participants in the two years was quite similar: the mean was 29.3 years and 30.5 years, respectively. The age range was between 19 years and 68 years. Interestingly, the highest average age was found among the dancers, and the lowest was recorded for the administrative staff. Although this might seem counterintuitive, the dancers had invested a large number of years in their training, whereas administrators commonly were individuals trained in an artistic field who either purposely wished to

gain initial administrative experience, or who accepted such an assignment if they were not chosen for a position within their own discipline.

Overall, these groups were well educated. In each year, all but one individual had had some college-level training. In the first group 71 percent held bachelor-level degrees, and 28 percent of them also held master-level degrees. The second surveyed group had not attained such a high level of accomplishment, but was impressive nonetheless: 51 percent held one or more degrees. An additional 25 percent had had some college training, but had not completed degrees, and 22 percent had had some graduate training beyond the B.A. level without having completed a higher degree.

When asked to describe the stage of their own career few of these artists represented themselves as professionals or as being in an advanced stage. Rather, they responded most commonly in one of two distinct ways. Approximately one-half of each group described themselves as beginning in their careers, or portrayed their situations as just slightly more advanced: "struggling," "developing," and "advanced beginner" were common terms. The largest group from each survey felt they were between a beginning and professional status, that is, in a transitional state whereby they had mastered certain skills and felt themselves to be entering a new stage of their careers. Such a feeling was often expressed within the idiom of their artistic pursuit. For example, a visual artist described her situation as being "between school and the galleries," while an actor expressed a similar feeling in a more general way representing many others in the performing arts fields: "In a sense, I could say 'formal training' is behind me and that I'm at the stage of continual exploration of myself and my place in the field." However expressed, the characterization of their present situation as a "pivotal" or "fluxy" one was clearly relayed through responses to this open-ended question, which many of the artists found difficult and frustrating to answer.

The resistance to this question probably reflected the incongruence of their situations: highly trained and old enough to be advancing in career lines if they had been in many other fields, yet aware that artistic pursuits require a long period of time for professional maturation and there are not many clearly established routes to stable employment and success. As one artist stated, "Nearing the age of thirty and having gone this far, to stop is insanity." It is one thing to confront the difficulties and frustrations of such a situation on a daily basis; it is another to be required to describe it on a questionnaire without some degree of defensiveness.

Involvement in this CETA program was initially approached by some of these individuals as an opportunity to extend their training and enlarge their skills and to therefore enter a new stage of their careers. AIR provided some chance to escape a state of "artistic limbo," in many cases tolerated for a considerable length of time. The following respondent's hopes were clear: "I have completed formal training in my field but lack the proper experience to obtain a good paying job. With the experience I am gaining on the CETA program and a lucky break, I should be well on my way."

Many of the artists brought with them both a sense of prior frustration and expectant feelings, which can be better understood by considering their past employment records. Few of these individuals had been able to support themselves entirely by their artistic work in the twelve months prior to their AIR tenure. In the 1978 survey, only 12.5 percent of the group had been successful in this attempt; for the 1979 group, 21 percent found that their chosen professions could provide adequate support. Work outside their own field was therefore necessary for the majority. The 1978 survey revealed that about one-quarter of the respondents used teaching to supplement the income derived from actually practicing

Figure 2. Many AIR participants utilized their past experiences as art instructors; here a muralist supervises a group of children working on a fantasy panorama for their school. Photograph by Warren Friedman, courtesy of the Chicago Public Library, Special Collections Division.

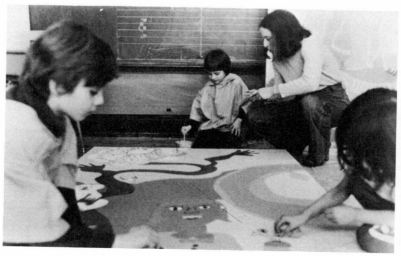

their art, while another one-quarter of the supplemental activities could be called art-related, applying artistic skills to such services as advertising, design, public relations, and announcing. In 1979, about one-fifth engaged in teaching, while 29 percent of the responses were in the art-related areas (fig. 2). For both years, however, the largest category was comprised of activities that were not art-related, such as the classic waiter and waitress jobs, secretarial work, sales, odd jobs, and a wide variety of other pursuits.

Artists were also asked if they had *ever* been able to support themselves entirely by means of their art work. In the 1979 survey almost one-half responded "yes," while 50 percent responded "no." For this latter one-half, employment in the AIR program was their first opportunity to overcome some of the contradictions of being an artist, alleviate some of the discomfort of being in limbo, and potentially ease the transition into professional status. To what extent these expectations were actually realized remains to be examined in greater detail.

Working for "The City That Works"

"EVERY CITIZEN WORKS FOR THE CITY
IN THE CITY THAT WORKS"
They'll pay me to write that on sidewalks
Soon the buses and trains will carry my poems
Ads for myself, a non-profit corporation.[16]

Each artist accepted into the program concurrently acquired the status of being a city employee because AIR was a city agency. This distinction was both a blessing and a curse. The blessings came through the provision of equipment, supplies, and other materials necessary to execute artistic assignments. AIR was forced to solicit such additional resources through the sponsorship of its projects by other city agencies, especially in the initial stages of the program, because CETA provided money for salaries only.[17] In addition, AIR had access to important services such as printing and photographic developing that the city provided at no charge. These were valuable assets that were heavily utilized by an organization which found it crucial to document its accomplishments and disseminate information about its activities.

The curses, however, came in many forms. For example, AIR was subject to a wide variety of policies and to the ripple effects of changes in policy implemented on a level far removed from its

own operations. Some of these had humorous implications while others seriously threatened the continuation of the project. In the former respect, in the winter of 1979–80 AIR participants were informed they would not be able to use their vacation time; as city employees they might be needed in a mobilization of manpower should there be a snow emergency as there had been the previous year. Joking around the office envisioned the potential scene of artists collectively battling the elements instead of engaging in their regular activities.

More serious, however, were the implications of a change in city government due to the election of a new mayor. During the period of transition, the kinds of changes which would occur throughout city government, and the fates of the directors of CCFA, AIR, and supporting agencies, were unknown. For a certain length of time AIR's continuance seemed to hang in the balance; daily consultation of the morning editions of the newspapers became standard procedure in the office to find out what new reorganization schemes were being planned, what new cuts were being announced, or which department head might have most recently joined the ranks of the unemployed. Further, office factions argued whether the results of the transition would be disastrous for the program or if AIR was such an insignificant element in the larger scheme of local government that it would not be bothered, or if so, only belatedly.

Another concomitant of working for the city and with city agencies was having to negotiate projects with agencies and balancing the demands of artistic concerns with agency needs, understandings, and aesthetic priorities and prejudices. Such oppositional situations figured prominently into the circumstances some artists found themselves in when they attempted to execute specific assignments. More generally, however, these often contradictory forces surfaced in debates over the nature of public art, and the uses to which art should or should not be put. Thus, would the watchword of AIR be "safety" (read: conformance to bureaucratic procedures and continued successful operation of the program) or "daring" (read: follow the dictates of artistic sentiments and beliefs, regardless of one's employment status)?[18]

For many of the artists, City Hall and its representatives did not figure prominently into their day-to-day functioning. For the administrative staff and artists engaged in certain projects, however, the city's sponsorship of AIR was either subtly, or occasionally, not so subtly felt. "City Hall" was variously pictured. Sometimes

it was portrayed as a hulking Neanderthal grossly unsophisticated in cultural matters. It was AIR's purpose, CCFA's director once stated, to "drag City Hall into the twentieth century." Influence did not always flow in that direction, however; other instances proved that AIR was intimidated by its position in relation to city government. For example, in an early edition of the project newsletter, a story on the graphic arts team working on designs for a rat control poster brought the following comment: "They've been looking at and drawing pictures of them and conceiving them [sic] in all sorts of locales, climes and poses. No, it's not spring fever that has hit them, but orders from higher up (does the Mayor's Office sound impressive enough to you?)"[19] (fig. 3). In another

Figure 3. AIR graphics executed for city agencies were widely distributed and positively received. This poster for rat control was reissued numerous times and became a familiar sight in local alleyways. Note the inclusion of the mayor's name, a de rigueur feature of all AIR material produced for general public view. Graphic design by Rachelle Marcado.

instance, an office inspection by a member of the new mayor's transition team initiated something of a panic and prompted a general clean-up. Overlooked on the wall of an administrator's office, however, was a comic mask portraying the late Mayor Daley with green skin, painted lips, and glitter for eyebrows. The city hall representative was a former partisan of Daley and was quite upset by this image, which was then removed. Because of the uncertain status of the program under a new administration, this caused great concern as an ill-advised display.

Less dramatic instances also highlighted the program's relationship to the city. For example, separate evaluation forms were designed for use by both the artists as well as by representatives of the sites where they were working to summarize their experiences. When the city's printing service returned thousands of copies of these forms, the site evaluation forms carried an addition which had not been included on the originally submitted copy: "Michael A. Bilandic, Mayor, City of Chicago." These were the evaluation forms distributed to the various schools, childcare centers, and senior citizen homes where AIR worked; that is, they were distributed to *outside* agencies. The artist evaluation forms, for in-house use entirely, were not provided with a similar addendum. It was obviously deemed important that AIR be presented as yet another service provided to the citizenry of Chicago through the sponsorship of its mayor. Further experiences with producing forms verified that any material for public use was spotted by the careful eyes of city hall copyeditors and revised accordingly. The following memo to the artistic director of the visual artists demonstrates the consistency with which this occurred: "We're afraid that the invitation [to an exhibit of her section's works] can not go through as is. The Mayor's name must be set in larger type and be put on the cover of the invitation. Sorry, but it can't be approved this way through City Hall."[20]

These instances attest to how AIR could be used as a "booster" of the city's image and a promoter of its services. Another example of this function was a photodocumentation project which captured a wide range of city workers at their jobs. The title of the exhibit, "The City That Works," was a phrase that formerly had been popularized by Mayor Daley to represent the effectiveness of city government in serving the needs of its people. AIR's relationship to city government proved to be an important factor in determining what activities the program engaged in, the manner in which they were executed, and for how long.

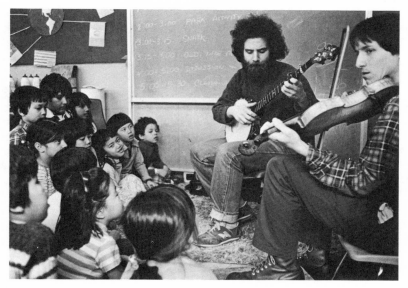

Figure 4. Youngsters in a city-operated childcare center receive their first exposure to a live performance and working artists. Photograph by William Higgins.

Fitting Pegs Into Holes

> . . . [you] may suggest that I'm a complete fool. But to try to make a civil servant do his job? Well, I'm not as foolish as that.[21]

AIR administrators felt that their project was extraordinary among CETA-arts projects. It did not exclusively place individual artists into situations with established arts and community groups. Rather than passively adapting to a preestablished structure, AIR assembled performing groups which actively offered their services to the community. Further, AIR emphasized that artists in such fields as film, video, and visual arts (whose work resulted in products rather than performances) engaged in an active negotiation process with their sponsors regarding what form the ultimate product would assume.[22]

The format of the program can be summarized in the following way. For artists in the performing arts fields, these types of work situations existed: (1) performances (visiting a site for no more than one day); (2) workshops (programs which lasted at least three days but no more than eight weeks at one site); (3) residencies

(programs operating at one site for more than eight weeks, most typically within the public schools for an entire semester); and (4) special events (fully mounted productions with large segments of AIR participants—often presented in public places in hopes of attracting broadly based audiences).

Performances, workshops, and residencies were concentrated in three distinct service areas: public schools, city-sponsored childcare centers, and senior citizen and handicapped centers. Programming was intended to reflect the distinctive needs and interests of these various constituencies. In the childcare segment, for example, theatre activities included interpretations of fairy tales or the presentation of moralistic themes: *Crossing the Street,* written by an AIR participant, "deals with the problem children face when they want to break promises made to their parents in order to explore the exciting and independent world across the street," according to a catalog description. Offerings by musicians, poets, and mimes gave children an introduction to the fundamentals of their respective fields in a participatory, entertaining way (fig. 4).

Programs in senior citizen homes typically presented material thought to be of particular interest, for example, songs from ear-

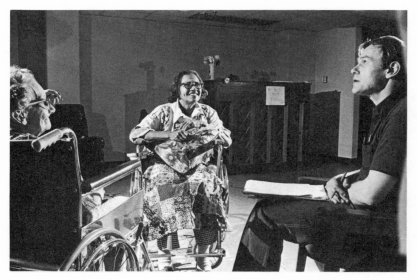

Figure 5. Residents in a senior citizen home share their life experiences through a workshop conducted under the guidance of an AIR writer. Photograph by William Higgins.

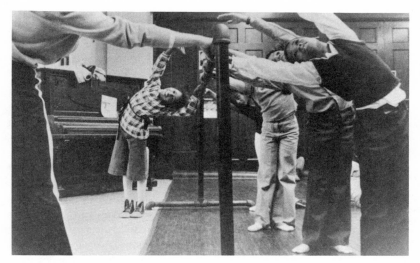

Figure 6. Students receive training in the arts that the public school system could not routinely provide. Photograph by Lauren Deutsch, courtesy of the Chicago Public Library, Special Collections Division.

lier periods; or, programs were assembled from material the seniors themselves provided, for example, dramatizations of the poems of reminiscences they produced in writing workshops (fig. 5). And finally, the schools were offered both an entertainment and instructional plan. The rationale here was to enable the students to have contact with practicing artists and to offer supplemental activities to broaden a school's existing fine arts program. An illustrative example was a program on African influences in American music that combined performance on one day with later follow-up discussions about the music and the instruments; this could also be combined with a workshop to provide further information and experience (fig. 6).

This schedule was supplemented by special events mounted with the theatre, dance, writing and music components (separately or in collaboration). For example, three plays which were AIR creations in all respects from the writing of the scripts to the direction, costuming, and set design were presented during the summer of the second year. While these productions had been preplanned into AIR's program for that year, other productions were occasionally initiated by individual artists who could actualize what were often long-standing concepts only with the mobilization of AIR's

resources. Examples included a music/theatre piece based on the poetry of Paul Laurence Dunbar; a music and writing collaboration on the lives of artists who had overcome handicaps; and, a music/theatre recreation of a black nightclub environment from the 1940s and 1950s.[23]

For those artists creating products, work was usually done in conjunction with the proposal of a supporting city agency. In a much-quoted statistic, the program claimed that it worked with twenty-five city agencies and on more than seventy different projects during the first year. In most cases the proposed project would either document and diffuse information to the public about agency activities; create informational tools for in-house use; or provide works of art for public display. Representative projects produced public service announcements, posters, and brochures about various city services; developed a tour guide of city hall; assembled photographic and written documentation about works of art produced in Chicago during New Deal public works projects such as the WPA in the 1930s; created murals at the Chicago Alcoholic Treatment Center, in public schools, at the city zoo, and at city hall; and produced major pieces of sculpture for O'Hare Airport and for a public park.

Such a summary necessarily generalizes AIR; more important, it to some extent captures the program as frozen in time, without conveying a sense of important changes which occurred in its evolution. For over time service areas were dropped and added, the predominant type of format was modified, and the distribution of artists shifted across the different artistic fields. These alterations did not occur randomly, but in direct response to problems AIR encountered in handling certain groups of artists; promoting or defending certain artistic productions; meshing artistic concerns and needs with demands for program accountability; and handling debates over what public art meant. These changes were artifacts of how these major issues were defined and resolved.

Some observations can be offered in an informational sense at this point regarding some of these changes; more detailed analysis and interpretation will be provided in the upcoming chapters. Easily observable, for example, is the fact that the sizes of some artistic disciplines expanded over the course of the three main program years while others contracted. This is illustrated by the data presented in table 4.1. First, some of the disciplines remained rather stable in their relative representation, for example, music,

Table 4.1 *Distribution of AIR Participants within Artistic Discipline by Program Year*

Artistic Discipline	Number of Participants		
	Program Year 1	*Program Year 2*	*Program Year 3*
Administration	7	13	14
Dance	11	14	14
Film	7	3	2
Music	14	13	14
Photography	6	4	9
Theatre	26	30	25
Video	6	2	4
Writing	10	7	8
Visuals Arts:			
Fine Arts	19	19	11
Graphic Arts	2	3	7
Total	108	108	108

theatre, dance, and writing. Second, some other disciplines (most notably administration and graphic arts) were expanded, as an indication of an increased emphasis on accountability and control. And visual arts, film, and video all decreased, reflecting management problems that were unanticipated when the program was initiated, but which unfolded over time and presented challenges to AIR's definition of who it was serving and in what ways.[24]

Further, workshops and residencies became the primary activities of the program. For example, from a figure of 3,684 during the 1977–78 program year, workshops and residencies increased to 6,123 during the third year, 1979–80. Part of the increase can be explained by the difficulties some segments had in initiating their activities the first year; for example, it was only after a series of lengthy negotiations that the program in the schools could finally be undertaken.[25] In addition, the reporting procedures became more refined each year, which also tended to increase the aggregate statistics over time. Even with these qualifications, however, the workshop/residency format was definitely the predominant form of AIR activity.

And finally, service areas were added or dropped when issues of control could not be resolved in alternative ways. For example, service was extended into the public library system in year three

largely to incorporate the visual artists into a workshop–type format (fig. 7). They had previously operated in a more independent fashion than any other discipline, very often working within their own studios with the only requirement being that they produce a certain number of pieces within a prescribed period. By drawing them into this new arrangement, documentation could be made of at least a minimum number of hours that they were actually engaged in AIR activities. Conversely, the multidisciplinary operation in the Chicago Housing Authority (CHA) public housing projects (which had been an AIR priority) was dropped after the first year. It is no accident that this was the one service area where the nature and scope of public service art was most spiritedly debated and where the artists seriously challenged what AIR should be doing.

Figure 7. As AIR's bureaucratic structure was refined, artists who were previously allowed a high degree of self-direction were subsequently given specific assignments to execute within a predefined format. New programming areas were developed, as this visual artist working in the library system illustrates. Photograph by William Higgins.

In the remainder of this discussion much of AIR's program-ming will remain in the background. Since individuals participat-ing in a workshop or residency capacity did not typically create problems for the program, these aspects of the program will be noted for comparative purposes but not particularly highlighted. Those artists, service areas, and types of format which did not readily fit into the evolving structure of AIR or whose existence challenged what the program was becoming over time will be in the foreground. This caveat is presented as a reminder that at most times this program operated with a certain ease. However, situa-tions which disrupted this equilibrium can tell as much or more about AIR than a description of its typical day-to-day functioning.

5

The Primacy of Organizational Goals

A predominant view of bureaucratic organization posits a structure that is rather pervasive, unyielding, and immovable over time. Weber's image of an "iron cage,"[1] even though familiar only to the relatively small audience which consumes social science literature, concisely captures this popularly held perspective. The study of organizations, however, has come to take fewer things for granted and looks to a variety of factors to explain their growth and development. The observation of real organizations reveals a more complicated picture of rigidity and flexibility, stasis and change, dependent upon such factors as their personnel, problems in the external environment, and the other organizations to which they are accountable.[2]

The analysis of the Artists-in-Residence program as a bureaucratic organization is important precisely because it sought to disguise or deemphasize those aspects of its operation. AIR was subject to unusual constraints. Internally, it had to deal with personnel who might balk at minimal impositions of structure. Externally, there was a complex, challenging, and unpredictable environment. The initial organizational strategy was therefore one based on restraint. Less structure was believed to be more effective, and defensive maneuvering was assumed to exhaust all the organization's capabilities.

This course of least resistance proved to be problematic, however; features such as flexibility and informality—originally embraced as strengths—were redefined as liabilities. The lack of self-direction and control derived from AIR's dependence upon other groups provided powerful incentives to fortify the organizational structure. Administrators tightened boundaries and more carefully regulated who joined the project. Programming was reevaluated, and organizational survival took precedence over artistic merit in determining what AIR would offer. AIR was able to develop independence and a competitive edge by identifying and eliminating areas of greatest vulnerability, leading to a more offensive stance toward its environment and greater durability.

This scenario largely capsulizes what the institutional approach to organizations would predict. Because this approach deals with such themes as organizations trying to survive in volatile environments and struggling to maintain their legitimacy and the tendency for them to develop isomorphic structures (i.e., organizations increasingly come to resemble one another), it has obvious value in evaluating AIR's experiences.

As two of its major proponents assert, ". . . the formal structures of many organizations in postindustrial society dramatically reflect the myths of the institutional environment instead of the demands of their work activities."[3] And AIR displayed several characteristics which generally contribute to isomorphic change. It was in a position of dependence, largely to one funding source, its "technology" was uncertain, and its goals were ambiguous.[4] What is so compelling about AIR's attempts to act "rationally" is that its administrators had few specific examples to use in modeling its structure to conform to what an organization should be like, in contrast to what happens in other institutional contexts which instead provide clear formulations in this regard (e.g., the public school system).[5] AIR administrators had only *generalized* notions of rationality and efficiency to guide them, which they had to approximate and implement quickly; their actions attest to the widespread diffusion of such ideas throughout contemporary society.

The analysis of AIR as a bureaucracy will accentuate some of the problems generated in its organizational evolution and the responses they evoked, at the same time conveying a sense of the working conditions AIR provided for its participants. The internal problems AIR confronted will be given primary emphasis here, and the following chapter will highlight external problems and their impact to a greater extent. These distinctions, however, should

not be rigidly upheld; problems often emerged from these do-
mains simultaneously, and organizational responses were geared
toward comprehensively combating difficulties regardless of their
source.

The Reluctance to Act as a Bureaucracy

There have been previous allusions to AIR's organizational
structure; for example, a casualness and informality were culti-
vated to supposedly facilitate creative work. Further, the organiza-
tion was forced to adopt a somewhat defensive stance. Criticism
came from a questioning press, public, and representatives of nu-
merous other agencies and had to be responded to. And AIR was
sometimes cowered by the expected reactions of its artists to pro-
posed regulations and structural changes. But while the recogni-
tion of certain distinctive features of the artist population may have
initially contributed to the development of specific organizational
features, acceding to the perceived needs of its workers in order to
minimize internal problems subsequently heightened AIR's adap-
tive problems within its environment. Some of these difficulties
and modifications can be examined in greater detail.

It is somewhat unusual to view an organization as reluctant to
control, on the defense more than on the offense,[6] and engaging
individuals relatively inexperienced with and unwilling to be man-
aged by a bureaucratic structure.[7] Such a view, however, emerges
from considering certain aspects of AIR's operation. The current
problem is to understand how environmental conditions and per-
sonnel problems spawned the organizational structure they did and
to determine to what extent even a relatively unbureaucratic orga-
nization can act in a "bureaucratic" manner.

A clear division exists in the organizational life span of AIR
between the first and the remaining years of its operation. The first
year was a time of setting up and exploring crucial issues, and a
sense of openness and fluidity was experienced generally. It also
provided a nostalgic point of reference for those whose tenures
spanned both periods and who later felt discontented. The struc-
ture of the organization was much tighter for those artists entering
the program from the beginning of the second year onwards, what
was required was more narrowly prescribed, and fewer issues re-
lating to the purpose and scope of the program came to the fore.
AIR came of age as an organization after a year of groping and
questioning which did not recur during any subsequent period.

These changes were reflected in an organizational chart developed just prior to the second program year which situated every participant under a dual system of control. Questions of artistic quality were the responsibility of artistic directors supervising each discipline. And each artist concurrently answered to a coordinator supervising activities within one of the major areas of programming. The thoroughness of this organizational chart was without precedent in the first year of operations and was promoted with pride. It was thought to make it extremely unlikely that individuals could slip by the administrative structure, hide in the relatively unexposed recesses of individual projects, or be subject to the conflicting scheduling demands inherent in the previous loosely structured design.[8]

Program administrators felt it was imperative to impose this tighter organizational arrangement for a number of reasons, yet it was done with some hesitancy. This, it seems, had a great deal to do with the nature of the personnel with whom they were dealing. Whereas individuals often enter bureaucratic organizations with some understanding of organizational procedures, with at least a portion of their training geared toward developing skills adaptable to such situations, and with a willingness to embark on a career whose lines of development are largely outlined for them, this was not the case with many of the artists entering AIR. AIR participants were relatively inexperienced in working in bureaucratic settings; their training and past experience were most often assumed to have allowed or even demanded an extreme independence of operation. There was a reluctance, then, to impose a structure which was too dissimilar from situations these artists may have experienced in the past. Any new regulation was scrupulously considered before it was enacted; the waters were carefully tested lest anyone be swept under by the implementation of additional forms of control.

For example, sets of forms were designed to monitor the artists' activities and to expedite the collection of statistics in order to report to supporting agencies. Designing these forms, by which the artists communicated information such as where they had been working, problems they encountered, and the type and number of audience participants to whom they played, caused program administrators a great deal of concern. Not only were they unsure of whether or not the forms would be understandable to the artists and useful in collecting the necessary information; they also had profound doubts regarding the artists' willingness to use them. In practically every meeting at which proposed forms were discussed,

Figures 8, 9, 10. A public service orientation was an important asset to artists wishing to secure an AIR position. The possession of specialized skills (e.g., knowledge of sign language) or prior experience with AIR target populations significantly increased the chances of being hired. Figure 8 courtesy of the Chicago Public Library, Special Collections Division. Figure 9 photographed by William Higgins.

the reaction which might be imagined from a particular dancer was raised as the basis on which procedural decisions should be made. "Would _____ know what we want here?" the top administrators would ask. "Would _____ ever use them?" they continually questioned. This individual became a symbol of obstinacy, the inability to understand, and unwillingness to cooperate; the responses expected from him came to represent in an exaggerated sense how the artists generally were anticipated to resist rules and procedures.

The most interesting aspect of this situation is that AIR had potential sources of pressure it did not choose to utilize. Recall that the pool of eligible individuals for each slot in the program provided a wide range of choices in selecting personnel. Therefore, reference to the large reserves from which replacements could be chosen could stand as a threat for those unwilling to conform to

AIR's demands; if participants would not adhere to what was expected, they could risk termination. The program, however, was instead satisfied with demanding a minimal amount of compliance it felt would not seriously infringe upon what it assumed to be the typical ways artists conduct their business. AIR only infrequently terminated individuals and then underwent the process of getting approval from CETA officials to refill a position by reviewing the credentials of available artists. Accordingly, the program's artists often failed to take seriously the attempted imposition of new procedures, knowing either that they were proposed with some reluctance, or that they generally allowed a wide degree of latitude in the compliance they actually demanded.

Over time, however, AIR was able to act more like a bureaucracy. In large part this was accomplished by choosing participants whose backgrounds would more likely be adaptable to the program's needs and purposes. Just as job descriptions became more formalized as the program developed, the choice of participants was more frequently made on the basis of past experience in the public service sector. In AIR's second program year, forty-two percent of the entering artists reported that they had previously worked with audiences similar to those which AIR dealt with. In the third year this proportion increased to sixty-three percent; artists were chosen less for their artistic quality than for their prior familiarity with working in such situations (figs. 8, 9, 10). The assumption was that these artists would be less resistive to a predetermined programmatic structure than their predecessors had been in earlier years.

Administrators became less hesitant about exercising authority and control as the original participants gradually left. Their ability to exert control over this crucial area of who would enter the program guaranteed greater certainty in AIR's operation and minimized the potential for discrepancies to develop between the respective expectations of the artists and the program. Predictability was incurred at a certain price, however. As the director and other administrators commented during the third year, the artists caused fewer headaches and contributed to a relatively smooth operation, but they were also quite boring.

Innocence and Maturity

[Some artists] are dismayed and disappointed that they must work on city agency projects and not those they suggested in their ap-

plications. They did not realize the purpose of that question, which was to gauge how they felt about public service art.[9]

Nostalgic longing for the past typically intensifies positive experiences while it also diminishes the negative. Further, it often recalls a sincerity which in retrospect seems naive at best, fatuous at worst. When the beginnings of the AIR program were recollected, the attempt to accommodate the needs of an extraordinary group of individuals in a special way was described. That the final outcome did not conform to the original expectations was recounted in different ways. Individual artists expressed regret, but administrators were satisfied because certain of their original assumptions had been modified in response to real situations, and they had developed a structure they believed would enable the program to survive.

The administrators of AIR attempted to develop the most minimal of possible administrative structures from the beginning. They viewed bureaucracy in general with suspicion; they doubted its applicability to artists' needs; and they were greatly relieved that this was an entirely new organization not having to carry the excess baggage of an entrenched administrative structure. CCFA's director expressed these notions shortly after the program began:

> Bureaucracy always enters in as planning time increases; ideas become fixed and problems, real or not, become obstructions. If nothing else we hope that the projects as they now stand are flexible enough to permit the individual artists to modify or change them as needed. Program staff will be working throughout the year to increase those opportunities for the artists.[10]

AIR's designers felt that with there being only two months to plan the program flexibility was insured. Individual artists could have a degree of leeway which a previously established structure could not offer and which the organization of CETA-sponsored programs in other cities did not. Some artists, however, entered the program with the impression that since they were asked to put forth their ideas about what public service art meant, their proposals for projects would be the basis for the work they would be doing under AIR's auspices. But as the opening quote indicates, the solicitation of ideas was more for the purpose of assessing the applicants' appropriateness for inclusion in the program rather than for automatic incorporation into the program's agenda.

Instead, that agenda was largely established in consideration

of supporting agencies' needs and interests. This discrepancy between the expectations of the artists and the need of the program to balance the demands of other constituencies provided the circumstances for some of the major confrontations whereby the program's structure and mandate were challenged and refined.[11] Over time, AIR emphasized having an existence beyond the tenures of individual artists, and the need for artists to accommodate to the ever-expanding bureaucracy assumed precedence over the bureaucracy bending to the perceived needs of its personnel.

The sense of incompatibility between the artists' needs and priorities and those of the program was communicated by the statement of a video artist:

> It's clear misrepresentation when the city says to you in the application you fill out—in the cover letter—you're going to be employed for a year to do *meaningful* work of a public service nature, which is ill-defined, and also to "create new works of art, exhibits, and performances" and "enliven the cultural life of the city." . . . Some people are able to do that, but most of us are not, without a humongous hassle. It's a lie. It was doomed to failure from the beginning—video especially for concomitants [*sic*] of reasons. And nothing was done to save the ship by the administration.[12]

It was, however, exactly in the effort to save the bigger ship—AIR itself—that individuals were cast aside and the organization added the ballast to its structure deemed necessary for continued survival.

Both the lack of lead time and the minimal structure which were initially celebrated received quite different evaluations later by AIR's director:

> [AIR] has established a certain amount of autonomy and momentum . . . it's passed through a difficult period because of a lack of structure in the program—not enough lead time—but *everything is downhill from now on,* now that the foundation is done. . . . All the energy that has gone into getting things done can be used creatively now.[13]

Interestingly, while the director used "everything being downhill" to describe what she felt to be the successful resolution of certain problems, the same imagery represents the opinions of many participants who disliked the increasing restrictiveness of AIR's format and the growth of procedural effectiveness that they continued to witness. Another year later, on the occasion of the original as-

sistant director leaving the program, the retrospective evaluation of what had occurred was informed by an even greater sense of having successfully discarded unrealistic notions and having developed a workable organizational strategy to help guarantee continued survival:

> It was grandiose to imagine that overnight with no money for materials or equipment, in a cramped office with ventilation rivalling a Finnish sauna, we could create a program of 108 artists and a range of projects that would aim at the most lofty—and mundane—standards possible to set for public art.
>
> It was compulsive to keep at it night and day, seven days a week. There seemed no end to the crises, as artistic life styles and egos collided with the sometimes static and often abrasive bureaucracies of city government.
>
> I had imagined an opportunity to express more fully my creative ideas and, instead, I found myself absorbed completely in time sheets, schedules, and budgets.[14]

Obviously, many of the original assumptions and operating procedures were modified in relation to the actual circumstances confronting AIR. What some of those assumptions were, the problems AIR faced in its external environment, its relationship to other organizations, and the ways in which it was held to be accountable all deserve closer scrutiny.

AIR as an Organization: How It Stacked Up

> Many of the artists are used to working when the spirit moves them, which may mean putting in twenty hours straight one day and not showing up for the next three.[15]

Those studying the problems of industrializing societies frequently highlight the difficulties such societies encounter incorporating complex organizations into a social system previously unfamiliar with this type of arrangement. The source of the problem is the lack of an *infrastructure,* "the notion of career, aspirations defined in career terms, and the preparatory socializing agencies."[16] In fundamental ways the artists AIR recruited were deemed to be as uninitiated into the ways of modern systems as entire native populations have been by either early colonialists or later representatives from multinational corporations. AIR administrators believed that artists' work habits, their standards, and

their experience dealing with formalized procedures were atypical for the modern worker. Their task was to erect a structure which could deal with this special challenge, not an ideal-typical bureaucratic organization.

What workers bring into a situation with them obviously contributes to their relative success and satisfaction. As Selznick notes, "The human tools of action come to an organization shaped in special but systematic ways. . . . This will make staff members resistant to demands which are inconsistent with their accustomed views and habits."[17] And workers bring with them not only past experiences but also motives and goals in regard to their present organizational participation. Therefore, while workers are affected by their work setting, the nature of a worker population simultaneously affects the structure designed to incorporate them.

Bureaucratic organizations are typically believed to have carefully defined positions or offices; that is, the office is separated from the incumbent, facilitating the finding of replacements when an opening occurs. And once such roles are formally established, anyone with the appropriate qualifications should be able to occupy them.[18] However, qualifications and standards of evaluation are less rigidly set in artistic fields than in other pursuits, making it more difficult for AIR to evaluate its applicants.

Further, initially there was an attempt to defer to the unusual characteristics of this population by permitting a significant proportion of the artists to pursue individual projects, thus allowing a high degree of latitude in questions of style, theme, and execution. Table 4.1 (p. 55) indicates that a higher proportion of the program during the first year was composed of artists in the fields of film, video, visual arts, and writing than in subsequent years. For the most part these artists were working on projects that would have to be completed by the person initiating them and could not easily be taken over by another artist. Because of this, some artists had a bargaining wedge they could use to try to force concessions from the program. If administrators or sponsors were not pleased with an individualized project once it was undertaken, their choices of what to do were limited. They would either have to devote extra supervision to problematic artists or dismiss them from the program before their expected tenure was up. In some unusual cases artists were able to insure their continued employment because a somewhat unsatisfactory product was deemed more valuable than an incomplete one.

In all cases, these individualized projects necessitated addi-

tional supervisory scrutiny and coordination with many agencies. Because of this the number of positions which commissioned artists to sculpt a particular piece, compose x number of musical works, or produce a film, videotape, or painting significantly declined after the first year. Positions were more carefully predefined to accommodate the needs of the program rather than those of individual artists who might wish to have the program fashion itself around their skills and schemes. Roles became more standardized so that individual artists were not as irreplaceable. And performing segments (e.g., dance, theatre, and music), which by the nature of their work are more accustomed to the discipline and interdependence of ensemble work, either increased or remained stable in their relative proportion of the program, thereby easing the supervisory demands made upon the administration.[19]

Another commonly cited aspect of bureaucratic organization is a hierarchical order with clear-cut lines of authority and responsibility. As we've seen, however, such a hierarchy only gradually emerged in AIR. Before the development of the organizational chart at the beginning of the second program year, lines of authority and responsibility were often implied at best, confused at worst. Program administrators were hesitant to develop a hierarchical structure since many of the artists had previously functioned as independent entrepreneurs and were unaccustomed to having to report to others. Yet when their services were engaged by other agencies, it was necessary for the artists to organize and present their ideas throughout the creative process, to negotiate between their concept of a project and an agency's understandings, and to be accountable both in regard to artistic quality and in relation to actually producing the promised amount.

The insistence upon spontaneity and freedom emphasized by many of the artists conflicted with the more rational mode of the organization, necessitating the development of a hierarchical structure to insure cooperation between these antagonistic elements. This became increasingly important as the concern with the durability and survival of the organization achieved more prominence. It would be one thing for artists to balk at the conditions placed upon their work while operating independently; the implications were quite different if they were unwilling to cooperate while being employees of an organization struggling to maintain legitimacy and support.

Some artists viewed the hierarchy that gradually evolved to minimize the problems individual artists could cause for the orga-

nization as a whole as a major cost, however, and considered having to be answerable and responsible to others as an excessive burden. A visual artist expressed such sentiments soon after the program began:

> I'm a really industrious person, a real honest worker, and a pretty prolific worker. It's gotta flow naturally . . . if the stuff becomes contrived, and that's what's happening to these things [a series of projects stalled in meetings with city agencies], [what it means] is that they're becoming paper and bureaucracy first and art last. I mean, it may not look like it in the final product, but it loses it, a lot.[20]

As the organization became more bureaucratic and hierarchical (insisting, for example, that the artist quoted above continue with a negotiation process she would have very likely dropped if working on her own), its survival capacity was enhanced, while at the same time its ability to convince artists it was acting in their behalf diminished.[21]

Another characteristic of bureaucratic organization is that it offers the possibility of a career, including advancement through the offices within the hierarchy and the security of tenure. Such a system is supposed to encourage continued efficiency in the performance of duties and to make job incumbents less susceptible to outside pressures.[22] These characteristics, however, were negligible in AIR, contributing to one of its most interesting features. AIR offered very little in the way of promotions, rewards, or job security. There was only one basic distinction in job classifications available to the majority of the artists which brought with it a modest increase in salary and responsibilities. These positions as "senior artists" were quite limited, yet they did not generate a heated competition. They were usually held by the artistic directors within each discipline, a position most program participants were quite willing to forego because it meant assuming administrative duties. Further, it was possible only infrequently for an artist to gain a "permanent" administrative position if and when the salary costs could be absorbed by the larger city budget. Again, however, there was very little jockeying to secure these positions. Few individuals entered the program with the intention of being an arts administrator, and even fewer had any desire to undertake a long-term career as a city employee. The rewards the program could offer were therefore roughly commensurate with the demand.

In addition, the artists were hired with the understanding that, in accordance with CETA guidelines, job tenure did not exist. Artists were hired with the promise of one year of employment only; an extension of six months to an additional year was possible at various times, but not guaranteed. Regulations limiting the maximum time a CETA worker could be employed were designed to discourage participants' expectations that the projects would continue indefinitely, to increase the number of eligible individuals who could be incorporated, and to stimulate the development of new activities.[23] It was possible, however, to appeal for and get extensions for some individuals. In AIR this was only done for the artistic directors of the major disciplines at the beginning of the third program year, when they had already served twenty-four months. Because AIR had some commitment to maintaining high professional standards, as well as continuity for the organization, it was willing to contradict the intent of a major CETA regulation.

Conversely, individuals could be discharged before their maximum potential service time was realized, not necessarily because of a lack of need or talent on their part, but because of their group assignment. As an example, artists whose work was done in ensemble with other artists might lose their positions if their colleagues' tenure expired before theirs did. Rather than recompose a group, performing groups were discontinued on occasion when some of their members left; again, the precedence of organizational needs over individual needs was demonstrated.

The consequence of these factors was a remarkably uncompetitive organizational culture. Most individuals had little reason to try to develop an advantageous edge; those who did were usually scorned by their fellow participants, and their activities were deemed uncharacteristic of the way artists should act. While the casual nature of AIR's internal environment was previously attributed to an effort on the part of the administration to promote informality, it was also the consequence of the program's natural limitations and the general acceptance of these circumstances by the artists. The relative lack of rivalry among AIR participants— who might well be contending with one another for rewards in arenas outside this program—strongly contributed to the uniquely unbureaucratic feel of the organization.

AIR contained a mixture of bureaucratic characteristics existing alongside more atypical types of organization, and the effect on its employees was naturally circumscribed. On the one hand, the quantitative engagement it offered was severely limited in time;

participants knew they would be involved for only a relatively brief period of their professional careers. On the other hand, many found the qualitative engagement to be limited as well. They often judged what they were required to do for AIR to be different from what they considered their "real work." Many artists felt that within the program they were merely applying their artistic skills to perform a specific type of service, whereas their art was necessarily pursued *outside* the program's purview.[24]

6

The Politics of Survival

Organizational character does not emerge as a deus ex machina. The important question to ask is why does a *particular* type of organization develop and in response to what factors? And as corollaries, why do certain organizations become more rigid and seem to grow out of touch with their original intentions? What do they feel they have to do in order to survive?

A critical assumption here is that organizations exist and interact within environments comprised of other organizations. While this point might seem self-evident, it has been painstakingly established and refined in the research literature.[1] Closely related to this supposition is the idea that the nature of the organizational environment affects the development of an organization's distinctive features. For example, modifications of internal structure can be undertaken to meet external demands;[2] marginality to other organizations can be related to diffuse organizational goals and can lead to a service orientation (or an "other-directedness") and unguided institutional development;[3] or, an uncertain political environment can contribute to the abandonment of progressive ideals in favor of a safer, constricted, and more conservative emphasis.[4] Uncertainty in the environment (regardless of its many possible sources) and the various strategies to minimize it are now seen as major factors in the evolution of organizational character.

Likewise, the theme of a gradual conservatism in organizational goals threads through numerous studies. For Selznick, the process of co-optation may have enhanced organizational survival capacity, but correspondingly led to a sharing of power which diverted attention away from original purposes. He cautioned, "if you have to compromise, guard against organizational surrender,"[5] much as Michels did in noting the drift towards oligarchy, even when it ran against initial ideals and intentions.[6]

AIR actively struggled for survival in a number of arenas: within the CETA program in general, in relation to other CETA-arts beneficiaries, and within the complicated world of city government. And, it generated specific strategies to increase its control over the uncertainties these other groups could cause. If in this process primary assumptions and procedures were jettisoned, it was in response to specific environmental pressures. Corresponding to the presumed development of the survival capacity of individual artists, then, was AIR's strategic pursuit of ways to polish its own resume and help to insure its continued economic viability.

Abandoning the Defense, Building the Offense

AIR self-consciously promoted its own accomplishments. Further, it purposely identified areas where it was most vulnerable and then devised strategies to move from a less defensive to a more offensive posture. This was largely done through the refinement of its bureaucratic structure, a process that may have been puzzling and disturbing to some of its artist-participants but which is understandable given the environment in which AIR operated.

AIR was accountable to a large number of groups: the public at large, with its concern about the use of tax dollars; the press, as the supposed guardians of the former's interests; the Office of Manpower and Training, which made the decisions about the amount of CETA allocations and their relative proportion to different groups; the mayor, whom the activities of the program represented; specific supporting agencies, who expected the payment of artistic goods in return for their investment in materials and administrative assistance; other art groups, which closely scrutinized the activities of this new entrant into a competitive arena; and the specific audiences served by AIR efforts.

One of the most important ways AIR presented verification of its activities was to report statistical information regarding their amount. While it would be difficult to measure how good AIR pur-

suits were or how much effect they had either on participants or their audiences, it was possible to make an account of *how much* they were doing.[7] As the service mandate gradually superseded attempts to justify the program primarily on artistic grounds, questions of quality were generally not that important a consideration. The strongest elements of defense followed from what became AIR's preferred public image: a service agency giving its various audiences large amounts of what they wanted.

During the first program year, AIR had issued reports on its activities only when outside groups demanded them. This meant that information had to be assembled on an emergency basis, thus producing documents of doubtful credibility. From the second year onward, however, collecting and reporting information was routinized to allow the program to be ready with an answer to any question. Further, even though AIR moved principally to a workshop and residency format in order to minimize its supervisory problems, this shift also contributed to the magnitude of the figures it could report. This meant that offerings were repeated over and over during the second and third years instead of having a significant segment of the artists engaged in individualized pursuits. This change in format greatly inflated statistics; AIR administrators were aware of this and hoped it would not be missed by any of the agencies they reported to.

While individualized projects came closest to being in accord with an artist's "own work," they did little to contribute to the volume of AIR's statistical record. Further, such activities would be exposed to potentially more critical audiences.[8] Certain activities therefore won favor as the program matured, to the dismay of artists with different interpretations of what the program might offer. The necessity for this emphasis was understood by an individual who advanced from being an artist to an artistic director and finally to a top administrative post; his acceptance of the realities of organizational survival contrasted sharply with opinions he had held while in his earlier roles:

> . . . maybe that's the difference between public service and quote, unquote, great art—because in great art you're allowed the time for subtleties and in public service . . . you have to knock them out with statistics right away. You've got to show right away what happens. God knows what happens to people who see a play. It might not happen 'til four years from now. "Oh, wait a minute, how do you measure that for a city that has to justify the funding all

the time?" I think that's the problem with the program—you've got to allow for the inherent problem with public funding: does the government allow for that subtle, long-lasting interaction?[9]

AIR was compared to other arts organizations competing for limited CETA positions. In 1977 AIR received funding for 108 positions in the amount of $1.3 million, while fifty-seven not-for-profit arts and community service organizations were allotted a total of 284 positions costing $2.4 million. For most of these groups two to seven positions were supported. Although funding was fairly consistent for these agencies the next year, they were severely hit by CETA cutbacks during the 1979–80 fiscal year. AIR was similarly threatened but managed to survive intact at the same level of funding for three entire years. AIR had a number of distinct advantages whenever cutbacks were proposed. First, it had the political savvy to understand how the central agency channeling the funds worked and knew where to make appeals on its own behalf. Second, it had a comparatively large administrative staff with the strategic resources of time and individual connections to apply pressure in its favor. And finally, it was considered to be more stable: it was sponsored by a city agency, therefore it was less innovative and "safer." AIR's activities were presented to large audiences and were easier to understand; the small arts organizations often concentrated on the exploration and development of newer art forms. The potential reverberations from discontinuing support for small numbers of positions within organizations with limited audiences would not compare with trying to disassemble a highly visible program that the city actively promoted[10] and that had developed an administrative structure capable of actively interceding in its own behalf. Smaller organizations were just not able to compete on these terms.

AIR was ultimately able to parlay its organizational structure and expertise into the basis for developing a greater degree of independence than it initially had. For example, toward the end of the first program year AIR sought to broaden its financial base. Since CETA provided for salaries only, AIR was dependent on city agencies for its other expenses. The difficulties of this situation were stated in an application for $40,000 to a state program awarding funds for community service projects:

> Tied to City agency support for project funds, the artists have not been fully able to create programs and/or performances which can

tour and meet the needs of those individuals who most lack encounters with the arts. In addition the AIR program has not had funds available with which to provide proper rehearsal/work space for the artists to create their products. Of course, the major resource of any arts program is the talent, energy, and dedication of the artist[s]. However, the quality and the quantity of interaction with the public is greatly dependent upon proper facilities within which to work and sufficient materials with which to create the full magic of a theatre or a dance performance.

The subtext to this proposal was the desire to be detached from the immediate scrutiny of other agencies, many of which had proven to be cumbersome to deal with.

A major part of this application explained the anticipated enactment of rigorous scheduling, monitoring, and evaluation of activities. AIR described in detail the administrative structure it was prepared to implement, stressing the inclusion of coordinators for the major service areas, a research coordinator, budget director, and public relations personnel. Noticeably absent from the list, however, were the artistic directors. AIR was attempting to establish its organizational credentials *qua* organization, not to authenticate itself in artistic terms. AIR did successfully use this expansion and refinement of its structure to develop a broader base of support. By the middle of the fourth program year, when CETA funds had virtually dried up, AIR had acquired sufficient community development funds to guarantee that a program (albeit much altered) would continue to exist.

While AIR gained organizational expertise and effectiveness, this was beyond the reach of many similar arts organizations. The NEA had advised in 1978: "Defining long-term needs implies both an artistic and a fiscal policy that operate independently of CETA. A sponsoring organization should never be dependent on CETA for the bulk of its operational costs."[11] Many of the smaller organizations, however, embraced CETA support as an angel and did not believe the flow of support would be stopping in the foreseeable future. Thus infatuated, they expanded their activities without correspondingly designing survival skills. As a representative of one such organization stated at the 1979 CETA–arts conference:

We've had support of artists and non-profit organizations over the last several years; it's been very important but it's been like drug addiction. We are now dependent on it and we don't know what to

do when it's removed from our system and it's about to be taken out of our system. We are going to be in serious, serious trouble.[12]

The expansion of AIR's administrative structure helped it attain independence, control, and staying power it would not have enjoyed had it continued its initial organization design and direction. Table 4.1 (p. 55) reminds us that the proportion of artists' positions allocated to administrative duties doubled from seven the first year to thirteen and fourteen slots in the second and third program years respectively. Additionally, all the top administrative posts were provided for under other budgets so that the administrative staff was actually larger than these figures represent. With this expanded organization AIR was able to alter the balance between defensive and offensive strategies in its relation to other groups.

The initially hostile and questioning attitude of the press has been mentioned. During the first year a number of news articles appeared which AIR felt unfairly represented its activities. AIR's response to such reports typically took the form of angry and disappointed letters to the editor of the offending publication. In most cases, however, the articles themselves received wide distribution whereas the responses were generally known only to the parties to the exchange. The following reply to a critical article reveals the weaknesses of such answers:

> To the editor:
>
> To put away a million dollar arts program in "shoot 'em down" gossip-style journalism depriving the public of even basic information on a truly unique program on the arts is really a state of poverty in the news business . . . [The article] is very much like describing Chartres Cathedral by zeroing in on the dove dung on one of the kitchen windows [The author then enumerated what was ignored about the program, and what could have been highlighted in a positive manner] . . . None of these [other things] were even mentioned. This journalist did kick a few things around the page long enough to execute them. What we need is an in-depth study, not a dimly lit non-view of a program through a reporter who (I've been informed) made a few phone calls![13]

This response was a typical one: they generally expressed concern over tone, regret over omissions, and then elaborated the positive accomplishments which could have been reviewed instead.

The public relations component was expanded and refined as

part of the general expansion of the administrative structure. AIR gradually gained a better understanding of the news operations in the city and actively solicited positive coverage of its activities. Following is an excerpt of a letter from AIR's director to the program director of a major Chicago radio station, a man who had also been a member of a panel responsible for selecting AIR participants:

> There is one important way you could give us a hand. I think it is essential that we carry the message to the public about the value of the Artists-in-Residence program, but we have had difficulty getting much coverage in the media of our events or ongoing activities. If you could give us any advice along these lines, I would be grateful. We've only had minimal coverage in *Chicago* magazine, for example [a publication sponsored by the same parent company as this radio station]. Any suggestions would be appreciated.
>
> I'm enclosing a copy of our calendar for major events coming up during the next six months for your information.[14]

The strategy thereby changed to cultivating allies rather than only awaiting attacks.

A related problem also centered on media coverage. When AIR presented special performances and displayed artistic products in public places, they were subject to review by the same art and drama critics who judge any such events. One influential critic on a major newspaper typically reviewed AIR events with a degree of moderation. Any faults he exposed were tempered with an explanation of the constraints imposed by the inadequacies of time, money, or other resources at the program's disposal. In his opinion the products were generally good—considering. Other critics were not so predictably supportive of AIR's activities, however, as evidenced by these excerpts from the review of a major show of the Art Bank, a body of visual artworks from which city agencies could borrow:

> One of the most sensitive plants in the city's artistic garden is the Chicago Art Bank. . . . On the positive side, few of the pieces are as reactionary as one might expect. . . . Unfortunately, most come under the heading of armchair avant-guardism. That is, they domesticate current media and modes. There seem to be no compelling reasons for any of the pieces to exist beyond the fact that no one likes to see an artist unemployed.
>
> The ideas are as dull as standardized government forms. . . .

The most these artworks achieve is to suggest that contemporary art is thin, low in interest, and easily adaptable for office "use."[15]

This reaction was devastating, especially since the Art Bank had been the major activity of nineteen visual artists during the first and second program years. Primarily because of problems of supervision and control, only eleven participants were included in the third year, largely within a workshop format. The visual artists were considered to be a lightning rod that attracted critical attention but failed to diffuse its destructive aspects; it was necessary to partially dismantle this component in order to protect the image of the program as a whole.[16]

Thus, while it was not always possible to anticipate and head off adverse reactions to the idea of AIR, it was possible to alter those activities which were the most visible and potentially the most controversial. As previously demonstrated, programs of a more

Figure 11. AIR activities were generally popular successes, although they drew a more critical response from the media and established observers of the artistic scene. Photograph by Linda Schwartz.

innocuous, service nature gained ascendence because they guaranteed a greater predictability of response. AIR activities in the schools, at childcare centers, and at senior citizen and handicapped sites played to audiences who were generally starved for any kind of artistic programming, and they were greeted with a uniform sense of gratitude and uncritical praise. Take, for example, the following statement on a site evaluation form: "Our Resident Club members totally enjoyed the performance. The only incident was when one of our depressed club members stood up and danced the polka! P.S. A delightful incident!" (See fig. 11.) Stacks of similarly completed forms provided an impressive volume of support to demonstrate the effectiveness and merit of the program in a way that one unfavorable public review could counteract almost immediately upon its publication. The program therefore strategically decided to concentrate on those activities which could insure a positive response and thus simplified the problem of accountability. This strategy may have disappointed artists who desired to work in challenging situations corresponding to their theories of art and its functions, but for an administrative structure seeking to expand its control and insure *its* survival potential, this conservative drift in program goals became one of the central facts of AIR's organizational development.[17]

Expecting the Uncertain: Additional Sources of Environmental Insecurity

Taking the proposition that a central problem of organizations is coping with uncertainty, sufficient evidence has already been offered to demonstrate that a constant fact of life for AIR was the insecurity stemming from the demands of its various constituencies. The presentation of some additional incidents will clarify how challenges confronting the organization were also experienced by its individual members. Problems specific to the political environment in Chicago, crises more generally related to the CETA program, and the competition for control by professional organizations such as unions each pressured AIR to adaptively respond to its environmental circumstances.

The Political Transfer of Power

AIR's connection to the political center of power in Chicago and its attempts to curry favor with important leaders have been

alluded to previously. Eventually these tactics were invalidated due to the defeat of AIR's major ally. Jane Byrne's victory over Michael Bilandic in the primary election of February 1979 immediately created a sense of uncertainty. While she was virtually assured of victory as the Democratic candidate for mayor, however, she could not officially assume office until after the general election on April 15. For nearly two months significant governmental changes seemed inevitable, but the exact form these changes would take was unknown. There was even confusion over what to call Byrne at this point; one aide finally coined the term "mayor-obvious" to capture the mixture of certainty with unofficial confirmation.[18]

Concern over who is at the helm of city government is not likely to be a major consideration for most arts organizations. Since they generally have diverse financial and institutional support, they might take note of major political changes but then reasonably return to their standard ways of operating. For AIR, on the other hand, most of the strings of support were held by other city agencies, all of which were in a state of flux for at least the remainder of the calendar year of 1979. It was extremely difficult to plan budgets, arrange projects, or prepare for continued operations under such conditions. Nothing could be taken for granted—it was not clear if money would continue to be allocated, if key personnel in supporting agencies would remain in their positions, or if there would be any interest on the part of city government in continuing AIR.

For example, the new mayor announced across-the-board cuts in all city departments of ten percent and initiated large layoffs of city employees to "purge the dead timber that has been clogging up the system."[19] She subsequently called for the consolidation and elimination of departments and additional personnel cuts. With the mayor's motto of "there will be austerity, there will be cutbacks, and there will be layoffs,"[20] AIR felt extremely threatened. Its efforts to establish credibility as a legitimate activity had been short-lived, and it feared that support for the arts would be one of the easiest commitments to withdraw. When Byrne declared, "As long as I am mayor, the City of Chicago will never again squander the public's money like a profligate welfare queen,"[21] she made programs like AIR shudder. For if recognized services and personnel were in jeopardy, those with a comparatively less developed support system had little hope for survival at their previous levels of operation.

Besides these generally felt threats to the organization as a whole, individual fates were also imperiled. The media presumed

there was a "hit list" of personnel to be replaced.[22] CCFA's director was rumored to be on this slate of potential dismissals, as were a number of contact people in other agencies AIR consistently relied upon. As previously cited (see chapter 2), CCFA's director was forced from her position four months after the new mayor entered office; the uncertainty which marked this period was then replaced by anger and a new sense of confusion.[23] Over the next year AIR lost many allies, including agency directors who had sponsored major programming efforts as well as the director of the city department responsible for allocation and disbursement of CETA funds. AIR's support system was seriously eroded as a result of this political change.

How were these organizational changes consequently experienced by the artists? First, since budgets could not be assured, artists were uncertain of whether or not their particular positions would remain. At several crucial points AIR did not know how many slots (if any) it would be allocated, and program participants did not know if they should assemble individual contingency plans for themselves. Further, many AIR projects were disrupted. Projects were often underwritten by the support and understandings negotiated through a specific agency representative. If such individuals were displaced, or if their agencies suffered cuts and reorganization, understandings that were the outcome of lengthy bargaining processes were lost. And finally, the artists couldn't be sure that their programmatic and artistic supervisors would be retained because many of the AIR administrative positions were paid for by the general city budget rather than the CETA budget. The most artists could be assured of was that the program would not persist as they had known it.

The Threat of CETA Cuts

One of the most consistent features of CETA was the annual threat of reductions secondary to Congressional allocations. Coincidental with Mayor Byrne's local economy drive in mid-1979, for example, was a nationwide undertaking to trim CETA-sponsored positions in local communities. Just as 2,000 jobs were being eliminated from the city budget, an additional 5,000 jobs were lost from the enforcement of the 18-month CETA limitation clause. And six weeks later, 700 more CETA positions were discontinued, reducing Chicago's CETA budget by twenty-two percent.[24]

With such severe constrictions of available monies, recipient agencies had to anticipate corresponding reductions, but anticipation of such losses did not necessarily cushion their impact when they occurred. For example, on 10 September 1979, AIR was notified by the Mayor's Office of the Budget that its program size would be reduced from 108 to 60 positions. This necessitated a major reconsideration of the program scheduled to begin on 1 October. Commitments had already been made both to retain old artists as well as hire new ones. But no sooner did administrators design a plan to determine who would be accommodated than the entire complement of positions was restored. While this news was gratefully received by AIR, these proposed changes provoked a great deal of anxiety over individuals' fates.

CETA and AIR rebounded from fiscal crisis to fiscal crisis. Before any comfort could be enjoyed from the successful settlement of one threatening situation, another usually developed. If CETA as a whole seemed secure at one moment, its arts components could be in jeopardy at the next. One of the most unsettling announcements was received in May 1980: all of New York City's 612 CETA-sponsored arts positions were being cut. This was devastating news because AIR's New York counterpart organization was being eliminated, as were all arts positions within the nonprofit sector. This signaled the complete dismantling of the CETA-arts component in the most important arts center in the country. Other CETA-arts organizations (to the extent they still remained intact) were painfully aware of the limitations of their organizational lives because of this major decision.

The total elimination of CETA became a major priority of the national administration elected in November 1980. Organizational uncertainty was replaced by the certainty of dissolution. The only pertinent question was the length of time involved. Significantly, CETA Public Service Employment died in Fall 1981 much as it had lived—marked by ambiguity and confusing its directors as much as its recipients. When a bill to eliminate the program was presented to Congress, it was amended to reauthorize the program's continuation for three additional years instead. As an unusually convoluted news story reported, "Rules of the budget committees of both chambers of Congress provide that a law can't spell out how much a program is to be cut if there is no program in existence."[25] CETA survived briefly, but its major component was curtailed just a few weeks later.[26]

Boundary Skirmishes with Unions

A final example of how conditions of uncertainty affected AIR as an organization and likewise its participants stems from the attempt of another group to exert control over AIR's management and programming. In one case the presentation of a large-scale theatrical production provoked conflict with Actors Equity; this threatened to seriously disrupt AIR's overall operations.

AIR did not solicit the advice or participation of artists' unions in the initial design and implementation of the program, despite the fact that there was union representation on CCFA's governing board as well as on the Chicago-wide CETA advisory council. Ad-

Figure 12. Special events allowed large numbers of artists to collaborate on mounting major productions; they also threatened the artistic interests of other groups, e.g., Actors Equity and their constituents.

ditionally, the AFL–CIO urged AIR to include union representatives on the artists' selection panels as a "legitimate desire," which "would be of undisputed assistance to the program's success."[27] Further, the CETA Reauthorization Act of 1978 urged increased labor participation in the areas of job design, establishment of wage rates, and determination of job descriptions.[28]

Actors Equity resented this exclusion and tried to block performances they interpreted as competitive infringements on protected territory. This emerged when a union representative stated that AIR's proposed touring of city schools with Shakespeare's *Comedy of Errors* (fig. 12) "is better left to those other agencies that provide, because of experience and professional competence, 'excellent theatrical experiences for children in the schools.'"[29] CCFA had originally maintained that the union protest was based on inadequate information and was, in effect, "much ado about nothing."[30] Although the union continued its opposition until just hours before the play's opening, a resolution was worked out with city lawyers (and later supported by the Department of Labor) which verified that a conflict of interests did not in fact exist.

The play completed its entire run with no further formal union interference,[31] even though an interesting act of sabotage occurred which strongly suggested that some individuals continued to harbor hostile feelings. This production integrated the use of live actors with film segments to gradually unfold the story of confused identities among two sets of twins separated at birth. The film was especially important at the play's climax, when the twins confronted one another and discovered the theretofore unknown existence of each double, because there had been only two actors playing the four parts. The dramatic problem was solved at this point by picturing one of each set of the twins in the film. However, one evening the film was cut up and a large segment was stolen from the projection room, even though a great deal of expensive sound and projection equipment was left untouched. For that evening's performance the actors were forced to improvise dual roles because they had been robbed of an all-important prop.

Not only did this conflict provide legal and procedural problems for AIR, it also caused considerable difficulties for individuals. For several weeks those AIR participants who were Equity-affiliated members[32] were alternately torn between their obligations as union members and the demands of their status as CETA employees. The union forced work slowdowns and kept the idea of a

strike alive while these artists were concurrently reminded of their obligations to the program which was providing them with full-time employment. For *all* the actors, the extensive preparations for this production were jeopardized, and they also feared that bitter feelings incurred during this incident might linger on and blemish future employment situations. The actors therefore wanted the problems between the program and the union to be resolved to eliminate both present and anticipated difficulties.

The eventual resolution allowed for the complete run of this production and the designation of AIR's theatre division as an Equity company. While this did not mean all participants had to be members of the union, it did insure that the union was consulted in a wide variety of professional matters and could be called upon to help adjudicate disputes between any program actor and the AIR administration. This determination permitted the union the "in" it had desired and entitled it to participate within this artistic arena.

In summary, AIR administrators developed distinctive strategies to overcome the problems of accountability and control they had not initially anticipated when designing the program but which quickly surfaced as threats to its continuation. In some cases these strategies helped AIR establish a more independent base of support than it had at its inception. In others, AIR deepened its understanding of the complexities of the surrounding environment, increased its competitive edge, and moved from a defensive to a more offensive position. And in still other instances, it readjusted its priorities and sponsored activities that brought the most uniformly favorable returns, at the cost of curtailing those which made the program more vulnerable to adversely critical responses.

In most of these cases the perceptions of AIR administrators and many of the artist-participants greatly diverged. For the former group, such manuevers produced positive developments for the program; they helped insure a greater degree of internal control and a diminution of the authority of supporting agencies, and they contributed to the program's continuation. The artists, however, experienced these innovations differently. They felt the changes decreased their independence and seriously circumscribed AIR's potential as a public service art project.

Some organizations are more successful than others in the struggle to persist over time. Outcomes, however, generally are measured in relation to the organization; personnel responses to changes and their results are generally not considered. Responses could range from relief (that they could continue to identify with

the organization despite its changing character) to feelings of alien-
ation and disenfranchisement (from sensing that the organization
had moved too far away from its original purpose). AIR admin-
istrators often implemented refinements which they believed were
not adequately understood or appreciated by the artists. In fact,
evidence from AIR's experience contradicts the institutional ap-
proach to organizations in an important respect; such theorists
maintain that "institutional isomorphism promotes the success and
survival of organizations. Incorporating externally legitimated for-
mal structures increases the commitment of internal participants
and external constituents."[33] In AIR's case, the commitment of its
participants did not necessarily develop along these predicted lines.
The artists' point of view—how they actually experienced their AIR
tenures—will be considered next.

7

AIR from the Artists' Point of View

The words of a character in a Federal Theatre Project play of the 1930s capture some of the anxiety engendered by the search for an appropriate work situation:

> Work! . . . Usefulness! . . . A place to fill . . . A task to do! . . . Being one of the crowd! Belonging! . . . Those are the things that count! . . . Those are the things that bring a man happiness and contentment.[1]

The speaker in this case was a man with a Ph.D. who had tried unsuccessfully for five years to find employment. He represents the general dilemma of unemployed professionals in this society who are trained in specific ways, yet unable to match their skills with available positions. The parallels between these Depression-era conditions and more contemporary circumstances cannot be easily dismissed, for in each period careers have been difficult to construct.[2]

Such a disheartening situation has been long-standing and pervasive for artists. Even in the best of economic times an artistic career is a hazardous and risky endeavor. And while examples of success may be dramatically touted in public, the individual

chances of "making it" are severely limited. AIR recognized these conditions and largely justified its existence as an organization capable of addressing such needs.

Building upon its concept of artist as worker, AIR purported to offer an alternative to the conditions of uncertainty typically experienced by artists. AIR insisted that these conditions would not be replicated within the program. In addition to providing such relief, AIR's intentions were twofold. First, it proposed to supply training to enhance its artists' survival potential—learning and performing opportunities would heighten their ability to adapt to the contemporary market. And second, it sought to demonstrate to the public that artists legitimately deserved to be provided for, thereby anticipating an alteration of the artistic job market in the future.

We have seen that as it worked out, however, problems experienced by the organization were transmitted to its participants, complicating the implementation of the program's goals and having deleterious effects on the artists. In order to expand our understanding of AIR's operation beyond a formal organizational analysis, we can pose the following questions. To what extent *was* AIR able to provide different conditions under which its artists would operate, and to what extent were more typical working conditions recreated within the program? Further, while an outside observer might not classify AIR as being a highly developed bureaucracy according to standard criteria, how was their employee status experienced by the artists themselves and what adjustments did they feel they were forced to make?

How a Bureaucracy "Feels"

Visual Artist: I'm wasting my time just to please the bureaucrats.
AIR Assistant Director: I think the experience we get dealing with this
 kind of bureaucracy can be real valuable for artists It's
 real frustrating when you've got ideas and want to
 work . . . [but] I think it's real important in understanding
 how the money moves and how the power moves and how
 to work within those powers.[3]

The above exchange capsulizes a fundamental discrepancy between AIR's participants and its administrators. For the artists, the bureaucratic aspects of the program were often felt to be sti-

fling to creativity and an unnecessary complication in carrying out projects. AIR administrators felt quite differently. They understood the necessity of expanding the bureaucratic structure to increase their internal control and to enhance the organization's survival chances. In addition, they felt they were giving their artist-participants experiences and valuable training which these individuals previously either had not taken seriously for their own survival's sake or had never had the opportunity to acquire. In this respect they sought to educate these artists in the verities of modern economic life.

A well-established tradition romantically casts artists as free and independent craftsmen and their work as necessarily opposed to society.[4] It is not that such notions do not persevere. Instead, they are moderated by artists as they are forced to pragmatically assess and strategically confront real sets of circumstances; learning how to actually survive as an artist can attain parity with more idealistic considerations.

This sense that some sort of compromise is inherent in the pursuit of an artistic career has surfaced in a number of studies, several of which have centered on the process of obtaining an artistic education.[5] Common to each is the importance of career choices and adjustments primarily made prior to actually securing employment. There is, then, a critical element of conjecture: major choices are assumed to occur during the training process which presumably equip artists to cope with real work situations and demands.

Some other observers have moved their analyses to a distinctly different and sequentially later career stage. For both Becker's dance musicians[6] and Faulkner's recording studio musicians,[7] for example, this conflict between the ideal and the real was shifted to specific work scenes. While Becker focused primarily on those artists for whom conventional demands had not yet forced much conciliatory adjustment, Faulkner dealt with an artistic population which had similar problems but for whom successful solutions had been devised. Becker's artists were viewed as being jostled by conflicting demands, whereas Faulkner's had adjusted; as the latter observer concluded, "[these] musicians come to terms with their world of work."[8]

This conclusion, however, begs certain questions. At what price was adjustment obtained, and how was this process experienced at the time when success was not assured, but rather a desired

and uncertain goal? Studies of artistic education may differentiate those who reach some sort of resolution to the conflicts between artistic principles and work demands from those who do not, but they do not follow this latter group to the next point when they confront work situations in a real rather than hypothetical way. At the other extreme, Faulkner had a set of marketplace victors reconstruct their occupational struggles. It shouldn't be surprising that these individuals lauded the virtues of the commercially structured world of work, while they simultaneously denigrated the pursuit of artistic ideals from which they had gotten few substantive returns. There are, then, important considerations which are ignored by focusing on either those who have come to an early accommodation with conflicts intrinsic to their profession or on those who have emerged in relative triumph.

These conflicting demands mark an interesting piece of occupational territory, populated by those individuals who are caught in the actual push and pull of opposing forces. Some artists might have naively entered the AIR program relatively unaware of the inevitability of some organizational demands. Others demonstrated a greater recognition of job and market demands and a willingness to learn to contend with these as an important and desirable part of their training. For all AIR participants, however, the process of hammering out some type of adjustment was a central problem.

In order to explore this, artists were surveyed at the end of the second and third program years and asked to respond to a series of statements relating to their AIR experiences. The responses to some of these statements indicate how the artists experienced working within a bureaucratic organization, in particular one designed as an alternative structure for learning and performing a synthesis of artistic and practical skills (the mean responses to each of the statements and their rank order are summarized in table 7.1).

For example, the responses to a group of these statements represent the clash between bureaucratic and artistic standards. Testimony from both administrators and artists alike has already demonstrated that artists' typical work habits and standards were not in accord with bureaucratic requirements. To further illustrate this, the responses to the statements summarized in table 7.2 represent aspects of bureaucratic standards and organizational goals.

Statements D and E relate to the general CETA mandate to provide training to the unemployed and underemployed and to enhance their later employability in the public sector. Responses to

Table 7.1 *Responses to End-of-the-year Surveys, 1979 and 1980*

	Questionnaire Statement	1979 Mean	(N=95) Rank Order	1980 Mean	(N=70) Rank Order
A.	The AIR programs you presented in the communities were valuable for the people they served.	4.33	1	4.39	1
B.	The AIR programs you presented in the communities were valuable for you as an artist	3.92	2	3.90	2
C.	The role of the artist in society should be to communicate his/her own personal ideas and feelings.	3.89	3	3.72	6
D.	Participation in AIR has provided you with job/work skills which you think might be beneficial in obtaining future employment.	3.70	4	3.79	4
E.	Participation in AIR has provided you with artistic skills which you think might be beneficial in obtaining future employment.	3.60	5	3.84	3
F.	The AIR programs you presented addressed the real needs of the communities	3.58	6	3.78	5
G.	The structure of the AIR program is responsive to innovation and new program ideas from the artists.	3.40	7	3.13	12
H.	Artistic freedom is promoted in the AIR program.	3.38	8	3.20	10
I.	The future emphasis of publicly funded government arts programs should be grants to artists rather than public service employment.	3.35	9	3.27	8

(Continued on next page)

Table 7.1 *(continued)*

	Questionnaire Statement	1979 (N=95)		1980 (N=70)	
		Mean	*Rank Order*	*Mean*	*Rank Order*
J.	Collaborative efforts within your artistic discipline are encouraged.	3.30	10	3.13	12
K.	When the contribution of CETA artists is evaluated in the future, it will be judged as significant as the work produced by WPA artists.	3.20	11	3.25	9
L.	Collaborative efforts between artistic disciplines are encouraged.	3.15	12	3.07	15
M.	The role of the artist in society should be to produce work reflecting and articulating major social and political issues.	3.12	13	3.13	12
N.	Participation in AIR encouraged the creation of your best work.	3.10	14	2.96	16
O.	Critical evaluations of the quality of your work were offered by your artistic director or other administrators.	3.07	15	3.10	14
P.	Critical evaluations of the quantity of your work were offered by your artistic director or other administrators.	3.05*	16	3.48*	7
Q.	There is a strong sense of community among artists in the program.	2.70	17	2.63	17

Note: Responses were marked on a scale from "1" to "5," with "1" indicating "strongly disagree" and "5" indicating "strongly agree." Thus, mean scores represent the amount of agreement to each statement.

*Statistically significant at .05 level.

Table 7.2 *Bureaucratic Standards as Illustrated by Statements on
End-of-the-year Surveys, 1979 and 1980*

		1979		1980	
Questionnaire Statement		*Mean*	*Rank Order*	*Mean*	*Rank Order*
E.	Participation in AIR has pro-vided you with artistic skills which you think might be beneficial in obtaining future employment.	3.60	5	3.84	3
D.	Participation in AIR has provided you with job/work skills which you think might be beneficial in obtaining future employment.	3.70	4	3.79	4
P.	Critical evaluations of the quantity of your work were offered by your artistic director or other administrators.	3.05*	16	3.48*	7
G.	The structure of the AIR program is responsive to innovation and new program ideas from the artists.	3.40	7	3.13	12

*Statistically significant at .05 level

these questions indicate that the artists consistently felt that both their artistic skills and their job and work skills were being developed through participation in AIR. What is most surprising here is that AIR continually maintained that it was not training people to be artists; rather, it recruited only those individuals who had already acquired formal training and sought to develop their packaging and marketing skills to help them adapt to real job situations. Nonetheless, the artists increasingly acknowledged the growth of their artistic skills as well, indicating an unanticipated consequence of participation in this CETA program.

 Second, bureaucratic organizations generally emphasize the importance of producing a certain amount of goods or services; success is typically indicated by either maintaining or increasing a particular level of output. Most importantly, did the artists feel

this was emphasized as a primary *raison d'être* for the organization's existence? Indeed, they felt this purpose commanded greater attention over time as evaluations of the quantity of their work dramatically increased. The importance of this factor rose from a rank value of sixteenth in 1979 to seventh in the 1980 survey. As a dancer stated, there was a "lack of understanding by [the] administration as to needs of artists. *Creative* needs. To produce *quality* work. I feel we weren't given the opportunity to do things at a high level—we had to deal with *numbers* of people not quality."9 Similarly, a filmmaker/administrator observed, "There is a tendency to lean toward quantity over quality. Evaluations should be conducted by a panel of one's peers rather than by how many workshops one can cram into one's schedule."10

And finally, organizations generally attempt to heighten the predictability of their production. In fact, many contemporary studies of organizations take as their starting point the analysis of organizational strategies instituted to insure predictability in typically uncertain environments.11 AIR's more careful selection of personnel to fit within a concisely defined and easily managed format was one such tactic mentioned thus far.12 Related to this, the artists were asked whether they felt AIR was responsive to innovation. It would be reasonable to expect that an organization that was responsive to innovation would concurrently jeopardize production levels and would need to constantly evolve new forms of management. Growth and development in new directions would come only with relinquishing a certain degree of control. AIR, according to its artists, was unwilling to do this. As the mean scores indicate, participants felt that AIR became less responsive to innovation from the 1979 to 1980 program years. In other words, AIR opted for the safety and predictability its established procedures and format provided. From the somewhat fluid, open structure which marked the first year of program operations,13 AIR was experienced more and more as a fixed entity.

As the information in table 7.3 summarizes, an additional set of statements refers to artistic, rather than bureaucratic standards. For example, the issue of artistic freedom was raised—that is, did the artists feel they were allowed to develop their work in accordance with standards developed *within* the art world, or was what they did determined for them by concerns extrinsic to their artistic productions? The questionnaire means indicate that the AIR participants felt that artistic freedom was only moderately supported by

Table 7.3 *Artistic Standards as Illustrated by Statements on End-of-the-year Surveys, 1979 and 1980*

		1979		1980	
	Questionnaire Statement	*Mean*	*Rank Order*	*Mean*	*Rank Order*
N.	Participation in AIR encouraged the creation of your best work.	3.10	14	2.96	16
H.	Artistic freedom is promoted in the AIR program.	3.38	8	3.20	10
O.	Critical evaluations of the quality of your work were offered by your artistic director or other administrators.	3.07	15	3.10	14

AIR (ranking eighth and tenth, respectively, of seventeen items), and they also felt its importance decreased as the program continued. Second, if artists had been allowed to produce in accordance with the crucial thematic and stylistic problems within their fields, they would be constantly refining their work. That is, we assume that artists aspire to continued growth by producing better and better work. However, when asked if AIR encouraged the creation of their best work, the artists could not give their assent. Not only did their support for this statement decrease slightly over the two years, but their ranking of this statement remained consistently low. As one artist remarked in 1980:

> I think administrators should be eager to give artists who exhibit abilities to be self-directing their own projects. Those personal forays into artistic experience are likely to be driven by more frenzy and zeal than any "public-service" group project to which their energies might also be harnessed. Not to say the latter is not the mainstay of this program, but individual creativity is the principal resource and should be given its most direct outlets.

And finally, a statement was included regarding the evaluation of quality of work by supervisors. We would again assume that artists would emphasize the growth of their work and their

competency over the amount they were able to produce. As the data indicate, the artists felt that the program's concern with quality did increase very slightly from 1979 to 1980. More important, however, is the fact that this item was ranked toward the bottom of the group of statements, third and fourth lowest, respectively. What is most apparent is that the artists were aware of a general tightening of AIR's administrative structure (as represented, for example, by the organizational chart which provided a dual system of control), but understood that quality itself was not a major program priority. Recall as well that the bureaucratic preference for quantifiable results was ranked in a similarly low position in 1979 but showed a marked increase by the end of the third program year.

This tightening of the bureaucracy existed beyond organizational charts and administrative statements, then. The artists experienced this as providing limitations in addition to demands upon how they were to function within this setting. Even though AIR might be rather unbureaucratic as compared to other organizations, it could be experienced as being quite powerful. For example, more than one artist characterized his or her participation in the program as similar to being in the military. According to a 25-year-old photographer, AIR "enhanced my career, interrupted my life on many occasions. I imagine this program to be a boot camp for artists."[14] Such responses indicated the artists were quite aware of a decreased responsiveness to innovation, less frequent encouragement of their best work, and less emphasis on the promotion of artistic freedom. Conversely, they increasingly experienced an emphasis upon the development of work and job-related skills and the production of a measurable quantity of work.

It should be clear by this discussion that organizational and individual needs and priorities were antithetical at several crucial points. What gradually emerged was a way to operationalize the idea of transforming artists into cultural workers. The artists understood the emphasis of the program to be upon the development of both their artistic and job and work skills, but without a corresponding encouragement of their best work, which demonstrated that AIR was interested in pursuing two goals. First, the organization wished to contribute to the development of artistic producers for whose later presumed marketability they could claim credit. And second, AIR sought the creation of artistic products in sufficient quantity and of adequate quality to reflect positively upon the program and contribute to its continued viability. It did not, how-

ever, propose to subsidize individual artists in order for them to develop their "own art."

Making Do: Maximizing Opportunities within the Limitations

I'm eating 3 squares [meals a day] and paying my rent. Savvy?[15]

What could it mean to be an AIR participant? When asked whether or not his inclusion within the program had enhanced or interrupted his career, the individual quoted above answered in pragmatic terms; references to training, learning, or other opportunities were absent. What stands out prominently instead is the sense of relief derived from not having to hustle together a living for a specified amount of time.

This individual's response is not necessarily representative of all program artists, whose answers to this question ranged widely. It does demonstrate, however, that there could be a considerable distance between the view officially promoted by AIR in regard to what it was doing and how the program was actually experienced by its participants. As we've seen, artists were reluctant to place complete trust in AIR and abandon their fates to its control because of the limited time span built into the program and because of the many challenges to its smooth operation and continuance. Since AIR replicated rather than replaced conditions of uncertainty for its participants, it was not able to deliver what it had promised. Instead, AIR rather unknowingly encouraged its artists to "work" the program for what it was worth, prompting individual adaptations to maximize what could be derived from this source within a circumscribed amount of time. This view of CETA as an opportunity to be exploited rather than as a well-conceived attempt to redress structural inequities in the marketplace more accurately reflects the participants' interpretation of CETA and the impact it had on them.

Pragmatic Advantages to AIR Participation

Many artists were most immediately aware of the practical aspects of being program participants. It did offer relief from other, less art-related activities. As a 30-year-old musician stated, "I might have been driving a cab [instead]."[16] There were, in addition, frequent references to the irrelevant and demeaning work situations the artists had had to endure prior to their AIR involvement. For example, "Last year at this time [the name of an AIR

musician] was working as a stockboy at Marshall Field's [Department Store]."[17] At the very least, AIR employment eliminated the frequent necessity of finding supplemental jobs to alleviate monetary problems.

Another practical aspect of being an AIR participant built upon this freedom from ongoing concerns. For with the alleviation of the press of day-to-day survival problems—at least in the short run—valuable periods of time were freed for alternative uses. A female visual artist evoked the sense of E. Erikson's idea of the usefulness of a "moratorium"[18] when she stated: "It's [AIR's] been good in that I've reevaluated my place and purpose as an artist. I thank your program for that. It gave me time."[19] The value of time was that it allowed individuals to confront questions of competency, continued interest, and self-confidence; their attention to such matters could easily be deflected in other situations.

And finally, certain tangible benefits could be adduced. A 29-year-old actress attested to the enhancement of her career through AIR participation in the following manner. "Membership in Equity has occurred, [as well as an] increase in auditioning skills."[20] At least within some artistic disciplines union membership and the refinement of skills were easily identified indicators of professional progress, as this theatre example indicates.

The Neutralization of Limbo: A Psychological Shot in the Arm

Q: What is your single most memorable experience in the program?
A: Getting accepted into the program.

> 28-year-old female writer
> 31-year-old male photographer
> 24-year-old actress
> 22-year-old actor
> 30-year-old male musician[21]

As the repetition of this response indicates, getting accepted proved to be an event of significance much as AIR had anticipated it could be. It is, however, informative that this occurrence at the very beginning of an individual's AIR involvement should retain such salience throughout the rest of the year. Yet how were the less pragmatic, less immediate purposes of the program experienced? Did AIR in fact provide a particular stage within a status sequence, opportunities to perform, and the occasion to develop a

Table 7.4 *Self-report of Stage of Career, End-of-the-year Surveys,*
1979 and 1980

	1979		1980	
Career stage	N	*Percentage*	N	*Percentage*
Beginning	22	31	19	29
Growth/development	14	19	20	31
Semi-professional	17	24	15	23
Professional	13	18	5	8
Transitional ("artistic limbo")	6	8	6	9
Total (codeable responses)	72	100.0	65	100.0

sense of being a professional, *as perceived by its artist-participants?*
Additional responses by the artists to end–of–the–year surveys can
help determine if AIR indeed affected its participants in the ways the
program intended.

For example, artists were asked at what stage of their careers
they felt themselves to be at. As was observed in survey responses
given by people upon entering the program,[22] the artists experi-
enced a great deal of difficulty responding to this open–ended ques-
tion; many did not respond at all, and others expressed confusion
or frustration over it.[23] The largest number of responses in 1979
and a comparably high figure in 1980 (see table 7.4) were recorded
in the "beginning" category. These respondents also furnished
graphic images to supplement their answers. For example, there
was the repetition of metaphors referring to childlike, even infant
status: "Umbilical. I'm a newborn playwright," "prenatal,"
"fledgling," and "infancy" were all used to describe these artists'
perceptions of their career positions, although these specific re-
spondents ranged from twenty-three years to thirty-three years of
age. Further, objective success within the program seemed to have
little bearing upon individuals' self-perceptions in this regard. A
30–year–old costume designer whose work was highly regarded
characterized herself as a beginner, as did a 36–year–old artistic di-
rector. When the latter explained where he was career-wise he
stated, "Hopefully the beginning; fearfully, the end."[24] Artists
therefore had some recognition that any success they'd experi-
enced in AIR was not necessarily transferrable to other situations
they were about to confront.

Table 7.5 *Self-report of Stage of Career, New Artists' Surveys, 1979 and 1980*

	1979		1980	
Career stage	N	*Percentage*	N	*Percentage*
Beginning	10	25.0	8	21.5
Growth/development	11	27.5	8	21.5
Semi-professional	4	10.0	3	8.0
Professional	3	7.5	3	8.0
Transitional ("artistic limbo")	12	30.0	15	41.0
Total (codeable responses)	40	100.0	37	100.0

The characterization of their careers as *somewhat* more advanced—using such descriptive terms as "growing," "learning," "developing," "struggling," and "maturing"—also comprised a significant group of the responses (the third and second largest in the two surveys, respectively). A similar proportion described themselves as semiprofessional, but very few (only 13 percent and 5 percent in the respective years) considered themselves to merit professional status.

The significance of these data emerges when compared with responses given to the same question when it was posed at the beginning of these program years (table 7.5). What is similar in these two surveys is that responses within the two categories nearest the beginning end of the continuum drew roughly one-half of the responses, ranging from 43 to 60 percent. Likewise, those characterizing themselves as professionals remained few in number. Somewhat surprising, however, is that the percentage of those perceiving themselves at the beginning stage of their careers actually *increased* after participation in the program. And, the category of "artistic limbo," which figured so prominently in the artists' perceptions when they entered AIR, practically dropped away. In the new artists' surveys, this category accounted for 30 to 41 percent of all responses, while in the end-of-the-year questionnaires the proportion of these responses fell to 8 and 9 percent respectively. These data indicate that AIR may have in fact contributed to neutralizing some of the feelings of being in limbo and without a clear-cut status. When they were incorporated into the program as working artists, individuals' doubts and insecurities

were offset for the time being. Further, it follows that large numbers of these artists could continue to think of themselves more as beginners than as professionals. While some of the instability of their positions had been counteracted, the incipience of their careers was simultaneously exposed and highlighted. As a 28-year-old musician described the stage of her career, "At the beginning—finally!"[25]

As noted, a number of artists described their situations in childlike terms, reflecting the close connection between attaining adult status with the assumption of full-time career responsibilities. The relative lack of opportunities within artistic fields guarantees that many individuals will be kept in a childlike position and will continue to think of themselves accordingly. However, the significant decrease in the number of individuals who were experiencing a sense of being in limbo indicates that some members of this group were able to take advantage of this moratorium period and start to assemble new ways of thinking about themselves and their activities. For example, an administrator who was an MFA-level artist made it clear that his confidence derived directly from his duties in the program and was not something he initially brought in with him:

> The rewards . . . come in the realization that somewhere along these fifteen months *I have crossed a line* that says that *I am no longer a student;* that having been part of AIR, I can approach new tasks with a reasonable suspicion that I will manage just fine.[26]

Of course, of prime interest are the experiences of the "rank and file" artists in the organization. And here, too, examples attest to the sociopsychological impact of having the time and opportunity to act as artists, at least somewhat free from routine insecurities. Many participants reported their appreciation for this suspension of some uncertainty. As one artist stated, "The time I have spent as an Artist-in-Resident has enhanced my career. By working in the program, my professional goals have been focused . . . and my confidence maintained." Similarly, "Being able to actually think of myself as a working photographer has done a great deal for my confidence in that field." And finally, "It [AIR] has afforded me the opportunity to learn something valuable, to develop a strategic direction—that's the first time a 'job' has done that for me."[27]

It appears that AIR did in fact create a new career stage to

replace the previously transitional and extremely unsettled state of these artists. In this respect it might have contributed to the provision of a status sequence not heretofore existing for this occupational group. Two caveats are necessary, however. First, not all of those artists who underwent some neutralization of prior occupation-related difficulties emerged with the psychological shot in the arm enabling them to confront the next series of career obstacles. Rather, this moratorium could lead to the opposite reaction; when asked where he was in his career, one musician stated "Final stage. It's too difficult and the reward is ever small. [I] would rather do something that is more socially understandable and acceptable."28 In this case participation in the program enabled an individual to develop a clearer focus but with a different outcome. And second, while AIR apparently offered a rather unprecedented career stage, to what (if anything) was it connected? If the artists would be leaving the program with certain sociopsychological benefits, of what usefulness could these be if these same individuals were to reenter an artistic world essentially unaltered during their time away from it?

Building a Career: The Costs and Benefits

> . . . symbolic rewards may help the inexperienced to feel professional, but matter less to those who have "been around."29

Beyond the relief from otherwise diversionary activities that AIR participation provided, how successful was AIR in altering the social structural conditions typically confronted by artists, in teaching their artists to adapt to these conditions, or in providing alternative structures? As Kadushin notes, "Anticipatory socialization takes place only when the social structure . . . allows one actually to play the role that will be one's full-time concern. The social structure—not the social psychology of the situation—is the major factor."30 Further examination can reveal how meaningful AIR's structural and sociopsychological provisions were.

One of the ways artists could indicate that the performing structures offered by AIR were indeed valuable opportunities was in their responses to the question of whether or not they had completed formal training in their fields. Artists often drew the distinction between training in a classroom-type situation and what could be acquired by working *qua* artists, especially when they were first entering the program. For example, a new writer commented, "I

plan to gradually acquire specific training [to supplement an already-earned B.A.] with the winter term. However, I feel no formal training would be as rewarding as actual work experience."[31] Similarly, an actor commented that "Yes," he had completed his formal training, ". . . but the *real* learning comes with professional *experience* in the field. One never stops one's training."[32] Thus, while artists could perceive the program as providing these alternative performing structures, when they viewed their careers in the longer run—beyond their AIR tenures—what did they anticipate the program's probable impact to be?

The most direct way to assess this is by examining the artists' responses to a question on the end-of-the-year surveys: "Do you feel the time you have spent as an Artist-in-Residence has enhanced or interrupted the progress of your career? Please explain." Table 7.6 attests to their consistent impression that AIR had enhanced their careers, beyond the recognition that it was but one stage within a longer sequence. A distinct majority (72 and 76 percent respectively) affirmed this statement. The other categories attracting a modicum of support indicated that participation had either interrupted or both enhanced *and* interrupted these individuals' career development as artists; these responses accounted for 20 percent of the responses each year.

The most enthusiastic supporters of AIR as a career-enhancing endeavor were those who most readily accepted the advantages of becoming cultural workers. Individuals who were most interested in learning to adapt their skills to existing work conditions gave thoughtful responses indicating the ways they had benefited within the program and how they anticipated its effects would carry over into the larger art world. For example, this sense was present in the

Table 7.6 *The Perceived Impact of AIR Participation on Artists' Careers, End-of-the-year Surveys, 1979 and 1980*

	1979		1980	
Career Impact	N	*Percentage*	N	*Percentage*
Enhanced	65	72	48	76
Interrupted	6	7	2	3
Both	12	13	11	17
Neither	2	2	2	3
Other	5	6	—	—
Total	90	100	63	99

following statement by a visual artist: "It [AIR] has . . . greatly expanded my knowledge of the arts matrix that makes up this city."[33] This individual realized that art is produced, recognized, and rewarded within a community of participants, realizations expedited by the concrete knowledge he obtained through the program.[34]

A more detailed response was provided by a 30-year-old video artist, indicating his gratitude that a situation he felt every artist must confront was offered under AIR's auspices:

> My experience with AIR has provided an opportunity most people coming out of art schools don't get: to orient their sensibilities *and* skills to the market and social realities, to mediate between either an attitude of predominately self-directed work or client-directed work. The particular expression will vary from person to person and within each discipline and tradition—but I think it's always present.[35]

And a 29-year-old visual artist attested to the concrete ways in which AIR helped to insure that someone who had "been around"[36] might be able to stay around:

> The program has done a lot to train me for employment in my profession. It *has* provided the "in" to an agency, but beyond that I have had to learn how to deal with them, how to propose, how to *convince*. It has shown me potential jobs, too. I have learned . . . internal workings of bureaucracies, how to [do] P.R., how to organize a big job with workers and many other things that I may not yet realize.[37]

These artists chose to emphasize the specific AIR-derived skills and information which could contribute to their survival chances. For them, the development of techniques to manage their progress was both acceptable and necessary and was acquired with no sense of compromise. "Willingness" probably overshadowed any sense of loss here.

Others, however, complied with the program's intentions while also feeling that a certain cost had been incurred in the process. And as might be expected, those who selected categories which indicated dissatisfaction with their AIR employment provided some of the most critical and insightful analyses of the program and their positions within it. For example, a 25-year-old

female dancer reflected the sentiments of that significant group who stated AIR had both enhanced and interrupted their careers:

> I advanced my career by learning about the technical-paperwork sides of artistic endeavors—bookings, p.r., grants, etc. But I feel I spent too much time running around [doing these things] and not enough time working on my dancing. My dance technique has significantly declined—my artistic standards became far below what they were. [38]

The respondents who comprised this category almost uniformly reported that progress in one part of their careers was accompanied by the neglect of other aspects. In the typical characterization of gain and loss, those features which initially distinguished them as artists were seen as decaying, and the artists also conveyed the sense of having lost sight of their original motivations. This predicament was especially true for those artists who were employed in administrative positions, as this statement by an artistic director indicates: "I've had many new experiences . . . [but as to] my creative work . . . that aspect of my development in this period of time has been pretty much overtaken by the solving of practical problems in my daily work." [39] In this individual's case, her job enabled her to actually work as an artist while assuming some administrative responsibilities as well. More poignant was the statement of a full-time administrator whose AIR duties precluded his work as a creative writer; his response alternately reflected sadness, resolve, and some surprise at what had happened to him:

> AIR has interrupted my development as poet-writer-teacher. But: "habeas paycheck," "one must have a paycheck." I don't have an opportunity as an administrator to practice my art. Of course, I ACCEPTED the job with that understanding. (Was lucky to get the job at all.) Nevertheless, arts administration *used* to be a *sidelight* to my poetry. I never thought it would replace my poetry. [40]

It is clear that a majority of AIR participants understood the program's role in teaching them to adapt their skills to extant conditions. And to a certain degree, it even attempted to develop alternative situations in which artists could continue to work after their CETA eligibility expired, for example, as arts administrators within the program and within other agencies. But the actual experience of these learning situations and the association with like-minded

individuals was differentially perceived as beneficial or debilitat-
ing. Not all the artists were enthusiastic about the kind of training
they were receiving, although most of them probably entered with
some willingness to undergo a process of change and develop-
ment, and a majority assented to AIR's enhancement of their ca-
reers. Individuals could comply with the dictates of the program
and acknowledge that AIR had enhanced their careers, yet at the
same time recognize what they had given up. The following state-
ment offers some indication of resistence to becoming a cultural
worker:

> Yes [AIR has enhanced my career] . . . however, I feel that the one
> quality which identifies an artist from a nonartist, i.e., a personal
> involvement in the quality of the work, has been diminished. I need
> to recover from my involvement in AIR.[41]

AIR and the "Real World": Goodness of Fit

While the statement of the last artist reflects a distressing
sense of loss, a final set of responses captures a somewhat more
resigned position—AIR participation was not totally unproductive,
yet not that useful; not exactly time ill-spent, but not that profit-
able; and not completely futile, yet not particularly helpful, either.
These individuals focused on the problems they would continue to
confront in the long run in their artistic careers, which correspon-
dingly reduced the esteem with which they could hold the pro-
gram's efforts. In these evaluations, the significance of having a
tenure of from twelve to eighteen months in a public-service arts
program palled in relation to the difficulties confronting artists in
their real world struggles.

The understandings of some artists led them to the awareness
that successful adaptation to the program was not necessarily relat-
ed to the possibility of success in the realm of the larger art world.
They emphasized the contradictory nature of the program. Not
only could AIR enhance as well as interrupt careers as other artists
previously reported, but it additionally might divert attention
away from more typical difficulties: "The program has done both.
It's given me the freedom to work—albeit under atypical condi-
tions, and yet it has interrupted my struggle in the mainstream."[42]

The atypical nature of their experiences was exactly what re-
mained uppermost in the minds of some artists—atypical in that
the idea of being trained tended to becloud the structural fact that

there is little to be trained for in these occupations. The observations of one artist working in an administrative position critically evaluated the superfluous idea of developing cultural workers when such an effort had not been matched with the provision of more permanent jobs:

> My AIR experience has given me a certain amount of additional background in arts administration. But since there are very few actual jobs in this field I do not feel as though my employability has been greatly enhanced. The progress of my artistic career has not been enhanced at all, although it has not been interrupted any more than it would have been from any other job.[43]

While this respondent judged the program's efforts to be rather inconsequential, one of the artistic directors reacted in a much stronger way. For this individual AIR might temporarily divert artists' attention away from their typical problems yet its basic inability to alter structural conditions would ultimately lead to feeling deceived. As she further stated, "While finding employment for artists is nearly impossible, hiring them for a year is a band-aid solution that inevitably causes ill feelings, guilt, and dead-end promises."[44]

Such reactions could only occur, of course, if participants placed all their career hopes in AIR's basket. For those artists who considered their AIR tenure as merely a specific point within a protracted struggle, expectations would be lower and the possibility of a major sense of disappointment diminished. For example, one artist shrugged off the magnitude of the effects of AIR on her career in the following way: "It's hard to say [if AIR enhanced or interrupted her career]. I feel I've grown up a bit—'matured,' as they say, but I'm not sure that couldn't have happened anywhere."[45] For another artist, AIR's value was that it provided the opportunity to try out a work routine and evaluate its suitability as a type of work environment for her future:

> It has interrupted my work since I find forty hours per week distracting . . . however, it has improved some of the more real and necessary skills for survival as an artist, I think. It has certainly taught me what I *am not* interested in doing.[46]

AIR participants therefore reacted to the avowed purposes of the program in various ways, largely in relation to their willing-

ness to assent to its goals and the strength of their belief that its impact was significant. A rank order can be established for how successful AIR was in meeting its goals. The program was most successful in teaching its artists to adapt to existing social structural conditions. For some this was expedited to a high degree and with a minimum of resistance; for others, enhancing their adaptation to the exigencies of the artistic marketplace was accomplished (if at all) only with a corresponding sense of the loss of some of the qualities they deemed vital to being an artist. AIR was somewhat less successful in its attempt to provide alternative performance structures for its participants. This was accomplished in the short run by its actual employment of artists for a specified period of time. However, the long-term goal of developing more permanent positions for cultural workers barely progressed. The proportion of individuals working in such administrative-type positions never exceeded fifteen percent, and a much smaller proportion of these individuals actually moved into jobs which continued beyond the life of CETA.

And finally, the possibility of altering the social structural conditions typically confronting artists was not fulfilled, largely because neither AIR nor CETA could bring direct pressure to bear on macro-level aspects of society. The most such programs could hope to accomplish was to set an example which would be so persuasive that it could induce change. CETA's controversial nature and its general lack of credibility and support did, however, undercut its acceptance as the harbinger of new social arrangements.

AIR's limitations were dictated by the preexisting market structure for artistic activities. In addition, organizational uncertainty generated from various sources replicated a situation more similar than dissimilar to what the participants had customarily confronted. The centrality of the concern with security can be seen in a reference to an artist moving from her CETA position into a permanent job as an exhibit coordinator, a good example of what AIR defined as a match between developing a cultural worker and a corresponding slot to absorb that individual. In a section of an *AIR Newsletter* entitled "Transitions," the following note was recorded: "[Name of visual artist] has entered the realm of security . . . jobwise, that is."[47] However, such positive outcomes were more the exception than the rule. In fact, it was deemed important yet virtually impossible to develop an adequate tool for measuring how successful AIR participants were after leaving the program. For while such an inventory was attempted at various times, the typ-

ical approach was to tally the proportion of those who had been able to return to a level of work at least comparable to where they had been prior to acceptance into AIR. This meant that most AIR participants returned to uncertain conditions where they *might* have a commission for a particular project, *might* be engaged for the run of a play, or could have *possibly* found part-time teaching in their field. At any one time program administrators could count as "successful" those artists who were so contracted, although the number varied greatly because of the working conditions typical for artists. When such surveys were undertaken, they claimed that about seventy-five percent of former participants had successfully "transitioned" into private employment. Such figures, however, somewhat disguised the similarity of the individual struggles to which most artists had had to return.

8

On Their Own: Individual Adaptations to Uncertain Conditions

Commitment is the acceptance of an offer, the fulfillment of a promise. For commitment to develop, opportunity has to be extended and supported with continued good faith. Investigators in research settings as diverse as American corporations and British schools have discovered that commitment is not something individuals bring with them into these situations, rather it is shaped in response to the conditions they confront there.[1] It is a capacity, not a finite amount. However, an optimism pervades these works, a sense that people usually respond positively to responsibility and opportunity but withdraw their best efforts when they sense they are in positions that are not rewarded within the organization or which don't seem to be connected to advancement in the larger world.

Lack of commitment can materialize in a number of forms, ranging from disengagement to passive or active resistance. In all these instances the individuals and the organizations involved incur losses. For the organization, potential resources are underutilized; for individuals, the psychological costs increase as potential material and status rewards are limited. In AIR's case it was difficult to successfully complete the transaction that results in commitment because so much of the uncertainty peculiar to the position of art-

ists was replicated in this program, encouraging distinctively individual solutions and adaptations.

There was a fundamental difference between AIR and other artistic experiments which preceded it. For example, a study of the California Institute of the Arts capsulized a primary feature of that work environment by the statement "In the beginning there was the money."[2] "The money" was just the starting point, though. It was associated with images of unlimited resources and inexhaustible opportunities and taken as the basis for a type of institution building which could assume a vanguard role in the implementation of societal-wide change. The dividends of this financial base were a sense of openness and possibility. With CETA support, however, what was guaranteed was the certainty of limitations and the assurance of insecurity; the set of social circumstances in which CETA was embedded spawned AIR as an organization of a much less utopian nature.

Distinctive attitudinal, behavioral, and thematic consequences followed from this organizational insecurity. AIR was characterized by divided loyalties, limited commitment, little mutual support and collaboration among participants, and an introspective rather than group emphasis. Whereas similar organizational problems in the WPA era were counterbalanced by a climate of opinion that supported communal identity and resistance, AIR artists had little to draw on to formulate responses other than withdrawal and passive resistance.

"Split" Labor Markets on an Individual Basis

You're past the point of believing that work
You don't get paid for feels better
Like playing poker for potato chips lost its aura
When you realized no one would know
You were ahead if you ate your winnings
And when they hit me up for tickets to
The Policeman's Ball, tell me to trick-or-treat
The neighborhood door-to-door for votes
I've got a plan—I'm gonna dress up
As City Hall and if they drop the Neutron
Bomb that night, I'm a building, I'll survive.[3]

This poem, written by an AIR participant while in the program but privately published by a small press, is interesting for

two reasons. First, the poem emphasizes his determination to survive the program's demands, regardless of how extrinsic they are to the pursuit of his art, because to get paid "feels better." His individual determination to endure might mean being transformed into something as indestructible yet inanimate as a building; but it is a strategy which emphasizes durability over all else, rather than a return to familiar but undesirable conditions. And second, this was written and published apart from the artist's official duties in AIR. In this respect he was typical, for most participants continued to pursue their creative work on their own time, segregating what was owed to the program from what was closer to their "own work."

This reflected an attitude artists commonly assume toward their work, a distinction that is made between what they are doing to provide an income for themselves and their own work. The former is most usually considered necessary only to provide a return to the latter at some point. Work for money is typically performed with some degree of role distance. while an artist's "own work" more fully engages the person. A similar distinction is made by Hannah Arendt. Calling "labor" that which is done to make a living, she maintains that the artist is the only contemporary example of one who works in a laboring society.[4] A primary rationale for initiating artists' projects within CETA was to counteract the necessity for these individuals to draw such distinctions while being offered employment commensurate with their interests and abilities, but AIR participants—almost to the person—continued to embrace such a separation.

The dichotomy between one's own work and what has to be done for money is clearer in some artistic fields than others, as was the case in AIR. For example, documentary photographers in the program found that their AIR jobs closely approximated their own work; the major difference was that within the program they had less individual control over choice of subject matter. Dancers and actors, however, performed mostly in workshop or residency situations with such groups as school children and senior citizens at a level far below their training (see figs. 13, 14). It was only in large-scale, publicly mounted performances that these artists were able to display the wider ranges of their expertise (fig. 15).

Similarly, artists in some disciplines find this to be more of a problem in the private sphere than others do. As one example, many visual artists in AIR had been previously employed doing such publishing tasks as keylining and paste-up—*related* to their

Figures 13, 14. AIR audiences were relatively unsophisticated, which meant that AIR artists were required to draw upon only a narrow range of their artistic skills. They generally considered their AIR duties to be "labor," not their "own work." Photographs by Lauren Deutsch, courtesy of the Chicago Public Library, Special Collections Division.

Figure 15. Public performances were more artistically challenging for the artists and reached more diverse audiences. Photograph by Carolyn Turner.

work, yet hardly coextensive with it. Graphic artists, on the other hand, generally find much more overlap between employment opportunities and what they are trained to do; this holds true for these individuals in the private sphere as well as for those in the public service arena.

Because the structure of the program replicated rather than supplanted conditions of uncertainty, most individuals decided to rely upon familiar modes of operation and treat the program as a means to secure an income and other limited benefits rather than as a terrific opportunity to "be" an artist. This response was directly related to working within a bureaucratic organization rather than indicating something pathologically inherent in artists' psyches, as corroborating evidence from the WPA Writers' Project illustrates. Although individuals were hired to write, the assignment for most was to work on a narrowly defined project (the American Guide

Series, a combination history/travel guide to each state). Only a few participants in the program were given license to pursue projects they personally designed, and antagonism developed between those who "labored" in the first sense and those who were allowed to "work."[5] One concern of those laboring artists was that their best work should be done on their own time so they could determine what to do with it; if they produced their best under the aegis of the project, control over the final products would have rested with the sponsor, not the producer. As the project director Henry C. Alsberg stated, "Very few of our writers care to risk a possible best-seller as a contribution to the United States Treasury."[6]

AIR artists shared these exact concerns. Few were allowed to freely pursue their own interests. And further, when groups such as the visual artists were initially allowed considerable independence but subsequently subjected to more tightly prescribed duties, they bitterly resented the necessity to reimpose their distinctions between work and labor. Under both sets of conditions, however, they differentiated the works produced during their AIR tenure into two categories: there were those which would minimally meet the program's requirements and those which they wished to retain as either more interesting and more important to their artistic development or more valuable in the marketplace.

AIR quickly recognized that its artists-employees could not limit their activities to the requirements of the program, but instead continued to cultivate their positions within broader art communities as well. Rather than try to curtail them, the program realized it had to allow its artists to compensate for what it could not offer (i.e., employment to work only on their own projects) and help insure they not lose touch with the art world beyond AIR's scope and duration. In response it implemented a procedure whereby artists were required to submit requests for extra employment or professional activity at least two weeks prior to the activity but routinely approved such proposals. Throughout the course of a program year most artists had filed such requests. AIR, however, also sought to guarantee that it received what it was paying for:

> Those employed with the Chicago Council on Fine Arts' Artists-in-Residence program should understand that during their employment with the Council their first priority and strongest commitment professionally is their work with the Artists-in-Residence program. It is the firm policy of the Chicago Council on Fine Arts

that any extra employment or professional activity should not conflict with the responsibilities involved with a full-time job with the Artists-in-Residence program.[7]

While the program tried to recognize the special needs of its artists, some of them continued to feel that exchanging limited financial security for the adaptive use of their skills was problematic, as this statement by a visual artist/administrator indicated:

> Each artist, including administrative types, should be allowed at least twenty percent of their work time to pursue their own artistic disciplines free from outside requirements. The public service angle is a delight to the beneficiaries, of course, but not necessarily to the artists themselves who have to compromise all of their best energies to focus in on other people's needs. This directly contradicts my definition of a healthy artist-type who must "unconditionally" unfold his/her own personal visions, messages or concerns.[8]

This reference to individual rather than collective concerns was a sentiment that was widely shared in relation to many aspects of the program.

One for All and All for One? The Lack of a Sense of Community

The uncompetitive nature of AIR's organizational culture has been cited as an unanticipated consequence of the lack of tenure in the program. In a crucial way this also contributed to the lack of a strong sense of community among program participants. Precisely because the organization had limited opportunities to offer, there was little payoff in either identifying with the interests of other participants or with the organization as if it were an ongoing concern. This therefore encouraged individual strategies to maximize the benefits that could be derived within a delimited amount of time. And not only did AIR's structure generally promote the insular functioning of its participants, but the artists themselves also resisted those specific attempts to bring them together.

A very crude index of the individuation of AIR participants is that typically they knew few of their fellow artists outside of their own disciplines. The most important explanation for this is that as the program developed, more artists were engaged in standardized residencies and workshops; this left little time for collaborative projects either within or between disciplines, thus segmental rela-

Figure 16. Collaborative efforts between artistic media generated interesting results, but they were overshadowed by a standardized workshop and residency format which fragmented the artists into their own working groups and left little time for such explorations. Photograph by Lauren Deutsch, courtesy of the Chicago Public Library, Special Collections Division.

tionships predominated. This was in contrast to such activities as the aforementioned *Comedy of Errors* during the summer of the first year and the presentation of three large-scale theatrical productions during the summer of the second year, where artists from several disciplines actively contributed to the mounting of these works. Similarly, some quite innovative projects had been undertaken such as *SRAMRAP,* a co-operative effort between the actors and video artists to instruct and entertain children through the joint use of live and taped performances (fig. 16). By the third program year, however, there was considerably less room for such activities because of the way AIR administrators had decided to structure the program.

This was recorded in artists' responses to items on the end-of-the-year surveys. For example, they were asked to respond to the statement "Collaborative efforts between artistic disciplines are encouraged." The artists ranked this statement rather low each of the two years of the survey—twelfth and fifteenth, respectively, out of seventeen items (see table 8.1). The artists also felt in-

creasingly isolated within their own disciplines when they were required to devote a larger proportion of their work time to workshops and residencies. In response to the statement "Collaborative efforts within your discipline are encouraged," the artists acknowledged this to exist to a slightly greater extent than the preceding feature. Here, the rank order of the statement was tenth and twelfth in the respective program years, and the mean for the two years similarly decreased a small amount.

Although the structure of the program promoted the separateness of its participants, AIR had tried at various times to encourage a sense of esprit de corps; but as AIR tried to bring the artists together and accentuate their mutual interests, these efforts became increasingly coercive. The principal mechanism AIR used to induce a sense of community was through what became known as "Big Deal Days." The idea for these events was conceived midway through the first program year, and they were scheduled on a monthly basis in order to diffuse information, to discuss problems, and to expose participants to one another's activities through live presentations. Although they were mandatory, an attempt was made to enliven Big Deal Days during the first year by convening them in interesting locales throughout the city. Program administrators anticipated that these events would be enthusiastically received as a welcome respite from the artists' typical routines. Instead, they were met with reluctance rather than eagerness, and the proposed monthly schedule was gradually abandoned.

Table 8.1 *Individual versus Collective Aspects of AIR Participation*

	Questionnaire Statement	1979		1980	
		Mean	Rank Order	Mean	Rank Order
L.	Collaborative efforts between artistic disciplines are encouraged.	3.15	12	3.07	15
J.	Collaborative efforts within your artistic discipline are encouraged.	3.30	10	3.13	12
Q.	There is a strong sense of community among artists in the program.	2.70	17	2.63	17

Figure 17. Artists took their work to varied public venues like museums, parks, and, in this instance, a busy commuter railroad station where a poet conducted a reading. Photograph by William Higgins.

Interestingly, these events were anathema to the artists even during that first year, the time when the program's structure was the least rigid and the sense of opportunity was most pronounced. During the second and third program years administrators attempted to schedule Big Deal Days only twice per year. With even such a limited program demand, however, the artists resisted coming together. AIR participants defined themselves in group terms or identified with one another's interests only minimally, as a quantitative measure confirms. In the end-of-the-year surveys in both 1979 and 1980 the statement, "There is a strong sense of community among artists in the program" received the lowest mean score, ranking seventeenth out of seventeen items (refer to table 8.1).

Not only did the artists resist these program-wide gatherings, they often were unenthusiastic in their support of activities within their own artistic disciplines. It is useful to quote at length from a memo by the artistic director of the writing component to members of his group whereby he expressed his dissatisfaction with their lack of support of their fellows' activities:

> Despite the widely held notion that writing is a solitary act, therefore writers are "lone wolves" who oppose efforts to form a community of shared interest and concern, I continue to tell myself that this needn't be so. I don't think any of us are so overburdened with work that we couldn't take time to stop in the office once a week to check our mailboxes (some even forget to fill out their time

sheets) and to also make it a point to attend *every* performance in the Poetry in Public Places [series], whether or not we are scheduled to read. If we don't care about our own programs, how can we expect anyone else to care enough to hear our words?

[Regarding writing workshops:] I felt that the atmosphere of shared interest in talking about writing would be spoiled if those attending felt they "had" to be there or their wrists would be slapped. Now I find that as strongly as I suggested (even calling attendance *imperative* at one point) that we all attend the PPP performances, only those people directly involved were seen at the Adler Planetarium last Sunday. So consider this official word that I will no longer trust people to attend events just because I assume they'll want to be there. From now on it will be *required* for all writers to be at the PPP readings . . . and any future writers meetings.[9] [See fig. 17]

This lack of camaraderie and mutual support contrasts sharply with reminiscences of many participants in the comparable WPA arts projects. In fact, in a survey done of surviving artists of that period, seventy-five percent affirmed the centrality of a sense of community to their experiences.[10] Curiously, these same artists attested to the noncompetitive milieu of *their* work settings but confirmed as well the excitement and mutual support endemic to their work groups.

A possible explanation for these differences can be suggested. It has been well-established that the 1930s was an ideological decade. Many artists were swept along by the radical rhetoric of the time, but their "rebellion" ironically lead to a clearer role within society. By ostensibly challenging the system, they were drawn into it even more. In the 1920s artists had been quite alienated; it was, after all, the time when "the business of America was business." Circumstances in the 1930s allowed artists to "come in," however, and to play an active role in society, largely through involvement in such groups as the Communist-sponsored John Reed Clubs.[11]

The Party offered social as well as political participation[12] and it brought artists out of the isolation of their own work and into direct contact with others of their kind. Malcolm Cowley reminisced in the following way in a 1966 symposium: "There were certain enormous ideas working through the 1930s, and one was the idea of comradeship, that you were no longer alone, isolated, helpless, but if you took the side of the working class you were one of a larger body of people marching toward something."[13]

In the WPA era, then, the role of the artist was defined in rather broad terms. The WPA artists experienced the exhilarating sense of the expansion of opportunities and the growing recognition of their own importance, despite the worst of economic conditions. CETA artists, on the other hand, were generally aware of the temporary nature of their present solution to occupational insecurity, and could look no further than the end of their appointments and a return to largely erratic, marginal employment. Their role was narrowly defined within the service mandate of bureaucratic organizations and was not supplemented by a competing ideological influence. Collective definitions were rare for them; instead, individual explanations and responses prevailed. Because CETA artists for the most part failed to believe that the program could continue for any period of time, the strategy of choice was to personally maximize available benefits.

Individual versus Collective Definitions of the Situation

This form of government support is a sometime thing. The government giveth, and the government taketh away. And right now, the government is taking away.[14]

As noted, proposed and actual cuts were a continual fact of life for CETA programs and their participants. Rather than examine the complex interplay of economic and political factors which inaugurated such moves, the responses formulated in the attempts to either protest or offer alternative courses of action will be featured here.

One of the major types of responses to cuts in CETA or to the difficulties encountered in incorporating artists into the CETA structure took the form of proposing more permanent programs that could possibly eliminate basic problems and uncertainties. For example, a New York City congressman supported a bill proposing a permanent jobs program specifically geared to the needs of artists which would be administered by the National Endowment for the Arts. The primary rationale for the bill was to subsidize the private sector's employment of artists rather than create public service jobs as CETA had largely done.[15]

Similar proposals were initiated within the arts community itself. Following the 1979 CETA-arts conference in Chicago, which was sponsored by the Department of Labor, a coalition of representatives of various arts organizations sent a letter to the secretary

of labor expressing "outrage" that the "arts industry" largely had been left out of private sector programming in the new CETA title (then seen as the hope for the future). The letter registered the following demands: (1) "that the arts receive a share of public service employment funds proportionate to the share of unemployment and underemployment composed of artists"; (2) the establishment of a national resource center to assist arts organizations in utilizing federal funds of various kinds; and (3) the establishment of a separate CETA title for artists which would recognize and adapt to their special problems.[16] What was central to both proposals was the desire to avoid problems by proffering alternative programs. While the language of the latter included the term "demand," these were essentially appeals for relief and greater consideration. And further, in both instances action was proposed *for* rank-and-file artists rather than *by* them.[17]

However, some attempts were made to mobilize the support of the "average" artist. In June 1979, for example, a memo was distributed to AIR participants urging them to write their state representatives to advocate increased appropriations for the state arts council. Somewhat similarly, an interdisciplinary group of arts organizations distributed information to AIR artists urging they "register for the arts." They pressed artists to register to vote locally, for "the only way we can shape our future in the city is to speak out and vote!!!"[18] According to their arguments, "money for the arts, jobs for artists, improved zoning and licensing ordinances, artists' representation for the arts councils are just a few of the issues facing us in 1980!"[19] They provided no explanation, however, for how artists could affect the outcome of these issues in their own favor, nor was there an indication if consensus existed as to what their needs and interests were. More important, perhaps, there is little indication that AIR participants took either of these appeals seriously or responded as was requested.

Also distinctive to both of these proposals was that they expressed faith in change through legislative action. Yet more direct action was undertaken in response to critical developments. For example, when 5,200 CETA workers were dismissed in Chicago in September 1979, various groups combined to pressure Congress to extend CETA eligibility requirements. In addition, they filed a class action suit to prevent such dismissals and staged a public demonstration.[20] While AIR participants were personally affected by the rulings which dictated these dismissals (the 18-month service lim-

itation), they again failed to support collective action in their own behalf.

Interestingly, there were some organized protests by CETA artists in New York City. In November 1978 they demonstrated at city hall to protest CETA cutbacks; likewise in May 1979 there was picketing at the local Department of Labor office.[21] Further, a New York CETA artist initiated an attempt to organize a national union of CETA-employed artists, although it never garnered much support. One observer of the contemporary art scene described the resistance to such a movement in a way strikingly similar to the early debates over unionization of the arts. "The AFL-CIO is spoken of in hushed terms by arts activists, almost as though any taint of unionism would be alienating. Too many artists still think of labor as a gangster in a double-breasted suit, an intruder into the very private process of creating art."[22] Active wrestling with these issues did not surface among AIR participants; although the New York union organizer contacted AIR, no one in the program responded to her appeal for mutual support.

CETA arts projects existed in a period of relative political quiescence. Prior to this time artists had collectively mobilized to express anti-Vietnam war sentiment. With diminution of that effort, artists generally returned to more individualistic pursuits, mobilizing in a "community" sense only briefly over local issues regarding such things as working and living conditions.[23] Just as the CETA-arts alliance was coming to an end, however, artists again linked artistic concerns with wider social issues and actively formulated responses to contemporary events. For example, in September 1981, artists rallied in Washington in alliance with a broad coalition of interest groups to protest the withdrawal of financial support by the Reagan administration from a variety of social programs. In October 1981, writers from the entire country met in New York City to discuss issues relevant to their work as artists, as well as social issues such as the threat of war and the fear of a rise in political oppression and censorship.[24] And in November 1981 a Peace Museum opened in Chicago as a gallery/resource center/workshop "dedicated to raising the public consciousness about the issues involved in building peace."[25] Quite suddenly, it was noted, "oppositional culture is rising like mushrooms after a hard rain."[26]

CETA projects were largely unaffected by such political struggles. In contrast, picketing, sit-ins, and sometimes violent con-

frontations marked the conduct of WPA artists—especially in major urban areas such as Chicago and New York—as they adopted a critical, aggressive stance against cutbacks and the tightening of regulations.[27]

The artists of the 1930s utilized a universe of discourse which offered both intelligible definitions of their contemporary situation and suggested means for effecting change. CETA artists, on the other hand, were not grounded by a larger social movement such as Communism or one of its institutional manifestations like the John Reed Clubs. In the CETA era no ideological system had captured the attention of large numbers of artists, and the predominant climate of opinion emphasized individual growth, self-help, and self-awareness rather than collective action. A pervasive cynicism also helped to preclude active intervention in social concerns and profoundly affected the way artists interpreted their situation and chose to react to it.

AIR participants tended to adopt a conservative approach to their circumstances. Since they recognized that their CETA employment offered distinctly limited rewards, they did not risk jeopardizing those benefits they could secure. Rather, they confined themselves to a significantly limited role, as reflected in the responses to two additional statements on the end-of-the-year surveys (see table 8.2). The artists were asked to respond to the following: "The role of the artist in society should be to produce work reflecting major social and political issues," and "The role of

Table 8.2 *The Artists' Perceptions of Their Roles, End-of-the-year Surveys, 1979 amd 1980*

		1979		1980	
Questionnaire Statement		Mean	Rank Order	Mean	Rank Order
M.	The role of the artist in society should be to produce work reflecting and articulating major social and political issues.	3.12	13	3.13	12
C.	The role of the artist in society should be to communicate his/her own personal ideas and feelings.	3.89	3	3.72	6

Table 8.3 *The Role of the Artist: Alternative Views*

		1979	1980	New artists, 1980
	Questionnaire Statement	*Mean**	*Mean**	*Mean**
M.	The role of the artist in society should be to produce work reflecting and articulating major social and political issues.	3.12	3.13	3.20
C.	The role of the artist in society should be to communicate his/her own personal ideas and feelings.	3.89	3.72	3.94

*Differences between the means on these questions are statistically significant at .05 level.

the artist in society should be to communicate his/her own personal ideas and feelings." The respondents clearly favored the personal interpretation of the artist's role over the broader rendering of the artist's role in social terms. The reluctance of AIR participants to collectively define problems and their failure to undertake group action was the result of an interaction between specific conditions within the program and larger cultural currents. Each of these factors prompted this group of artists to focus on their own individual concerns, to the abridgment of a wider focus.

The general existence of this contemporary definition of the role of the artist was further verified when entering artists were presented the same statements in a questionnaire administered in October 1979 (their responses are summarized in table 8.3). Here the same pattern was revealed: the mean score for the statement which cast the role of the artist as expressing personal ideas and feelings was significantly higher than the mean for the more social/political role. And these sentiments were recorded elsewhere as well, for example, in the thematic aspects of some of the works produced under AIR's auspices.

Individual versus Social Themes in Public Service Art

Emma: . . . it's time you grew up and accepted things for what they are.[28]

Lee: . . . I don't like remembering the past.
Bud: (Quietly) Why not? We don't have a future.[29]

The resignation and cynicism that surfaced in these quotes from a play written and produced within the AIR program represent how some of the program participants must have felt in regard to their own past, present, and future situations. They also serve to introduce a final examination of ways in which AIR employment could be used for individual ends. First, some artists successfully adapted the program to their own use, rather than exclusively bending to the process of training which AIR proposed. Whereas the conditions of uncertainty affecting AIR caused some artists to be disheartened, they sometimes spurred others to use the program either as a means to produce their own long-anticipated projects or to develop previously untested skills. Such productions exhibited a degree of independence from the program's standard workshop and performance format. And second, the thematic character of certain AIR-sponsored productions can be considered with attention to the individual as opposed to social motifs within these works.

Each year black AIR participants convinced program administrators to sponsor plays and revues they had previously conceived but for which they had not had the necessary personnel and financial resources to produce on their own.[30] Two things were notable about these events. Each one was a nostalgic look at the black experience that attempted to recapture the "feel" of a distinctive period of time. While this in itself was not noteworthy (for these productions were often offered in conjunction with Black History Month), the specific individuals and time periods they focused on were somewhat surprising. Also, the success of black AIR participants in finally bringing their projects to fruition demonstrated the advantageous adaptation of the program to their needs, utilizing AIR as a short-term, available resource. This was somewhat contradictory to the program's avowed purpose of training artists in a particular way to enhance their long-term career possibilities. Yet for this group of artists, the most self-evident way to further their careers was to turn their previously untested concepts into real events.

Two such events were representative of the kinds of projects with minority themes that AIR sponsored. *The World of Paul Laurence Dunbar* featured Dunbar's poetry and biography, recited with musical accompaniment. Most significant about this choice of subject matter was that Dunbar had received his greatest recognition at the turn of the century, and his dialect poems which focused on life in the old South were considered nostalgic and romantic even

then. "An Easy Goin' Feller," one of the works reviewed in this production, contained the following illustrative passage:

> I allus try
> To do my dooty right straight up,
> An' earn what fills my plate an' cup.
> An' ez fur boss, I'll be my own,
> I like to jest be let alone,
> To plough my strip an' tend my bees.[31]

This imagery is interestingly contradictory. On the one hand, the speaker expresses a wish to work independently and to be "his own boss," an idea contrary to the typical condition of blacks at the time to which the poem refers. On the other, this individual's compliance with the necessity to do his "dooty" is also pictured. While contemporary lessons might be drawn from these ideas, considerable distance is established both by the removal in time and the archaic nature of the language.

Another special event with a black-related theme was entitled *Runnin' With the 8 Ball,* consisting of flashbacks to a South-side Chicago nightclub in the 1930s and 1940s and picturing famous entertainers and community leaders. The exhortation to use education as a basis for individual achievement ran throughout the play, and the young protagonist was told to build upon the examples of others who had succeeded:

> You have a lot to be proud of, a lot to relate to in you [*sic*] city, and enough resources right here to use to get where you want in life.
> Just remember one thing, something an old man told me, "each of your impossible dreams is waiting just for you, as long as you continue, continue to pursue!"[32]

Again, the focus was a nostalgic search in the past; markedly absent in these presentations was anything from the experiences of the past thirty to forty years.[33] Correspondingly, there was little consideration of structured inequities, the typical adjustments to these conditions, or contemporary attempts to redress these imbalances. Consistently offered, however, were portrayals of individual adaptations and resourcefulness.

This emphasis upon individual triumph was the rationale for the development of another special project under AIR sponsorship. *Three Horns with Ease,* composed by a black writer in the program,

consisted of a group of poems set to music which focused on artists who had overcome disabling handicaps in order to create. The title referred to a blind and paralyzed musician who could play three horns at one time; additional sections of the piece related the stories of accident victims, the deaf, and those stricken with diseases such as multiple sclerosis. Central to each of these stories was the exceptional nature of an individual's struggle. What such a focus concurrently highlighted and ignored became clear in the following passage about a blind singer/songwriter:

> . . . perhaps it may have been
> a blessing in disguise for him
> Not to see the painful things
> that devastation and poverty brings
> And to see instead a spring of notes!
> that might to some bring gleeful hope—
> of happiness to come.[34]

Here was an interesting transformation—what would commonly be judged to be debilitating was seen to be ennobling instead and was embraced as the source of artistic vision. In harmony with this view was the belief that individual adversity is the wellspring and the preferred subject of creative activity, not social problems and the *social patterning* of pain.

This triumph of individual over social themes was most apparent in three plays produced during the summer of the 1978–79 program year. Because they were large, public presentations for audiences more heterogeneous than those viewing AIR workshops and residencies, they were less circumscribed as to subject matter as well as structure; that is, they could be more like plays presented by other groups to similarly diverse audiences. These scripts were "commissioned" by soliciting ideas from AIR participants, and then AIR administrators selected those three proposals which demonstrated high quality while also being compatible with the production resources the program had to offer. In these instances artists were allowed to work with a greater degree of freedom than was usual, and what they produced was likely to be closer to their own interests than AIR's dictates.

An initial consideration of these plays would seem to reveal no common ground among them. One dramatized the fight of a black professional woman to prevent the extradition and probable lynching of a black tenant farmer accused of murdering a white

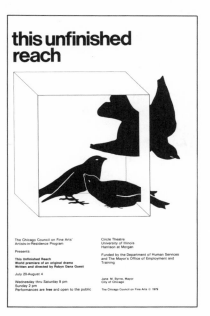

Figures 18, 19, 20. AIR routinely produced graphics to publicize its own activities. These examples from a series of plays written, produced, and performed by AIR participants during the summer of 1979 demonstrate the skills of this artistic segment. Graphic designs by Ann Brumbach.

man at the turn of the century; the second examined the intra-familial struggles encountered by a young woman who returned to her small-town home and alcoholic relatives; and finally, a fantasy adventure play similar to *Alice in Wonderland* presented the alternating fortunes and misadventures of a snail[35] (figs. 18, 19, 20). CCFA's director described the summer's productions in the following way: "Through public supported theatre we can reach new audiences in various parts of the city and address social issues through art."[36] These plays, however, markedly de-emphasized social issues and focused instead either on individual efforts to deal with problems, introspective and interpersonal dilemmas, or subjectivity and whimsy.[37]

In AIR productions such as *Beautiful Chicago* (fig. 21), the booster-oriented campaign to clean up the city's image, there was a decided emphasis on individual responsibility.[38] Here the content of the production was dictated by programmatic concerns and obligations, but to a large extent AIR participants replicated this emphasis even in works which were not so completely controlled by the program's administrators or circumscribed by the organizational structure.

Once again the most striking contrast this evidence offers is with the corresponding record of the WPA arts projects. The artistic products from this era have most often been characterized by their focus on collective concerns. The appeal of an art dealing with social or "proletarian" issues during the WPA period strongly collided with an earlier emphasis on subjective, introspective themes on the part of many artists. The most representative of the Federal Theatre Project plays, for example, dealt with contemporary social problems, some of which were being addressed by various New Deal schemes. One can find, then, plays concerned with the widespread lack of safe, affordable housing; monopolies working against the public interest; and the rise of fascism.[39] The Federal [Visual] Art Project employees similarly emphasized social themes, relying to a great extent upon what has come to be known stylistically as "social realism." When they heeded director Holger Cahill's call to produce an "art for the millions"—that is, the creation of works reflecting the concerns of, and accessible to, a majority of the population—artists highlighted some of the critical problems of their time.[40] Many of the artistic debates among the WPA artists were not centered upon *if* social and political themes should predominate in their works, but rather how extreme their

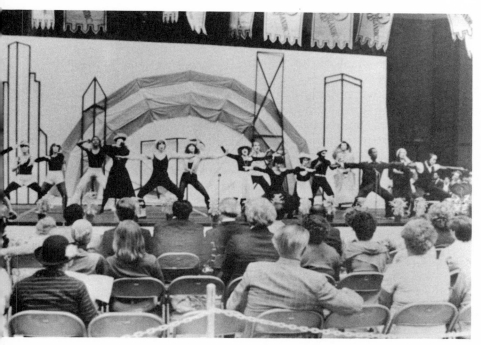

Figure 21. Artists became public boosters as they touted the city in this produc-
tion of *Beautiful Chicago.* Note the profusion of banners across the top of the
stage which clearly identifies this as a mayoral-sponsored event. Courtesy of the
Chicago Public Library, Special Collections Division.

espousal of various shades of active political involvement would be
in directing their personal as well as professional conduct.

While AIR's theatre productions provided a comparison to the
work of their predecessors in the 1930s, AIR artists in other disci-
plines also favored an individualistic, subjective focus. The visual
arts component is a good case in point. Most of the works con-
tained within the Art Bank collection represented the artists' typ-
ical stylistic modes; little direct control was exercised over them by
the artistic director or other administrators. Therefore, the prod-
ucts were more reflective of the artists' general interests than of AIR
directives. Almost without exception these works were either ab-
stract experiments with color, line, and spatial composition or
super-realistic portrayals of objects or individuals. A remarkable
statement by AIR's environmental artist, who was noted to be one

of the most concerned with the social nature and impact of her work, demonstrates the introspective, individualized concerns of much of AIR's art production: "I make the stuff for me . . . It's a really personal interaction with the space. The people? It's there for them to see."[41]

The two preceding chapters examined the ways in which basic problems confronting AIR as an organization were similarly experienced by its participants. These artists correspondingly made adjustments to the program which were more similar than dissimilar to the ways they had previously learned to accommodate to situations which offered opportunities and financial renumeration that were severely limited in time. While AIR proposed to recognize its artists in terms of all their needs, it forced many of them to continue to split their work from their labor. Although AIR proposed to alter the learning and opportunity structures available for this occupational group, it was only able to provide temporary solutions to persistent market problems. In a fundamental way, when AIR participants joined the program they transferred their long-standing experiences to a new locale and gained some additional problems by working within this particular bureaucratic structure. Not too surprisingly, then, they gave a moderate amount of support to the statement, "The future emphasis of publicly funded government arts programs should be grants to artists rather than public service employment." This statement was ranked ninth and eighth, respectively, out of seventeen items in the end-of-the-year surveys. Those individuals who were just entering the program, who had high expectations without having yet experienced any of the program-related difficulties, gave this statement less support in their 1979 survey. Many of the AIR participants did not wish to repeat this experience; the similarity to their past experiences and the difficulties of handling employee status led them to prefer securing alternative means to more independently pursue their crafts in the future.

9

The Politics of Public Art: Case Studies in Organizational Controversy

"Public art" is a screen onto which larger political and organizational concerns are projected. When there is an attempt to define public art, interorganizational conflicts and political issues can emerge in a particularly vivid way. And when the cultural products in question derive from publicly funded sources, the probability of controversy is greatly enhanced. While this is not the only arena in which such public issues develop, it does provide a flashpoint for volatile concerns within a larger environment.

AIR's experiences graphically illustrate these problems. According to one of its participants, "Art is like potato salad. Share it with others and you will have a picnic; and what better place to picnic than in our parks."[1] As puerile and frivolous as such a definition might seem, it was one of the few self-conscious attempts to characterize the program. Conflicts over the scope, purpose, and meanings of public art nonetheless erupted throughout AIR's critical first year, and the resolutions which were hammered out became important components of its developmental history.

Administrators developed a rhetoric of control to try to diffuse debate over particular projects by emphasizing contribution to

Chapter 9 originally appeared in a somewhat different form as "The Politics of Public Art" in *Urban Life* 14, no. 3 (October 1985): 274–99.

the common good instead of focusing on artistic merit alone. Indeed, assessments of artistic quality in general tended to be overshadowed by the mandate to provide employment to unemployed artists.

The problems and interests of the AIR administrators frequently collided with those of AIR participants, especially during that initial year of operation, and these collisions frequently centered around definitions of public art. Yet generally what public art meant was indirectly, not directly addressed. When AIR was required to state a definition, it relied on rather tautological reasoning; public art was what its programming reflected and hence was reflected in the "record" of this programming. How crucial decisions determining this programming record had evolved was only infrequently referred to, however, and alternative definitions that had lost out in the competition for acceptance were largely forgotten. "Public art" was what AIR "did" but about which little was conclusively stated.

Figure 22. AIR self-consciously documented its own evolution through the medium of videotape. Here an artist looks somewhat awkward as she attempts to record one of the initial program meetings in Fall 1977. Photograph by Bill Randolph.

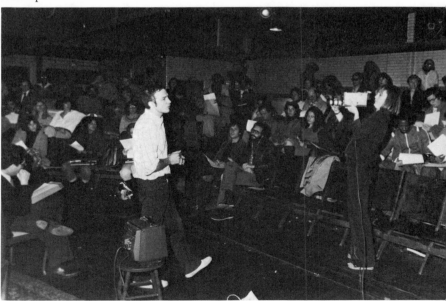

Recurrent internal debates over programming matters and over what AIR artists were to do as public art revolved around two general positions. At one extreme stood the popular notion of "public art" as artistic products developed for public display and enjoyment. While this imagery of public art retained for the creators of these products a significant measure of control over their production and display, the notion of "public service art" tended to subordinate this control to other concerns. In the public service art model, artistic performances and services were either consciously oriented toward generally underserved audiences, and/or specifically contracted to meet other agencies' needs. As the subsequent case studies will show, the public service art imagery became increasingly predominant as AIR developed, largely in response to demands from AIR's organizational environment.

As a result, public art came to mean: (1) standardized productions: (2) presentations stressing entertainment, devoid of broad social or political content; (3) an emphasis on serving largely uncritical audiences; and (4) insuring that the scheduling, production, and response to AIR activities would be highly predictable and "safe." This triumph of organizational over individual needs was continually refined and routinely experienced by the artists.

A Note on Methods

AIR possessed an unusual and rich record of its organizational development. A library of videotapes documents many of the meetings between artists and administrators in which the structure of the program was formulated. When the program was conceived, the video component was accorded an active role in mirroring back to the participants in a given situation what was happening. The tapes were to record events, certainly; however, they were also envisioned as part of an ongoing process of self-scrutiny and evaluation (fig. 22). For the most part these tapes are unedited, preserving a record of these situations without the bias of retrospective interpretations. They are, then, close to a social scientist's ideal source of data.

Controversy, Survival, and the Individual Artist

For the individual artist, a common goal was reappointment past their first year to ensure the continued benefits of AIR participation. For the organization, continued viability within its

complex and politicized environment was the central concern. *In most cases,* those artists seen as contributing to AIR's survival increased their own chances for survival.

The surest way to maximize the likelihood of reappointment was to adhere to the workshop/residency format and not cause any difficulties. Artists who took this course became cultural workers, conforming to the program's ideal of creative individuals adapting their skills to existing work situations and segregating "real work" to their own time. When such artists worked in a narrowly defined format, their efforts and products could be readily assessed by administrators as satisfactory or not. Participation in projects or special events that directly contributed to AIR's accumulation of political capital would also assure survival. Such "boosterism," an activity vehemently rejected by some artists but enthusiastically embraced by others, involved projects such as the following: writing informative brochures about the multitudinous services provided by the city ("Know Your City Hall"); designing posters and brochures about city public service campaigns ("Rats: Public Enemy" and "Hot Hints for a Cool Summer," the latter arguing that fire hydrants not be turned on); and promoting the city's local appearance and national image ("Beautiful Chicago").

Under these circumstances, any individual artist, artistic discipline or program unit which seemed "controversial"—really or potentially—created uncertainty for the program and risked nonrenewal. Yet in some instances the pursuit of creative or controversial work could provide a viable route to success within AIR. When an artist could rally external support to the program, even if producing controversial work, he or she could receive internal favor. In fact, however, few artists combined a high degree of creativity with the commensurate understanding of bureaucratic structures needed to pull off this strategy.

These dynamics can be explored in detail by examining the individual artist who most successfully combined artistic creativity and political and bureaucratic astuteness in carrying out controversial projects. An "environmental sculptor" hired as part of the visual arts section, this artist described her works as large-scale land drawings, using biodegradable materials such as sawdust, tree branches, pigments, and snow to create large geometric patterns throughout the city. In most cases she created these works in visually accessible public places such as along expressways, in open spaces visible to passengers in elevated train cars, and in city parks. Through these often temporary projects she sought to bring art

Figures 23, 24. "Snowfence Spiral" was an environmental sculpture which used lengths of wooden snowfence to create a design. It could be appreciated from a distance, but invited active engagement as well. Photographs by Janet Sullivan.

immediately to the masses of people rather than restricting it to museums to be viewed by only a few (figs. 23 and 24).

While not traditional in intention, composition or execution, her creations had to meet the approval of the sponsoring city parks department. As a result, she became involved in an extended process of negotiation to convince officials that what she was doing would be understood and deemed "safe." "Safe" initially required that she persuade these officials that what she was doing would not harm park district property nor bring injury to those using it. Somewhat surprisingly, she made a successful case for her artistic approach to city officials and won support for her unconventional work.

In this and other instances, AIR developed and enforced its own notions of "safe" projects. Dependent upon other city agencies for support, project administrators insisted that within the program artists operate differently than they would outside the program's purview. In general they proscribed controversial themes that could bring adverse reactions from other agencies. As an AIR administrator cautioned another artist, "The thing of it is, it [successful functioning] probably . . . means in the first year avoiding some of the more controversial subjects. And whatever we individually feel about them. Okay?"[2] In this way AIR administrators drew a line between art produced in AIR and art in other contexts, and artists were forced to distinguish what they produced on "company time" from their own work. For example, the AIR assistant director at one point warned the environmental artist:

> . . . the piece you did last week [on her own time]. You're taking a chance. Never identify yourself as being with the [arts] council. Now, your work has a certain style, and now that the park officials know what that style is . . . if you [could] change your style when you do your urban works, or something. . . . I'm not suggesting that, what I'm saying is that *me as a person says* "just keep on working," me as a person. But it can present a real major serious problem for the council, because in effect we're sanctioning you.[3]

AIR routinely imposed limits in anticipation of potentially adverse responses from city officials. Caution and calculation restricted works to a narrow range. Indeed, the artist in question came to feel she could negotiate more effectively directly with her sponsors as each party gradually became more familiar with the others' styles and preferences:

After I've worked a little with the park [officials] they['ll] know I'm fairly safe, because I am . . . I mean, I'm certainly not going to go off on a handle and do something weird, and we've already discussed the possible stipulations that there might be and I'm very sure I'm not going to go against that; as much as I'd like to, I won't.[4]

While this artist was willing to comply with certain conditions, she resisted control over her work based on considerations she judged extrinsic to, and lacking understanding of, her artistic intentions. Witness, then, this exchange between the artist and the assistant director after she had been informed not all of her proposals would be accepted by the park department:

Artist: Not only that, but they'll be putting this governing control over aesthetics. They're not artists, they're not curators. There are some things which are infinitely more important than others, but—because they're fast, or easy, or universal—are good ideas to do. But others that are real important they could just veto.

Assistant Director: [Mentions one of her proposed designs.] They're not going to understand the symbolism, and you know they might say, "We don't want any pagan things in our parks."

Artist: [Mimicking a possible response.] "A star? A star? What are you, a Communist?" And that's about the most absurd thing there could be.[5]

Artists came to realize that success in AIR demanded that they adjust their work habits in other ways to bureaucratic requirements. Many had to learn, for example, to present an entire project prior to actually creating it, thereby anticipating the nature of a piece before working through it. Artists accepted such requirements with varying degrees of resistance; some stipulations were viewed as cultivating desirable work skills, others as nuisances, and still others as ridiculous barriers which hindered their work. For many artists, to work on individualized projects under these conditions took away energy better channeled into their creative efforts. While they completed most such projects, although usually at least partially modified by the agency's suggestions, the cost was high. Many such individuals wanted to leave AIR after twelve months, a decision which generally coalesced with the administration's preferences. For attempts to finesse projects past wary high-

Figure 25. AIR's fortunes were closely tied to larger political currents in Chicago. The mayor pictured here enthusiastically supported AIR's efforts, but when he failed to win reelection AIR had to de-emphasize this past association and try to cultivate new political allies. Photograph by Warren Friedman, courtesy of the Chicago Public Library, Special Collections Division.

er-ups and outside agencies and to moderate some artists' sense of outrage at being held accountable in unfamiliar ways proved equally draining for AIR administrators. After the first year of the program, AIR officials contracted such individual projects at a substantially diminished rate to avoid these difficulties.

What, however, was the fate of this particular artist? Ironically, she achieved great success in the program despite the negative attention she brought AIR. For example, the *National Enquirer* cited her in an article on the misuse of government monies. She likewise attracted the notice of the more conventional press: "Artist's snow job gets chilly reviews" declared the headline of a metropolitan newspaper feature on one of her snow paintings.[6] Yet she left AIR after the maximum participation time of twenty-four months with the highest recommendation. If AIR tolerated only those artists working within certain limits, how can this success be explained?

A key to understanding this situation lies in a memorable AIR event. Late on a frigid afternoon in January 1979, this artist re-

cruited members of the program to trudge through the outline of a pattern designed in the snow while the mayor's wife lit candles around its perimeter for the benefit of local TV crews. This art event, entitled "Snow-Works for a Beautiful Chicago," sought to get political mileage out of the disastrous "Blizzard of 1979."[7] Nor was this the only time the mayor or his wife attended AIR-sponsored events, especially those convened by this artist. AIR regularly sent the mayor's wife a schedule of upcoming activities and often requested the couple's attendance at specific events (fig. 25). Thus city government support for the program was carefully cultivated and came to revolve around the efforts of this "favorite."[8] In this way her ability to sustain the support of select allies neutralized the problems she caused for the AIR administration. Unique and troublesome participants and their art could be accommodated *if* they contributed to the organization's staying power.

In other instances when artists promoted projects which were not easily explained in traditional terms, or resisted incursions into what they defined as their artistic territory, AIR officials reacted only negatively. If they didn't make a positive contribution to the continued support of the program as a whole, such artists were seldom tolerated and supported.

Latent and Manifest Cultures

While the experiences of AIR's environmental artist were rather unique, a variety of other artists in a number of different fields routinely faced difficulties in the program. The question arises here as to whether the contentiousness of these artists was individually or socially based. AIR administrators tended to opt for the individual explanation: troubled artists caused problems. These problems, however, were most definitely socially structured as well. Characteristics of the various artistic disciplines, especially those related to their social organization and to typical solutions available to confront difficulties, could either facilitate or hinder artists' adjustment to and survival in this particular organizational environment.

Becker and Geer's concepts of latent and manifest culture are useful here. As they developed these ideas, latent culture "has its origin and social support in a group other than the one in which the members are now participating."[9] Manifest culture, in contrast, is central to the setting into which individuals have been drawn currently and addresses the critical problems therein.[10] As

they explain further, these elements can either function in a sup-
portive relationship or act at cross-purposes.[11]

For present purposes it is possible to identify three elements
of latent culture which could affect adaptation to the manifest
culture that came to prevail in AIR. First, various artistic fields place
differential emphasis upon working in ensemble, which demands a
high degree of coordination in comparison to more strictly indi-
vidual creation. Second, the social organization of the arts varies
across disciplines in the development of professional identification
with one's field. With strong professional identification, adherence
to certain standards is expected; self-imposed controls ("acting like
a professional") can become as important as more formal sanction-
ing processes. And finally, fields of art have different sets of con-
ventions, that is, standard recognized styles of execution. The
degree to which these have been formalized and diffused estab-
lishes the range within which many artists will confine their ac-
tivities. Some fields place greater reliance upon well-established
modes of operation, while others support the constant exploration
of new forms.[12]

As an organization AIR promoted and rewarded artists who
worked in ensemble, showed strong professional identification,
and worked in more conventional modes. In those instances where
the structure of artistic fields commonly emphasizes these same
features, success in the program was appreciably increased.

For example, theatre personnel typically operate in environ-
ments in which their work would be structured in a manner sim-
ilar to AIR's expectations. The corollaries of ensemble work—
meeting production and rehearsal schedules, working with book-
ing agents and public relations personnel, and coordinating ac-
tivities with auxiliary support systems comprised of costumers and
musicians—were all familiar to theatre people. Further, actors
populate a field which is highly organized along professional lines.
Adherence to notions of professional conduct, both formally and
informally enforced, is considered important. Many AIR actors ei-
ther belonged to Actors Equity (AE), the Screen Actors Guild
(SAG), and the American Federation of Television and Radio Art-
ists (AFTRA), or aspired to such membership. Their AIR activities
thereby could be considered as professional employment, or pre-
liminary to such a status. These artists sought to maintain a mini-
mal level of performance, even if they were presenting preselected
material to rather atypical audiences.[13] Finally, actors practice a
craft which condones experimentation, but which also draws from

an established body of expressive techniques and diverse genres of potential production material. The combinations and permutations of technique and genre allow for extensive innovation before more radical innovation is necessary or possible. Therefore, even the unfamiliar can be relatively familiar within this field, change can be routinized, and artistic expression confined within certain limits. Accordingly, the AIR production of Shakespeare's *Comedy of Errors* transposed to a 1920s setting with a slapstick interpretation allowed its participants to be creative while at the same time presenting an understandable product (fig. 26).

The latent culture of the theatre personnel, then, was largely coextensive with major aspects of AIR's manifest culture. A similar association prevailed for the music component and, to a somewhat lesser extent, the dance personnel.[14] It was no accident that program administrators frequently remarked that *as a rule* it was easier to deal with artists from these disciplines. Their repertoire of prior experiences made AIR demands more understandable; likewise, their ability to interpret and execute what was expected of them made them more reliable employees.

In contrast, AIR's video artists brought a latent culture to the organization that conflicted at a number of key points with the agency's manifest culture. The video unit, composed of six artists during the first program year, was intended to be the "nerve center" of the entire operation. However, a number of this unit's major projects became focal points for controversy. Video artists do not characteristically work in ensemble. For while teamwork can be central to video productions, artists using this medium do not rely routinely or heavily upon the services of auxiliary personnel. Further, the newness of this technology and its recent adaptation to artistic purposes has precluded the development of conventions which are widely recognized. And even more problematic is the confusion that can arise from its outward similarity to other highly routinized media such as television and film. Adherence to conventions and expectations associated with television in particular would necessarily restrict productions to rather standardized, informational units. The distinctively creative work in video, on the other hand, is not widely understood or accepted.

The video artists were, if you will, positioned along a fault line; given the pressures of programmatic shifts a fissure developed and these individuals became the epicenter of the disturbance. Some artistic disciplines (especially the performing arts) were far removed from such difficulties; others were affected to a greater or

Figure 26. This reinterpretation of the familiar *Comedy of Errors* allowed theatre personnel to be innovative without jeopardizing the likelihood that their work could be comprehended by heterogeneous audiences. Photograph by Phylane Norman.

lesser extent, due to their similarity to one or another of these polar types.[15] Yet even within the video component not all were casualties. Those who sought the security of the service mandate were saved, while those who most adamantly clung to their artistic principles and who were unwilling to adapt to situational conditions perished. The following sections will discuss the specific circumstances which fomented two major disruptions centrally involving the video unit. First, they became the center of controversy with their refusal to make "training tapes" for the city's Department of Building. Second, the video unit became embroiled

in a series of hotly debated projects involving the Chicago Housing Authority (CHA).

Art versus Public Relations in Video Work

The Department of Building requested that AIR make videotapes for use as part of an orientation program to inform new employees about the functions of the agency and to familiarize current ones with the rules and regulations of a new personnel system. The video unit artists balked at executing the project. The conflict centered on how a new artistic medium could be utilized. Support for an innovative, experimental approach would have provided a challenge for the artists but would not likely satisfy AIR's clients. The decision to emphasize standard public relations techniques and procedures seemed prudent to administrators who sought to strengthen the survival potential of their organization.

In opposition, the artists argued that such tapes would have a very limited audience and would not represent a public service. Further, they maintained that face-to-face training, where the instructor could be stopped and questioned for clarification, would be more effective than a videotaped session. And perhaps most important, the artists contended that the project would make them mere "boosters" of the agency's standpoint, without opportunity to introduce any critical comment.

Before a resolution could be reached in what became a protracted controversy, an investigation undertaken by one of the city's major newspapers in conjunction with a consumer advocacy group revealed that the Department of Building had accepted bribes and overlooked building code violations. This "Mirage Tavern" incident confirmed the worst fears of the video artists. The very agency they were supposed to promote had been publicly defamed. Even though this project was not consummated, it provoked a series of heated confrontations between artists and administrators over the role and meaning of public service art.

In discussions of this project AIR artists framed the key question of whether they should be mere employees carrying out the demands of supporting city agencies or active participants with a voice in deciding what their projects would entail. Seeing themselves forced into the former role, the video artists advocated the latter role as more appropriate. In response to an administrator's emphasis on their employee status, one video artist observed:

> This is called the "Artists-in-Residence program" so I think that
> implies we have skills and that we're artists and passing them along,
> so our opinions and our skills should be respected . . . I reserve the
> right to make a good tape, and I know what a good tape is. I'm not
> willing to do something that compromises me to the point where
> I'm no longer an artist.[16]

Indeed, one of the group went so far as to portray their role as that
of "lackeys."

Seriously distrusting their sponsors, the members of this unit
also objected to the uses to which their products could be put.
Comparing the proposed training tapes to the initially stated goals
of the program, which included exposing inner-city residents to
the arts, providing meaningful employment for artists, and en-
hancing the city's image as a supporter of the arts, they concluded
that this project could not be considered public art even in the
broadest sense. And they adamantly defended their position:

> **First Artist:** . . . the people who have set this program up have
> underestimated what city departments are capable of
> understanding and capable of undertaking. They think
> they can undertake only the worst kind of PR shit, and I
> don't think that's the case. I think if your ideas are
> powerful enough, someone's going to under-
> stand . . . the Building Department has no interest in
> doing any of the things outlined here [in the stated
> objectives of the program], so they're inappropriate.
> **Second Artist:** You have the artists forking over their materials
> and their lives and getting the job and "Oh, boy, Art-
> ist-in-Residence," and so then it turns out you gotta go
> and make weird, do weird, questionable things, close
> to morally reprehensible things for city agencies.[17]

How broadly or narrowly to interpret the mandate of public
service art provided the bottom line in this dispute. The artists
wanted to produce art as well as offer a public service, compromis-
ing neither element. Program administrators, in contrast, accorded
highest priority to the successful completion of agency-ordered
products which would contribute to the recognition of AIR as a
dependable, responsible purveyor of services, independently of the
artistic and ethical acceptability of particular projects. The two
sides became almost irreconcilably polarized on this issue:

Artist: A PR tape is not art. There's no way to make the
words stretch to mean that a PR tape that lies about the
functions of a department is art.
AIR administrator: Bullshit. If it's giving an artist a job and
providing him with $8,000 a year so he can live,[18]
that's city support for the arts.[19]

The video unit provoked an additional crisis in its efforts to
develop a new medium. These artists took seriously the original
proposition that video should be utilized as an active, documentary
process. Given video's immediacy and investigative potential, they
also advocated its capacity for uncovering official neglect and mal-
feasance. As a recent arrival on the artistic scene, video attracted
practitioners who sought to explore the limits of its potential. In
particular they wanted to conduct projects that would differentiate
video's potential and products from those of other informational
media. Devotees of video technology therefore tried to combine
the diverse roles of *avant-garde* artist and investigative reporter in
their definition of what the medium might accomplish. However,
video could also be used merely to record facts, and AIR admin-
istrators promoted video projects of this character. These projects
were practical and limited, requiring artists to draw upon little of
their technical knowledge and practically none of their artistic skill.
They therefore viewed their assignments as requests to mass pro-
duce standardized units in an easily understandable and useful
form. These video artists experienced extreme frustration, es-
pecially when they compared these projects they were supposed to
do with what they might be doing.

Furthermore, the investigative bent of many of the video art-
ists brought them into immediate and direct conflict with the pro-
gram and *its* survival requirements. These conflicts, as well as the
distinctive concerns with video as an artistic form, are readily appar-
ent in the following discussion of a proposed set of taped interviews
with important individuals who had helped to shape Chicago:

Video Artist: I think specific questions are best left for print at
this point for these old guys. I don't think there's much
left to be found out. Nor do I care especially—I don't
think that's for tape. My point is that you want to
hang around with them, say, for a day, and you want
to sit down with them and ask them some very general
questions: "Do you love America?" "Why have you

been in politics?" "What do you think of the fact that
your best friend is in jail?"[20] I mean, I don't think
that's a very specific question, but you can't ignore
reality, either. But those are the kind of questions
which will evoke a sense of personality, not a recitation
of facts.[21]

This chasm between the interests of the video artists and
those of the program led to continual confrontation and discontent. In an unprecedented move never to be repeated during AIR's
history, four of the artists were eventually fired as a group. Their
letters of dismissal cited the lack of "sufficient work" to warrant
the continuation of the positions. This group, however, never
lacked ideas or project proposals. It did lack projects deemed acceptable to the AIR administration: limited in scope, not of an adversarial political nature, and therefore safe. It is reasonable to
conclude that problematic artists were not just troubled individuals, nor innocent (nor inevitable) victims of circumstance.
Rather, an interaction of individually and socially determined factors contributed to the relative degree of success artists experienced
within AIR.

Drama as Process: Confronting Community Needs and Problems

AIR gave special priority to the development of programs
within Chicago Housing Authority (CHA) housing projects, which
were located in some of the most economically deprived areas of
the city. The constant sense of turmoil in the unit from the artists'
questioning of the scope and purpose of public art demanded that
AIR commit considerable administrative attention to this program.
The CHA unit severely taxed limited administrative resources
which AIR could have devoted to problems in its external environment. The troublesome nature of these activities carried significant
weight when AIR evaluated what it would support within its artistic boundaries.

These programs incorporated nearly one-fifth of all AIR artists
and had a dual emphasis. First, AIR offered arts instruction to community residents in a number of different artistic fields. As described in a year-end assessment, "The training was geared toward
an involvement in the creative process which would enhance the
participants' self image and increase their effectiveness in daily activities, i.e., school, job, community activities . . ." Second, AIR

provided in-staff training for the personnel at five community center sites to increase the creative and leadership skills of community-based individuals.

CHA activities were routinely videotaped and then discussed at weekly meetings of the entire unit. At a number of these meetings controversies arose around the thematic concerns of taped dramatic exercises written and performed by the local participants. The issue centered on AIR's role and purpose in these communities—should it bring entertainment to these constituents, or should it use art to promote insight and to educate in regard to community problems?

Two videotaped skits provoked particularly heated discussion. In a skit written and performed by children at one of the centers, a wife accused her husband of infidelity, claiming he had been with the woman next door instead of at work. When the man insisted he'd been working, his wife exclaimed, "No man works with his clothes off."[22] The argument between the couple climaxed when she slapped him in the face. In actuality it was a "theatrical slap," with the young actress feigning the action while others provided the appropriate sound effect by clapping their hands together.

The second controversial tape recorded a skit written and performed by the staff at one of the CHA sites. Characters were drawn from real individuals involved with drugs and criminal activity who had been observed in the neighborhood. At a particularly dramatic moment, one character used a knife to shoot heroin into his arm. In later discussion the actor made it clear that the choice of a knife was symbolic; he stated he was "just showing that you're killing yourself . . . instead of using a needle, you put the knife there, just killing yourself."[23]

Some artists felt that it was critically important to allow CHA residents and employees to confront local problems in this way. According to one AIR participant, to ignore what was endemic to the community would not eradicate it; he stated, "Just because you don't show it doesn't mean it's not happening."[24] Other artists, however, felt that "negative" themes such as family discord and drug abuse should not be emphasized. A supporter of this position argued "As artists our role might be to turn them away from that . . . by offering them alternatives of beauty and harmony . . . that are outside this stuff and away from this stuff . . . to be able to walk even in the midst of this with some kind of grace."[25] These artists stressed that "intact" nuclear families

should be represented; otherwise, they objected that they would be glorifying tragic situations. The most impassioned response was voiced by the CHA supervisor[26] as she reacted to the tape of the young children who dramatized the family scene:

> When I saw [the] tape of those children saying those things, it upset me, it upset me to see them doing that, and what I wanted to find out is what can our role be to change that . . . what can our role be to show them something positive, so that they have another kind of image, because when they [the children] are destroyed, we will be, too.[27]

The question then became whether art should draw from the immediate milieu and reflect its concerns, or hold up alternative images in order to promote change? That is, should art be derivative or interventionist? The latter position did win some favor with the unit's supervisor, although there was confusion regarding how such a role would be enacted:

> Is it enough for us to be there and observe what is going on? Or, are we trying to interject other kinds of elements into society? When do we take that step? When do we take it from a step of being there and observing . . . and when do we interject what our beliefs are . . . and, in fact, are we clear in defining what our beliefs are?[28]

Camps of supporters formed to uphold each position, with neither side clearly gaining ascendence; the dispute was extended and divisive.

A closely related issue focused on the nature of the artistic process itself. Art could be presented in a rather static way which would underwrite nonparticipation. Or it could be defined dynamically, as a device which offered the opportunity to identify and cathartically work through problems. The actress who directed the community center staff in its skit stated, "What drama can do is it can bring out a problem . . . make a problem [be] faced. [We should] not use drama as entertainment, but [to] bring the problem out front."[29]

Art was thereby a process which could change its participants and potentially lead them to change their circumstances, but this would require a long-term process beginning with catharsis; as the skit director continued, "It's like a bodily function . . . when you're sick inside you throw up and it comes out and you say 'What made me sick?' And now, 'What do I do about it?' Unfortu-

nately, all we saw was the getting out."[30] Thus what was ugly in execution might be desirable in ultimate results.

Finally, the legitimacy of white artists working with and interpreting black experiences was questioned.[31] Initially local communities reacted with suspicion and resentment to the CHA artists regardless of race. They were perceived, the unit's supervisor noted, as "pacifying agents of the landlord."[32] As artists gradually established themselves at these sites, however, disputes arose among the AIR staff itself over whether white artists rightly belonged there. The overall unit's supervisor, herself black, argued that it was difficult for white artists to fully appreciate that blacks as a group were "facing annihilation"[33] and hence that these dramatic images had serious implications for future generations. Some artists also felt that the portrayal of negative aspects of the black community provided yet another instance of social control on behalf of the white community. In contrast, some CHA artists insisted that mutual exposure and sharing were encouraged when whites worked with blacks. And speaking in her own behalf, the actress who had directed the skit on drug abuse defended the drama as a product of the perceptions and concerns of local participants:

> As a white person I did not want to put out my ideas . . . how am I going to lay out my ideas and tell you what to do? And so I would ask, "What are your concerns at the center?" "What would you like to work through?" And these are the things that came out.[34]

Once raised, the issue of racism and the belief held by some artists that the development and transmission of black culture should be restricted to black artists lingered on on a somewhat subterranean level and threatened to surface at critical times.

By the end of the first program year, the CHA unit was the most controversial AIR segment. In late August 1978, AIR announced that due to a lack of funds, the Chicago Housing Authority was not able to provide the necessary assistance to continue programming there. What was initiated as an "interdisciplinary, model arts program" was allowed to die without much attempt to resuscitate it. As a result, a number of artists could not be absorbed into the schedule of programs for the upcoming year and had to leave AIR. It is evident that the continual turmoil within the CHA project led AIR administrators to expend little effort to find alternative methods to finance it and to fail to renew their commitment to this project.[35]

The definition of public art which evolved within AIR—and the parameters it set for shaping artistic expression—derived more from default than from explicit design. That is, it developed in reaction to perceived threats to AIR's durability as an organization rather than from pursuit of a distinctive artistic mandate. In this respect "public art" had less to do with art or the general public than it did with organizational and political concerns. Artistic concerns were accommodated only to the extent that they could be contained within rather narrow guidelines; entertainment took precedence over experimentation or explicit social and political commentary; and artistic productions were conventionalized by trying to provide "what the public wanted," anticipated by reference to audiences likely to be acritical and undemanding. Consequently, those artists who were willing to work within standardized formats were seen as contributing to the organization's survival chances and generally received rewards.

While AIR might have failed to construct a precise definition of public art, it was able to operationalize a satisfactory working definition. That this working definition reflected its organizational structure and priorities should surprise no one who recognizes the importance of situating cultural studies within social, political, and organizational contexts. The controversies resurrected here not only address the evolution of a working definition of public art, but also raise the correlative issue of the comparative amounts of freedom and control artists experience when they work within institutional settings. In this respect the various forms of social control exerted over artists and their work can be seen more productively as predictable and not necessarily pathological occurrences, as a final set of considerations will demonstrate.

10

Artistic Production and Social Control

They [publicly employed artists] have accepted new masters, the people, as represented by the people's government . . .[1]

"Social control" often eludes precise definition, yet is a constant concern to social scientists. Generally this interest is developed by highlighting examples of control which result in the imposition of criminal or other formal sanctions; studies of prisons and work situations are common and to be expected. Somewhat more unusual is the discovery of more subtle processes of social control in realms where these would not be so likely anticipated, for example, in the world of art and creative production.

Investigators have not neglected to consider the production of symbolic systems of meaning, however. Sociologists of science, for example, examine the norms and institutional arrangements which typically structure the work of scientists. As two such theorists have noted, "The relatively objective, consensual evaluation of discoveries makes science an extreme case of institutionally regulated cultural change."[2]

While such deliberate, incremental development and regulation is more unusual in the arts, the production of art is now examined in a similar way. And although the importance of individual

Chapter 10 originally appeared in a somewhat different form as "Artistic Production and Social Control" in *Social Forces* 64. no. 3 (March 1986): 667–88.

factors in the genesis of artistic production cannot be dismissed, the impact of social factors has drawn increased attention:

> . . . the vision of the artist remains the central determinant of form and content no matter what concessions are made. Nevertheless, there remain a social matrix and cultural system that direct and often even inhibit the work of the artist . . . conflicts . . . arise in the perpetual attempt of artists to produce work that expresses their own tastes and inclinations amid ambient restraints.[3]

The focus here is on the specific forms social control and censorship have assumed in the governmental sponsorship of artists. Lurking behind any proposal for the public funding of artists lies a crucial concern: to what extent will the artists and their production be controlled? In a sphere of activity in which the "freedom to" is touted as central, this exposes an extremely sensitive nerve. The apprehension which accompanies the acceptance of employee status by artists goes to the heart of an important matter—in what ways will such artists have to relinquish authority they might otherwise have to determine the form, style, and content of their work?

The main issue is not *if* artists must make certain adjustments; rather, the task is to determine what distinctive shape the predominant form of mutual adjustment assumes. It is not a matter of freedom *or* control, but how much of each can be discerned in a concrete situation. By examining the experiences of artists participating in the cultural components of the WPA in the 1930s and CETA in the 1970s and 1980s, the question arises, "Were the relative amounts of these elements similar or dissimilar from the conditions these artists would have been confronting had they been working under alternative arrangements during these times?"

The main objective is to trace the development of institutional capacities to contain artists and their activities more effectively. The intentional imposition of social control will be examined in two distinct ways. First, I will consider the specific social control measures designed to ensure compliance with institutional norms by this occupational group. Social control here was a desired *result*. Second, I will consider the enlistment of artists in the *process* of control, by having them contribute to the general perception of governmental activities as legitimate and deserving of support. Here social control was viewed as equivalent to effective social and political organization.[4]

In each case the comparative material from the WPA and CETA

projects will be used to demonstrate the consequences of an increased ability to deal with these particular individuals. I will examine how implicit forms of control supplant explicit censorship. That is, as artists have been drawn into bureaucratic settings to a greater extent, more efficient means of handling them and their productions have been devised and refined. This development is important because the study of censorship in itself is not necessarily all that instructive. Such investigations frequently chronicle dramatic moments, obscuring other considerations. As important is carefully specifying the degree, source, and circumstances accompanying the implementation of less obvious types of control mechanisms.

Denials and Minimalizations

Some of the most frequently cited contemporary works on economics and the arts maintain that censorship has not been demonstrated to any great degree, nor is there necessarily any reason to suspect the existence of such control, when public monies underwrite the arts. In one such source the statement was emphatic: "We encountered no case of interference by state or local governments, even where the amount of assistance provided has been relatively large."[5] Similarly, another stated that governmental intervention in subsidized arts projects "has been a rarity."[6] Censorship was thereby denied, although each author conceded understanding the fears which accompany such undertakings.

While these observations either predated CETA-arts involvement or barely overlapped with it, the official statements made by those overseeing the design and implementation of such programs were similar. In the resource book given to participants at the 1979 CETA-arts conference sponsored by the Department of Labor, only one direct reference was made to censorship in a volume containing several hundred pages:

> This issue has arisen in a variety of locales and situations. The Mayor's wife is offended by a mural; an actor decided frontal nudity is crucial to a scene performed at a convalescent hospital. But perhaps surprisingly (given the historic fear of government censorship among arts groups), the problems are generally small-scale. Applicant agencies should exercise judgment in selecting artists and projects that are sensitive to the need to control excesses. Most prime sponsors are less concerned with artistic material than with accurate reporting forms anyway.[7]

158

Artistic Production and Social Control

Censorship and control were dismissed at the conference as matters not warranting extended discussion.

The naïveté of these statements reveals a failure to consider important regulatory features of artistic and intellectual worlds and belies a reluctance to let go of outmoded images. First, the marketplace for the enthusiastic reception of ideas is not directed by an "invisible hand"; rather, the active role of gatekeepers in the production and distribution processes helps determine market successes.[8] Second, an awareness of such processes leads to self-regulation on the part of artists and intellectuals. "The relative rareness of examples of censorship in Europe are not proof of the freedom of the arts . . . Artists know what will be supported and what will not and tend to produce that which is approved."[9] Finally, instead of embracing the more contemporary view of the artist as worker, these statements all seem predicated upon the image of artists as independent of constraints. Rather than realizing the time-specific nature of this former image,[10] these observers assume artists are relatively free in government employ, and elsewhere. Yet those studies which have examined the actual conditions of work for artists as employees have consistently documented the ways in which their tasks have been structured by their environment.[11] Wherever contemporary artists work—in offices, in commercial studios, under government sponsorship, or even within what is considered the generally "free" marketplace—they encounter tangible sets of constraints within which they must work in order to be successful.

A key phrase within the previously cited CETA-conference statement typifies a much more subtle form of control, initiated internally in response to the perception of external threats: "Exercise judgment in selecting artists and projects that are sensitive to the need to control excesses."[12] As has been detailed in preceding chapters, AIR dealt with just such a necessity by its progressively more selective choices of personnel and projects. Not surprisingly, dramatic examples of excesses could be minimized as the goals of those who were selected to participate became more nearly coextensive with organizational imperatives. A relative absence of condemnation rituals does not indicate the absence of control, however. It instead signals the presence of an effective system of management which could largely anticipate and contain problems before they erupted.

Further, the examination of how artistic production can be controlled in distinctly political ways by society is a topic which

has been broached with some frequency. Useem, for example, explicitly maintains that government patronage of art is offered in order to strengthen ideological control and provide symbols of legitimacy for government programs and activities.[13] Haacke extends this reasoning by arguing that corporate sponsorship of the arts mobilizes liberal support for the state which might not otherwise be available. Potentially oppositional forces can be strategically enlisted: "A company [or government] that supports the arts cannot be all that bad."[14] The domination of the arts by elites and the mobilization of their supportive efforts are themes similarly developed by many others, even though they are not necessarily speaking directly to the issue of government patronage.[15] Control is thereby assumed to exist, even extending into realms of operation where the artist is not directly beholden to the government for a regular salary.

The various ways in which the WPA and CETA-arts projects controlled their artists and their output will be highlighted in order to see how artists as workers can be "managed" as can other groups of workers and to examine how art as an institution can be directed for specifically political ends. Further, any major changes in the ways this control has been extended, or the degree to which it permeates what has been produced, will be determined.

Depression-Era Arts Projects: The Explicitness of Control

When the Public Works of Art Project (PWAP, a forerunner of the WPA) was being discussed in 1933, President Roosevelt's response to its major proponent set the mood of caution with which such programs were generally undertaken. "I can't have a lot of young enthusiasts painting Lenin's head on the Justice Building."[16] By referring to the radical political motifs included in the work of popular Mexican muralists, national leaders decided from the beginning that the output of government-supported art projects would have to be monitored. It is my contention that an elaborate system of controls evolved over time, and to varying degrees, depending upon such factors as how potentially radical and influential certain kinds of output were assumed to be; the nature of different artistic disciplines themselves; and the choices made regarding what kinds of activity would be emphasized within each field.

Because artists have been relatively unsocialized into the workings of modern bureaucratic systems, arts projects administrators felt that a reliance on the more solid foundations of orga-

nizational structure for control purposes was necessary during this era—at least until an infrastructure of understandings and aspirations could be established within this worker population. This is distinctly conveyed by a tone which permeates some of the material recording the day-to-day operations of the WPA projects. As the national director of the visual arts project commiserated with the local director in Chicago, "I can realize that you have many difficulties keeping some of your artists in line, but that is the fate of all of us who have to deal with artists."[17] Similarly, when local artists complained to the national office that some of their fellows who were perceived to be too difficult to control were being dismissed, the local director defended herself against the charges in the following manner: "It is rather amusing . . . that anyone would get the impression that we might not retain on the Project 'artists of a controversial disposition,' as naturally that would mean letting off practically all the present personnel. Do you know of any artists who are not controversial?"[18]

Finally, the more recent image of the artist as worker, and the corresponding emphasis upon professionalization which marked CETA-arts projects, were both decidedly absent from this earlier undertaking which at times judged its personnel in a paternalistic manner. "There certainly seems to be no reason for the artists and [name of Chicago project director] to ask [*sic*] like a bunch of school kids and their teacher . . . [she] has done a helluva lot for them and consider[s] them her children so to speak, and she can do anything with them she so desires. You know very well that children sometime[s] grow up and resent such [a] motherly attitude."[19] Given these underlying assumptions, the accompanying illustration suggests how each of the four WPA arts projects—in writing, music, theatre, and visual arts—can be compared in terms of their respective amounts of freedom and control (see table 10.1).

The writers' project was the best able to control the output of its participants. From the time of its inception, the writers' tasks were designed to minimize the chances that anything "undesirable" would slip through the administrative structure. This largely reflected the fear that many writers and intellectuals had been attracted to radical political ideas which would affect what they produced. Consequently, almost all the writers worked within the standard format of the state tour guide series, which severely limited their discretion. Further, because tasks were broken down, no individual writer could have too much responsibility for, or too much control over, the content or tone of the finished product. As

one commentator has noted, "The cooperative effort that the Guide demanded served as a kind of white-collar discipline. The individual was subordinated to the group, and the creative concept to that of the socially useful."[20] And finally, when some problems

Table 10.1 *Varieties of Social Control in Works Progress Administration (WPA) Programs in the 1930s*

Freedom		Control
	Federal [Visual] Art Project (FAP)	
	The largest segment were easel artists who were allowed a great deal of latitude in design choice and execution—75% were never asked to revise finished work, 79% never had work rejected.[a]	
	Yet, work could be kept from public view and distribution if it was not acceptable to administrators.	
	Mural artists were more closely monitored.	
	Related visual arts programs exercised a greater degree of control over their artists; thus, a "contrast effect" existed whereby FAP workers knew what could happen to them if they abused their freedom.	
	Federal Theatre Project (FTP)	
	A National Play Advisory Board defined the pool of plays available.	
	Censorship of particular productions; if specific plays "leaked through" as problems, they could be stopped; for example, *Ethiopia, The Cradle Will Rock, Model Tenement.*	
	Federal Music Project (FMP)	
	Limit the available program: professional emphasis on symphonic music.	
	Rely upon the limiting features of artistic conventions and pressure from colleagues: limited range of interpretation.	
	Federal Writers' Project (FWP)	
	Work allowed within an established format.	
	Limited, segmented tasks provided.	
	Centralized editorial control exercised from Washington.	

[a]From Francis O'Connor, *Federal Support for the Visual Arts: The New Deal and Now* (Boston: New York Graphic Society, 1969), 102.

were encountered despite administrative safeguards, an official censor was added to the Washington staff and all copy had to be approved through the central office before publication.[21] Thus, there are numerous examples of the explicit alteration of some disputed materials and the blocking of the publication of others.

It is interesting but not too surprising that little has been written regarding the WPA's music project, for the amount of control exerted within the project effectively prevented the occurrence of major problems. Control in this section was exercised in two major ways. First, an administrative decision limited the choice of programs to one musical form, symphonic music. And second, the nature of this discipline and the exercise of professional collegial control were beneficial to the program's aims. Since the structure of symphonic music is one of the most obvious examples of Becker's conventions in art,[22] the latitude for innovation is quite limited.[23] Although some room for variation in interpretation is possible, the basic "text" is provided. Moreover, because innovation on the part of one member of an ensemble would seriously disrupt the performances of others, the exertion of control by one's associates is very apparent in this discipline.

The need to control the products of the theatre project was keenly felt; just as the power of words was feared on the writers' project, a similar concern was expressed regarding the potential influence of the dramaturgic presentation of ideas. The establishment of a National Play Advisory Board defined the available pool of approved plays from which local directors could chose their productions. If leakages were discovered in the system—if local officials or community groups had a strong negative reaction against a play, for example—production could be halted. Some plays were in fact suspended: those which were regarded timely because of world events, but feared inopportune in regard to national security (*Ethiopia*); those feared to be potentially inciteful of disruptive action by dramatizing past labor unrest during a period of potentially similar difficulties (*The Cradle Will Rock*); or, those deemed critical of governmental efforts on behalf of the needy (*Model Tenement*).

Such actions became less necessary as the project matured. The explanation for this, however, probably lies as much in the caution with which the project proceeded as well as "restraint" exercised on the part of project officials. A statement by Hallie Flanagan (the project director) clarifies the situation somewhat:

Any theatre operating with public funds will have to decide
whether it wants plays chosen by non–political people, in which
case some will probably be politically unwise; or by political peo-
ple, in which case either caution or party politics will rule. As direc-
tors of a government theatre, all of us on the policy board, and that
included all regional directors, were necessarily censors. That is, we
had to bar out materials which seemed inappropriate or dangerous
for a public theatre to do. We did this constantly on questions of
public taste and policy.[24]

Therefore, some plays were judged to be radical when they merely
exposed certain obvious social conditions and lent support to the
government's programmatic ways of dealing with them. Despite
the caution with which this project proceeded, its opponents guar-
anteed its early demise; it was the only one of the four arts projects
specifically dismantled by an act of Congress.[25]

Finally, there is the ambiguous presence of the [visual] arts
project. Most historical accounts of the wpa point to numerous
examples of artworks which were censored with a great degree of
notoriety. On the other hand, visual artists were given a degree of
freedom over their choice of form and subject matter unknown in,
and often envied by, the other artistic disciplines. How can we
reconcile this apparent discrepancy?

First of all, many of the more well-known examples of cen-
sorship actually occurred in Depression-era visual arts programs
preceding the wpa. Most often they involved works of a public
nature, especially murals. By the time wpa was implemented, cer-
tain kinds of difficulties had already been played out, problem
areas could be more readily identified, and a better system of con-
trols had evolved. The largest segment of artists were allowed to
work in their own studios and to determine the nature of their own
output; yet certain restrictions were implemented, as related by the
following newspaper account. "No nudes is good nudes for the
purposes of the wpa art project in the theory of the wpa art admin-
istration for Illinois . . . 'we tell them to bear in mind that they are
painting for a patron.'"[26] This official line was extended to read
". . . no nudes, no dives, no pictures intended as social propagan-
da. These [restrictions], she [the Chicago project director] seems to
feel, are essential if her Project is to get along with its Chicago
neighbors."[27]

License was granted, then, within bounds. While this still al-

lowed easel artists a relatively large degree of freedom, their finished products need never reach a large audience if local administrators deemed the work offensive in any way. Work could either be destroyed, "lost," or sold for scrap canvas. And those working in the mural format faced different constraints. Procedures were elaborated for securing approval for designs. But because of the public nature of this artistic mode, community reactions continued to be problematic, and administrative scrutiny was constant.

Finally, projects quite similar to the WPA, yet under different sponsorship, provided an example to artists of what being under rather tight control could mean. For example, the Section of Fine Arts, under the direction of the Treasury Department, initially controlled their artists by preselecting designs through competitions. Then, because artists had to furnish a performance bond and purchase all necessary supplies with their own funds, they had a vested interest in complying with any recommended changes. Since payment was typically made at two points—halfway through the project and upon its completion—the possibility of withholding payment was an additional threat. The notion of "painting Section" (deemphasizing individual styles and preferences in deference to what was known to be acceptable to Section officials)[28] was familiar enough to provide a "contrast effect" for WPA participants, indicating what might be expected of them.

The Ascent of Implicit Control

A character in an AIR-written play cautioned, "if something should happen and we were connected . . . as public servants, it would be disastrous. . . ."[29] "If something should happen . . ." is a phrase resonant with meaning in relation to AIR. This concern strongly dictated the posture it assumed in its conduct with supporting agencies. It was because of this basic guardedness that a specific type of control became central to AIR's operation: the supplanting of explicit censorship by implicit controls.

An observer of the contemporary scene offers a preliminary identification of this process: "Implicit censorship is not the same as explicit condemnation or destruction of images, but rather the structural characteristics, the rules and procedures, which eliminate the need for old-fashioned direct censorship by strictly limiting what is possible."[30] Following this lead, I maintain that such implicit controls would include, (1) the limitations on artistic output imposed by the organizational characteristics of an agency

within which artists are employed; (2) the nature of those institutions it actively works with and supports; (3) informally conveyed notions of "what is and what is not done"; and (4) deference to professional notions of conduct.[31] Further, the uncertainty over continued funding can constrain activities by counseling containment within narrowly proscribed boundaries as a reasonable organizational survival mechanism. The intensification of this process of control can also be attributed to the retrospective recognition of problems central to the earlier WPA experience and to additional constraints furnished by the expanded professionalization of the artists themselves.

As we have noted, organizational characteristics imposed limitations on artistic output in various ways after AIR's first program year. There were fewer artists working on individualized projects; reductions were made in the size of those artistic disciplines which challenged their proposed assignments; and an entire programming segment was eliminated. As we have also observed, these changes were instituted not only because of the difficulties these artists actually caused, but also just because they quickly became identified as *capable* of causing problems.

Interrelationships with other organizations were critical so that customers' tastes and preferences took precedence over the artists' concepts and proposals in determining the suitability of projects. Artists had to be willing to modify or even abandon designs, regardless of their creative preferences. As AIR's assistant director attested,

> . . . we may come up with a terrific mural for 43rd Street, and Public Works won't buy it. Then we're going to have to come up with a second terrific mural, or a third terrific mural. Now we can't force Public Works to take a mural they're not going to want.[32]

Building the reputation of the program as a dependable purveyor of services, while minimizing the likelihood of client discontent, became more and more central to AIR's operation.

Negotiations made way for discussions of "community standards" (much like current controversies over what is and is not pornographic and what materials to include in public libraries). This allowed individuals to champion group interests while in reality pursuing their own interests. As a representative example, an artist's original concept of a mural for the dining area of an alcoholic treatment center focused upon a realistic depiction of themes

such as hope and despair. The director of the center wanted instead the placement of a brightly colored abstract design within an area more directly serving the administrative staff. The director's demands won out, with the argument being presented as concern for the presumed sensibilities of her community of clients. Explicit censorship would not be necessary in this case because the artist was successfully immobilized in undertaking the project by an extended negotiation process. Although he was to play some role in the bargaining, the artist's needs and desires proved to be subsidiary to organizational demands.

The artist involved in this situation had previously been active in the "community mural movement," which stressed the representation of social, economic, and political issues relevant to local communities. However, decoration quickly became the preferred mode of muralistic expression for AIR. Such projects were so popularly received by city agencies that they developed tremendous reputational capital for the program. When agency heads saw the offices of others which had been enlivened with bold graphic designs, they competitively vied for the opportunity to have their own spaces similarly embellished. These designs most typically eschewed specific themes and content in favor of abstract or representational expression. The artist mentioned in the first instance did not last through AIR's first program year. A muralist working in the latter mode, however, became quite popular and was able to complete his full tenure, successfully securing a full agenda of approved projects (fig. 27). Such incidents were largely concentrated in the early part of AIR's organizational history. Explicit control was generally necessary only until such a time that experience enabled the more thorough containment of problems.

Self-imposed restraint followed directly from AIR's procedural requirements which could delay, frustrate, or prevent the execution of projects. To be successful in the program demanded that artists acquire a good working knowledge of "what is and what is not done." As has been observed in regard to the self-censorship processes at work in museums, shows are seldom mounted which would be likely to offend governing boards or corporate donors. "Direct and traceable interference happens rarely; everybody has sufficiently internalized the rules of the game."[33] Those AIR artists who encountered the most difficulties in this respect either failed to grasp the contours of the larger situation in which AIR was operating, felt they had already exercised a sufficient degree of self-restraint in adhering to program guide-

lines, or naively assumed that the constraints of the program were qualitatively different from work situations in which they might otherwise be engaged and did not deserve their respect. Their anger was strongly felt, to the point of decrying censorship at times, but they failed to recognize that given other work situations, *some* types of limitations certainly would have been imposed on their work. In general, they also failed to recognize the extent of their own contributions to both the generation and ultimate resolution of the controversies which arose over these issues.

As time went on, these notions of what is and what is not done were more efficiently conveyed, both formally and informally. For example, a muralist employed toward the end of AIR's organizational life was commissioned to create a scene capsulizing the history of a local community as part of a neighborhood re-

Figure 27. AIR came to favor artistically bland and politically neutral murals because they had broad appeal and drew praise rather than criticism. Photograph by Lauren Deutsch, courtesy of the Chicago Public Library, Special Collections Division.

Figure 28. Some murals engendered controversy. This modified design was the result of objections voiced by community groups which felt the original proposal might convey a negative image of their neighborhood. Courtesy of the Chicago Public Library, Special Collections Division.

vitalization project (fig. 28). The artist worked carefully within AIR procedural guidelines and also sought to gauge community response to her design. When her proposal was published in a local newspaper, however, some adverse reaction was registered. Her depiction of workers in brick factories (the economic basis of the initial development of the area) was judged to be unacceptable. In a community considering itself to be essentially middle class and where residents were largely of white, Western European backgrounds, the portrayal of working-class origins was not desired. Such themes were too closely associated in the complainants' minds with murals in minority communities which primarily focused on social and political themes. This community, it seems, did not want what some termed a "Puerto Rican mural," although the brick workers pictured in the design were not actually dark-skinned.

What had initially been promoted by the local alderman developed into a potential source of political embarrassment; a project which had been supported by AIR as capable of drawing favorable public attention to its entire program was now a liability. What was being questioned was not historical accuracy but contemporary preferences. At issue were community, not artistic standards. Survival became the bottom line which defined the responses of each of the concerned parties: for the alderman, continued tenure as a viable political leader; for the community, maintenance of a particular public image; for AIR, persistence as an organization capable of providing predictable, known products; and for the artist, endurance of organizational demands in order to protect the benefits of CETA participation. No dramatic incident of censorship occurred here, due to the coalescence of the artist's procedural caution and the organization's structural provisions.

Two distinct features were common to instances of implicit control. First, there was a relatively high degree of "informational isolation." That is, knowledge of these events rarely extended beyond a small number of persons; generally, only the artist, top AIR administrators, and key supporting personnel became aware of such difficulties. The public would have little awareness of the exercise of control or censorship; what became public were mostly products, not an appraisal of the processes responsible for them. And second, the artists who became involved in such difficulties were generally encapsulated and forced to assemble individualized responses to their situations. With little information available about their fellows' difficulties and practically no attempts made to mount collective defenses, the struggles of individual artists remained just that, with most of the combative resources available in a given situation concentrated against the individual's favor.

Implicit control could also involve a group of artists, with control coming from the artists themselves. Artistic survival remained a key issue here, not only within the AIR program, but beyond it as well. For example, one of the theatre groups was organized as an ongoing, racially mixed company. When AIR was asked to participate in a city-wide celebration of Black History Month in 1980, this was the one group available at that time to mount a production. *Passages,* a broadly conceived historical treatment of the black experience in America, was developed for this purpose. The thematic nature of the work was deemed appropriate for the situation. However, the integrated composition of the cast,

which had been unimportant in the group's previous productions, was feared by some to be potentially offensive to black audiences.

The play's target audience was high school students, but it was performed before such a group one time only. There were no overt expressions of hostility from this audience at this performance, but when the director went to classrooms afterwards for discussions, many of the students were angry that white actors and actresses were being used to portray black characters. The director feared the possibility of violence toward his performers and canceled the second performance of the day.

On the following day, a meeting was held between the cast, their director, and AIR administrative personnel to determine the play's future. The issue going into the meeting centered upon the legitimacy of using whites to represent the black experience to black youngsters. No one involved in the production questioned the sincerity of this effort. Yet, all further presentations were canceled.

This decision was not based upon the original concern over security, nor on the right of the company to assess the integrity and legitimacy of its own efforts. Rather, what emerged during the meeting was the revelation of rumored threats that representatives of the media and theatrical components of the black community intended to publicly condemn the production as insulting. Black members of the cast were concerned that their potentially viable (albeit dormant) careers might be jeopardized since the people from whom they feared an adverse response were exactly those in the community they would have to be working with professionally when their AIR tenures ended. The production was subsequently dismantled. What is so unusual about this incident was that the final determination was made by the artists themselves, with program administrators acquiescing with what they perceived to be in the artists' best interests.

AIR was able to develop a system of controls which could generally pre-identify potential problems and forestall the necessity of dramatic expressions of control. The relative infrequency of overt censorship testifies to its efficiency. Not only was this bureaucratic structure more effective in this respect than its WPA counterpart, it also commanded a high degree of compliance from its participants by treating them as young professional workers. While the forms of control may have been transmuted over time, control existed nevertheless in the publicly funded art programs of both the WPA and CETA eras.

A Singular Display of Control

[Taxpayer-supported plays should be] "very carefully censored" so as not to hold anyone up to ridicule.[34]

"John, really, this is in real bad taste. We don't want to assassinate anyone's character here."[35]

"Exceptions prove rules," the aphorism declares. In sociological terms this compels us to examine how aberrant phenomena both derive from, and highlight, normal conduct. The discovery of an incident of unquestionable directness might at first seem to contradict the contention that explicit censorship of works is not often necessary when their contemporary producers are enmeshed within bureaucratic structures. However, the close examination of just such an incident can clarify this central point.

AIR was but one of the projects undertaken by the Chicago Council on Fine Arts (CCFA), albeit one of its largest and most visible components. Another activity subject to public scrutiny was CCFA's responsibility for arts programming at the civic center (Daley Plaza), which included entertainment and exhibitions of works of art. In the fall of 1979 an artist received permission to display three tableaux for a week each in the civic center lobby. Each of the scenes parodied local situations with life-sized, caricatured sculptures and accompanying tape recordings which simulated conversations between the individuals. One such scene depicted Chicago Transit Authority passengers in a subway car, voicing the perennial complaints about service. And a second pictured a judge in court, a familiar situation in this building which housed judicial and governmental offices.

Neither of these works encountered difficulties in their display; not so the third, however. Billed as a Chicago version of Grant Wood's well-known "American Gothic," this piece presented Mayor Bilandic and his wife, with a tape which declared "Throw another log on the fire, Heather. I think it's starting to snow again. It must be eight feet by now." His reference was to the snow disaster of the previous season which was held to be largely responsible for this mayor's loss of his office. Recall that AIR had tried to turn this very situation into something positive by the previously discussed "Snow-Works for a Beautiful Chicago" (the same work that had also attracted the support of the mayor's wife, CCFA's former director).

The artist touched some particularly sensitive points with this

spoof, and action was quickly taken against the sculptural piece. Within hours of its installation it was covered and ordered removed from public view. While the first two displays in this series were considered to satirize institutions, this piece was seen as ridiculing an individual. In addition, this scene focused on a CCFA ally, while the preceding ones had not. An act of direct censorship occurred which CCFA justified on the grounds that the work entailed "character assassination."

This action received national attention, and a lawsuit was brought against the city and CCFA by the American Civil Liberties Union (ACLU) on the artist's behalf. The ACLU argued that the action violated the First and Fourteenth Amendments, as well as the Civil Rights Act: "Public officials must understand that [the aforementioned statutes] forbid them from imposing their personal tastes and political views on the public."[36]

The subsequent legal hearing established that no written standards had existed for the acceptance or rejection of works; rather, one CCFA representative was empowered with making such decisions.[37] She had accepted this artist's work without preview, but argued that the original proposal had specified the portrayal of a "typical Chicago couple" and had not indicated the incorporation of a tape. The sculptor admitted these points, but maintained that he had not willfully deceived CCFA. Rather, he argued it was only gradually that he had realized the sculpture resembled the mayoral couple, and his decision to include the tape occurred only on the day preceding the installation of the work.[38]

The court awarded the artist a compensatory exhibition of his work and admonished CCFA to tighten its operating procedures. At the same time, the court affirmed CCFA's legitimate right to restrict works rather than arguing for absolute freedom of artistic expression. As the court summarized, "For the City to censor, based upon a political message or social commentary or personal discomfort, if that is what the judgment is of [name of CCFA official], because of friendship or present or past working relationships, the City has to do what any other art exhibitor does, and that is, in fact, jury the pieces ahead of time."[39] Further, citing the precedent established in another domain, it concluded that "the public schools could pick and choose among books that they admitted to their libraries, but they could not, and later on, go back to those libraries and start picking books off the shelves that they disliked. . . . *That is the jurying process. That is the process where you keep them from coming in the front door at the outset.*"[40]

It was possible for this incident to occur precisely because the

artist in this case was working outside of the structure of a program like AIR. His work was therefore not subject to scrutiny as it was developing and was not under the jurisdiction of the established regulations and procedures which AIR developed in order to evaluate and approve projects. Since the sculptor was not an employee, CCFA had a limited repertoire of sanctions it could impose on him as an artist. And if he had been working within the program, it is very unlikely that a second such incident would have been allowed to develop.

This incident forced CCFA to make decisions in a largely unanticipated, crisis situation. This was power exercised from a position of weakness, not strength. The swiftness of action can best be explained by the subject of the work; however, the type and severity of the action demonstrated the use of emergency measures under extraordinary conditions. The right of CCFA to prescreen and limit what could come to the public's attention was never denied. Rather, it was counseled to tighten its procedures so leakages would be less likely to occur, thus limiting the public's awareness of what was being done. In this regard CCFA was forced to be even more vigilant than AIR. AIR had the advantage of a series of controls to systematically confront problematic situations at a number of critical junctures and to mobilize appropriate compensatory measures. Leakages could be detected before they became torrents. CCFA, however, more typically dealt with already completed products and individuals over whom they had comparatively little recourse. If they were not constantly prudent in making their gatekeeping decisions they could be forced to act in a more overt, public manner, and they risked being swept over by a flood of bad publicity.

It would be wrong to conclude that AIR did not exercise control over artists and their products while CCFA did. AIR was simply more accomplished in limiting the possibility that such control decisions would so noisily emerge. In this sense the program was effective in disguising what Bachrach and Baratz have identified as the "two faces of power."[41] According to this definition, the overt exercise of power is somewhat epiphenomenal; this restrictive aspect generally diverts attention away from what is allowed to be defined as an issue in the first place, or what can even come up for consideration. As they state,

> Under this approach the researcher would begin—not, as does the sociologist who asks, "Who rules?" nor as does the pluralist who asks, "Does anyone have power?"—but by investigating the partic-

ular "mobilization of bias" in the institution under scrutiny. Then, having analyzed the dominant values, the myths and the established political procedures and rules of the game, he would make a careful inquiry into which persons or groups, if any, gain from the existing bias and which, if any, are handicapped by it. Next, he would investigate the dynamics of *nondecision-making*.[42]

This more commonly disguised aspect of power is exactly what was being protected by AIR's more selective recruitment of personnel and its distinctive resolution of skirmishes over competing definitions of public art. The successful limitation of issues to within a carefully circumscribed area attested to the organization's gradual maturation.

The Extension of Social Control: Art's Contribution to the State

In a series of articles written on the general subject of social control, E. A. Ross declared, "In war stress the artist must be alchemist enough to turn lead into gold. Pain he must make sweet, disease comely, mutilations lovely, and death beautiful."[43] Undeniably, artists have been enlisted to lend symbolic support to major societal efforts such as the mobilization for war. However, important examples of their adoption of adversarial roles are also available. It follows that when artists are recipients of governmental patronage they will be expected to support regimes in exchange for their salaries. Opposition will less likely be tolerated when the government is a direct patron and has something tangible to withdraw. Further, in situations where either internal or external threats are feared to exist, a governmental sponsor would be expected to tighten its internal operations in order to wage the most effective battle. Examples from both the WPA and CETA experiences can highlight this additional example of artistic production and social control.

One of the indisputable conclusions from the 1930s is that the center held. The structure of capitalism may have been considerably altered, but the radical alternatives which had been feared by many were not instituted. Reform measures blunted the appeal of radical proposals. In fact, some appraisals of the relief programs of the 1930s argue that while they were developed to aid individuals, they instead strengthened the state and extended the amount and type of involvement the state had in individuals' lives.[44]

Artists were among the many groups to whom assistance

was offered, and in turn they were expected to contribute symbolic and substantive support to society. The director of the theatre project was so concerned about the economic and social disruptions of the 1930s that she entitled the first chapter of her history of the project "Danger: Men Not Working."[45] The arts were enlisted to extend social control in various ways in response to perceived challenges to the status quo: (1) by providing diversion; (2) by underscoring democracy through an emphasis upon its traditional ideas; and (3) by contributing informational and motivational support to the war effort.

Offering diversion from the severity of then–current conditions was certainly a function of the Depression–era projects. Flanagan quoted Chicago's park commissioner in regard to the importance of theatre performances in local parks: "These audiences are having a good time; people are off the streets and that's what we want."[46] Similarly, Edward Bruce (director of the Treasury Section art project) felt that "we are all thinking too much and laughing too little."[47] The function of public art in this view was to provide an emotional release, a "loosening up" from the serious considerations of the day.

Further, a large number of historical pageants presented by the theatre project served to underscore democratic ideals and reaffirm the legitimacy of the state's authority. Flanagan repeatedly emphasized the role of the dramatic arts as a bulwark of democracy, bringing about a renewed faith in society through presentation of past accomplishments and enduring symbols.[48] Flanagan also highlighted the potential of drama to help assimilate different groups into a "core culture" when she emphasized service to the ethnically diverse children of steel workers in Gary, Indiana. In this case the Federal Theatre Project "was in the business of making Americans."[49] And in yet a more abstract way, the arts projects were able to lend positive support to the system by exemplifying its "effectiveness." For example, the *Chicago Tribune* declared that because of the successful production of *Hamlet* "the Federal Theatre Project adds considerably to the stature of government forces in Chicago."[50]

Finally, the mobilization for World War II fundamentally changed the scope and operation of the arts projects. An increased emphasis on serving national defense purposes was accompanied by a decline in providing relief or promoting professional standards of art production.[51] The service role, always inherent in the

operation of these programs, now enjoyed considerable prominence. For example, the Writers' Project was called upon to amass various types of information: statistics on the numbers and ages of men affected by the draft, a survey of civilian organizations which could serve in home defense efforts, transportation routes, and county-wide information on the distribution of population, crops, and resources.[52] Additionally, they collected information on the geographical distribution of various minority groups, presumably to facilitate their containment should they be defined as security threats (as were, in fact, the Japanese).[53] Entertainment was also provided as a supportive service to training facilities, contributing to the development and maintenance of troop morale. These services were valued not only because of the extremely vital nature of the information involved, but because of their symbolic and ideological contributions. As the following wPA memo declared:

> The Writers' Program can perform a defense service which no other existing apparatus can undertake. It can supply cultural content to patriotism. The books . . . have provided a realistic basis for patriotic feeling; they reveal the multitudinous life of America that rolls out behind the flag . . . Awareness of a unified tradition is the most powerful stimulus to integrated action.[54]

The wPA and ceta programs were structured differently, and no event of the magnitude of a war during the ceta era redirected that program's efforts.[55] Even so, ceta artists were controlled in distinct ways and could also be mobilized in the process of extending social control.

wPA policy was determined and administered at the national level. The products of the component wPA parts therefore reflected on the political party dominating national offices. Because political leaders wished to have these products reflect well on them, the major control problem was to limit and standardize tasks throughout the country while also developing a back-up plan of censorship devices which could deal with any slippages through the system.[56]

ceta, in contrast, was locally administered, allowing for a wide interpretive range within broadly conceived guidelines. There was an immediacy between sponsor and employee which somewhat contradictorily enabled undertaking a wider range of projects, but for potentially narrower purposes. Local sponsors were relatively unhindered in deciding what projects they might underwrite to augment their stature in the community. However,

since they had a great deal at stake with the successful execution of these proposals, these sponsors relied on more subtle, sequentially mobilized systems of control to monitor activities and impose modifications as necessary.

The task for CETA-arts projects was not direct censorship of products the system failed to anticipate. Rather, it was to utilize these artist-employees as a resource, constantly directing their work (fig. 29). The problem which arose to a much greater extent under CETA than WPA was boosterism. It sent AIR participants dancing through the city dressed as trash cans as part of a city beautification campaign, predicated the writing of a "Beautiful Chicago" theme song, and dictated the final form of certain AIR murals and videotapes.[57] While these CETA artists might have had fewer concerns than their WPA predecessors over whether or not their projects would reach public view, they were more troubled about the final form of their productions and the uses to which they might be put.

This can be understood best by noting the distinctive time period when artists received CETA funding in Chicago. AIR operated just after the leader of the local political machine had died, leaving the city without the widely recognized symbol of authority with which it had long been identified. A critical task during the enactment of the two following city administrations was to reaffirm the capacity of the local government to meet community needs. Whether or not governmental services were as good as they had been in the past was to some extent a moot empirical question; more important than the government's actual capacity to deliver in substantive ways was its *perceived* capacity to do so.

Many of AIR's activities were symbolically potent ways of mobilizing attitudinal support for the city and its services.[58] AIR activities touted the city's image (the production of *Beautiful Chicago*); stressed individual responsibility for its upkeep, thereby minimizing the administration's liability for problems (the song "Trash Can Blues"); or, directly advertised city government's concern for the health and well-being of its citizenry (a widely distributed poster, "Rats: Public Enemy"). Further, AIR was always clearly identified as a mayoral-sponsored program which brought entertainment to thousands of city residents. These activities could be used as evidence to neutralize accusations of inactivity or neglect in other areas of responsibility, prompting the widespread recognition of the "bread and circuses" nature of these city administrations.

For the WPA artists of the 1930s, the explicit censorship of images and productions resulted from program administrators' fears of highly critical works and the inability of these administrators to design adequate organizational safeguards to anticipate and forestall such projects. A combination of structural and emergency responses resulted which publicly revealed a position of organizational weakness. The CETA artists, however, were more subject to implicit methods of control which were built into the organizational structures themselves. Problematic projects were more likely to be identified in process, so that alterations could be demanded in incipient stages. While vivid examples of censorship and control may not be plentiful, these contemporary artists were definitely subject to restrictions.

As these examples have shown, a supportive rather than an oppositional stance was exchanged for financial remuneration,

Figure 29. Artists were transformed into ersatz trash cans when they lent their voices and dancing feet in support of a city beautification project. Courtesy of the Chicago Public Library, Special Collections Division.

whether such services were demanded in a time of extreme crisis for the entire society (as during World War II), or in the more localized situation of garnering legitimacy for new city administrations. Artists are not exempt from the control exerted by occupational norms; rather, they can be likened to scientists, who also operate in a regulated sphere of symbolic inquiry. Further, artists are subject to the direction imposed by the institutional arrangements in which they work, much as are other, supposedly profane laborers. The study of artists can only be strengthened by continuing to de-emphasize their anomalous qualities and recognizing the more typical aspects of their work lives.

It would be extremely misleading to conclude from this evidence that constraints are unusual for creative producers, or that they are otherwise free from social control. Rather, under alternative production conditions—other locales, time periods, or funding sources, for example—different kinds of constraints would certainly exist. WPA and CETA artists voluntarily entered into the exchange of symbolic products in return for a regular paycheck. Their full-time employment *qua* artists expanded their opportunities and their freedom from other kinds of constraints. On the other hand, a price was exacted from these same beneficiaries; and who called the tune for them, and to what extent, was also specified.

Epilogue

[AIR] . . . was straddling a fence with art on one side and govern-
ment on the other. And fence straddling usually causes pain.[1]

As the artist quoted above understood, the very nature of an un-
dertaking shapes the difficulties that actually emerge. This study
has attempted to analyze those especially problematic aspects of a
government-funded program for the employment of artists with
the following working assumptions. The unfolding of key events
and the gradual evolution of a particular organizational structure
were the results of a complex interaction between program admin-
istrators, participating artists, and diverse constituencies in the ex-
ternal environment. When these different elements converged,
various forms of accommodation had to be worked out between
their numerous and often contradictory needs and interests. It
would have been even more of a challenge to construct a satisfacto-
ry explanation of what transpired had problems *not* resulted from
this process.

 The main purpose has been to examine the adjustments be-
tween an organization and its personnel. There has been an empha-
sis throughout upon discovering the social bases for events and
developments, with a relative de-emphasis upon individual per-
sonalities. Success within the program was differentially valued by
the AIR participants, and the opportunities for success were differ-
entially available. The outcome was "handicapped" for the various

kinds of artists, and they consequently developed distinct coping strategies. Both AIR the organization and its individual participants studied and weighed their odds for success and placed their bets accordingly. In this process some emerged as short-term winners while others gambled conservatively, risking little and coming out about where they'd started.

What should be recognized is that engagement presupposes reasons compelling enough to invest oneself, one's best work, and one's future career in an organizational setting. These are carefully considered decisions, the stakes are high, and control over these goods is not hastily relinquished. Therefore, engagement covaried with what artists believed they could get in return from this specific opportunity.

The different "horses" who sought employment in AIR could approach the possibilities inherent in this undertaking with two somewhat contradictory agendas. On the one hand, they must have been at least somewhat willing to be trained as artistic "corporation men," as per AIR's organizational mandate. On the other, it is apparent that the more immediate desire to obtain temporary relief from the difficulties of a subsistence existence was operative as well. Either factor could be mobilized to a greater or lesser extent, enabling certain of these participants to be more successful on this particular type of track.

Artists' resistance to AIR's operating procedures cannot be explained to any great extent by casting them as naive individuals confronting (or sometimes overwhelmed by) an oppressive social structure. Nor is it accurate to assert that the program was far-sighted in its goals while the artists were myopic if they failed to flourish under these employment conditions. Quite simply, AIR had more to offer to some artists than to others. Both receptivity and resistance to program demands were probably the result of some calculus of potential profit on the part of individual participants. The crucial point, however, is that profitability was generally reckoned in relation to careers in the wider art communities to which artists would be returning. It would make good sense to go along with AIR's demands if the resulting experiences or products would allow for the accumulation of capital negotiable in these other artistic worlds. If acceding to program requirements was judged to be either inconsequential or detrimental in this respect, the potential for resistance increased. In either case, the guarantee of limited tenure dictated that one eye be focused on making those adjustments necessary to survive in this environment for a specific

period of time while the other should be fixed upon a considerably longer view. To have acted otherwise would have been inexpedient.

Therefore, successful functioning in AIR did not necessarily indicate much about an artist's expertise or his or her abilities elsewhere. Similarly, failure to do well as an AIR participant could not be taken to indicate inadequate artistic skills or to predict that these individuals might encounter similar problems in other artistic environments. Instead, it could mean that a comfortable fit was just not possible; neither artist nor program could offer anything valued by the other. Artists were reluctant to let go of survival skills and what they often felt was their artistic integrity for inadequate or inconsequential rewards, especially when these same features were highly valued and usable in more common artistic situations. In a great many cases the reasons for relative success or failure within AIR comprise a gray area in which the availability of alternatives, the need for a degree of financial security, and the personal desire to practice and develop artistic and work skills were just a few of the factors which contributed to the particular shadings of any individual example.

While a range of adaptations was possible for AIR participants, AIR itself has been pictured more singularly as an organization continually trying to adapt to the challenges of other parties, whether their claims were economically, politically, socially, or artistically based. This was, then, a beleaguered organization that experienced a rather constant sense of assault. Understanding this central aspect of the organizational Weltanschauung enables the corresponding comprehension of how and why principal aspects of the program developed as they did.

AIR cannot be understood without taking into account the internal and external difficulties it confronted. Two internal factors were especially important in AIR's development. First, the perceived nature of the personnel with which it was working dictated designing an organization which would acknowledge the structural inequities and ideological overlays that have typified artists' situations in the past while at the same time addressing their economic needs. Here the problem was "modernizing" a group into the ways of the contemporary economic world. Resources had to be committed to doing remedial work which could probably be dispensed with for other types of workers. Second, the constraints imposed by the limited tenure feature guaranteed that employee performance would be incontinuous. Ambitious organizational

goals had to be tempered by the reality that personnel could not be held for a sufficient period of time to complete many types of projects.

While these internal elements provided natural limitations and insured a certain amount of insecurity, the large number of challenges from groups in the external environment contributed to a sense of instability which largely could not be anticipated. AIR was marginal to and competitive with other organizations seeking to establish their right to provide similar services. As an organization it was thus defensive and reactive. With no concisely articulated or widely accepted procedural mandate and beholden to a number of groups for both monetary and nonmonetary support, AIR was forced to be compliant with the needs of others. Survival meant acting in accordance with terms externally dictated.

Adaptations in original expectations were made as AIR gained a better understanding of its environmental situation. A gradual conservatism in goals paralleled the increased emphasis upon organizational survival *qua* organization, but the unintended consequence of accommodating a fleeting set of circumstances was that AIR fell out of contact with its personnel and became less sympathetic to their needs.

AIR evolved an organizational strategy that gave it a competitive margin. This was the most pronounced in relation to other CETA-sponsored arts organizations; its size and savvy allowed AIR to survive assaults which quickly crushed smaller fellow groups. Its capacity to endure was somewhat diminished in relation to other CETA endeavors, however, mainly because of the challenges leveled at the legitimacy of serving this occupational group. And finally, its competitive edge was the least apparent in regard to other organizations that were not similarly dependent upon the sponsorship of a program which increasingly attracted criticism and which correspondingly lost public favor. But while AIR did adaptively respond to the conditions it confronted, the winds of change were continuously building up strength at the same time. Just as a degree of harmony was being established between organization and environment, the climatic conditions abruptly changed and CETA was dismantled. AIR was like a dinosaur that had outlasted its source of nourishment; it was starved to extinction as the flow of federal monies slowed to a trickle.

Methodological Afterword

My overriding intention has been to understand what happened in the attempt to incorporate the arts into governmental bureaucracy. If a sense of smugness has surfaced at some points it is probably because clarity and insight are luxuries that are available in greater quantities after the press of events has been moderated by the separations of time and place. A sense of regret has possibly been expressed as well, because most AIR participants felt it in regard to one or another aspect of their experience. AIR was an exciting, promising, and often challenging venture, but disappointments were rife because expectations were so high, perhaps unreasonably so.

I was a CETA worker myself, and as such I was subject to a similar set of experiences in terms of applying, processing, and the applicability of CETA regulations. My entree into the program was expedited through art students I had met while in graduate school; these contacts proved to be valuable when they procured administrative posts in AIR. While such ties might be viewed from the outside as "weak" ones, they proved to be of the strongest kind, both professionally and personally.

I was employed during my 18-month tenure from September 1978 through February 1980 as a member of the AIR administrative

staff in the capacity of Research Coordinator. My role as a participant–observer was strategic: I witnessed first-hand the evolution of office structure and procedure and could observe meetings and more informal interactions alike in an unobtrusive manner. My position allowed me to come into contact with every participant in the program, and the relatively unstructured nature of my job brought frequent queries as to what, exactly, I was doing. My explanation included references both to my office duties as well as to my intentions to use my experiences as the basis for this study. This was also clearly established with the administrative staff from the beginning of my involvement in the program, and acceptance of this dual role was accomplished with little difficulty.

Part of my duties were to design and implement tools to collect information for reporting to other agencies and for in-house concerns. By having primary responsibility at this stage of the data collection process, it was possible to structure surveys and questionnaires to collect information necessary for the program's needs as well as for my own research purposes; most often these needs were complementary. Information was collected from the first group of participants by surveys administered at the end of the initial program year, subsequently gathered from each participant when he or she entered and exited the program, and at various times in between. I also had full access to files documenting such things as administrative decision making, interagency linkages, and organizational growth and change.

In addition, there was the unusual and valuable data provided by the videotapes. These were largely an artifact of the initial openness of the program, at which time close examination and mutual criticism was welcomed. As an early CCFA memo declared, "Videotape can facilitate communication and broaden interaction. We envision an actively engaged videotape process as providing the nervous system of this expansive body; the system of coordination and consciousness."[1] As circumstances actually unfolded this became an overenthusiastic endorsement. AIR had encouraged a vigorous self-scrutiny that revealed pimples and all—a sometimes unflattering and an increasingly unwelcome portrait. These tapes, however, captured critical moments in AIR's history *cinema verite* style and documented events in process, even though AIR administrators later might have wished to excise such things from the collective memory.

As much as I became drawn into the day-to-day workings of AIR, I also remained an outsider. It was ironic to me that I was

identified as the survey taker and the quantifier, since my methodological skills and sympatheties more generally lie with qualitative techniques. What to me were rudimentary questionnaires were received as advanced and "scientific" devices. This aspect of my role stood as a marker, for I was the only nonartist in AIR besides the clerical staff and the project director. Another ironic aspect of my role was that I contributed to the formalization of the bureaucracy which so many artists disliked. My job was important to the transition between program years one and two, especially in relation to scheduling and evaluation. While I was not the instigator of these tighter administrative features, any attempt to be a neutral observer was complicated when I lent my expertise to their development and implementation.

I was a fence-straddler much as AIR was, balancing conflicting demands and acknowledging alternative sets of definitions and values. My formal role guaranteed that I would be something of an anomolous character within this population which generally stressed the emotional over the intellectual and feeling over reason. Each of these opposing concerns held sway over me at different times, and while my reports on the AIR participants, client populations, and the scope and volume of AIR activities were the telltale signs of a social scientist, my personal conduct and the environment I created in my own office space left me largely indistinguishable from my "subjects."

AIR had an inviting organizational culture, one that was more pleasant than burdensome to work within. Yet the predominant ethos of the artists posed an interesting challenge. They largely endorsed modes of seeing, doing, and experiencing that contradicted the customary ways of social science "looking." Their emphasis was certainly not wrong in any sense, but it was undeniably different from the analytic approach I intended to take. "Going native" in this case would have strongly militated against writing this book with any of the rigor it might have. The appropriate model would have been closer to Sontag's call for an intuitive, emotional approach instead, with the result probably being a pastiche of impressions, reports, interpretations, and documents. The goal would have been to help a reader reexperience AIR, not analyze it. While this type of approach does strike a sympathetic chord in me, I entered this environment with an alternative agenda, and my goals required that I rely upon other methods. I hope, however, that I may have been something of a success at fence-straddling in this regard, too.

For all these apparent differences, the parallels between artistic worlds and contemporary academic life afforded me a sensitive vantage point. I didn't have to imagine these artists' lives because my own was similar to a remarkable extent. My existence before and after my AIR tenure was frightfully close to that of many of the artists—the financial insecurity, the inability to make a living through my "work," and the juvenilization which results from not having responsible and respected full-time employment were all present. The primary difference is that for generations artists have expected this in their professional lives. It is a newer (and now much more predictable) occupational hazard for academics. To an uncanny degree my experience duplicates that of Camus' character Dr. Rieux in *The Plague*: ". . . there was not one of their anxieties in which he did not share, no predicament that was not his."[2]

Notes

Introduction

1. Jane DeHart Mathews, "Art and Politics in Cold War America," *American Historical Review* 81 (1976): 777.

2. Susan Sontag, *Against Interpretation* (New York: Dell, 1964), 14.

3. One of the most important representatives of this type of approach grounds the analysis of culture within the situations where it is produced. Collectively labeled the "production of culture" approach, this emphasis has turned attention to the organizational and market constraints which influence the form and content of culture and examines such factors as social and technical arrangements, evaluation and distribution systems, and manufacturing decisions. See, for example, Paul DiMaggio, "Market Structure, the Creative Process, and Popular Culture: Toward an Organizational Reinterpretation of Mass-Culture Theory," *Journal of Popular Culture* 11 (1977): 436–52; Paul DiMaggio and Paul M. Hirsch, "Production Organizations in the Arts," *American Behavioral Scientist* 19 (1976): 735–52; Paul M. Hirsch, "Processing Fads and Fashions: An Organization Set Analysis of Cultural Industry Systems," *American Journal of Sociology* 77 (1972): 639–59; and Richard A. Peterson, "The Production of Culture," *American Behavioral Scientist* 19 (1976): 669–84. While the present study is not limited to such considerations, it strongly affirms the movement toward focusing directly on the circumstances under which artistic and cultural production occurs.

4. I have benefited from the insights of a number of approaches within organizational theory that have expanded its ability to examine both internal and external factors, including population ecology, the institutional approach, and analyses of corporate culture. The reader will

find both specific references to these fields and discover the more general impact of their main concerns in later sections of the text.

5. The Comprehensive Employment and Training Act, to be discussed in detail in chapter 2.

6. Edward C. Lindeman, "Farewell to Bohemia," *Survey Graphic* 26 (1937): 207.

7. Harold Rosenberg, "The Profession of Art: The WPA Art Project," in *Art On the Edge: Creators and Situations* (New York: Macmillan, 1975), 195–205.

8. Ibid., 196.

9. *Chicago Tribune*, 5 April 1980, section 1, p. 6.

10. Lenore Schiff and Suzanne Wittebort, "The Sound of Music," *Fortune*, 21 April 1980, 41.

11. Grace Glueck, "What Part Should the Public Play in Choosing Public Art?" *The New York Times*, 2 February 1985, Arts and Leisure, pp. 1, 27.

12. See Karal Ann Marling, *Wall-to-Wall America: A Cultural History of Post-Office Murals in the Great Depression* (Minneapolis: University of Minnesota, 1982) and Marlene Park and Gerald E. Markowitz, *Democratic Vistas: Post Offices and Public Art in the New Deal* (Philadelphia: Temple University, 1984).

13. See Robert Storr, " 'Tilted Arc': Enemy of the People?" *Art in America* 73, no. 9 (1985): 90–97; Eleanor Blau, " 'Tilted Arc' Dispute Brings New Procedures by U.S. for Buying Public Art," *The New York Times*, 13 October 1985, 63; "Chicagoans Protest a Fresco Project," *The New York Times*, 31 August 1985, 9; and Randall Beach, "Sculptor Baffled at Uproar," *New Haven Register*, 19 November 1983, 34.

14. See Francis Haskell, *Patrons and Painters: A Study of the Relations Between Italian Art and Society in the Age of the Baroque* (New York: Knopf, 1963); Edward B. Henning, "Patronage and Style in the Arts: A Suggestion Concerning Their Relations," in *The Sociology of Art and Literature*, edited by Milton C. Albrecht, James H. Barnett, and Mason Griff (New York: Praeger, 1970), 353–62; and Harrison White and Cynthia White, *Canvasses and Careers: Institutional Change in the French Painting World* (New York: Wiley, 1965).

15. See psychological studies such as Vytautas Kavolis, "A Role Theory of Artistic Interest," *Journal of Social Psychology* 60 (1963): 31–37; Ernst Kris, *Psychoanalytic Explorations in Art* (New York: Schocken, 1964); Miguel Prados, "Rorschach Studies on Artists and Painters," *Rorschach Exchange* 8 (1944): 178–84; and Otto Rank, *Art and Artist: Creative Urge and Personality Development* (New York: Knopf, 1932).

Chapter 1

1. See Dick Netzer, *The Subsidized Muse* (Cambridge: Cambridge University Press, 1978), 59–62, 81–93.

2. Cited in Cultural Council Foundation Artists Project, *On the Identification and Utilization of Largely Untapped Resources* (New York: Cultural Council Foundation, 1980), 16.

3. The first masters-level degrees in arts administration were granted from Yale University and the University of California—Los Angeles in 1966 and 1969, respectively; such programs proliferated throughout the 1970s.

4. *Chicago Tribune,* 24 October 1978, section 2, p. 2.

5. *Chicago Arts Newsletter,* Winter (1978): 7.

6. See *Chicago Tribune,* 19 November 1978, section 6, p. 5; and *Chicago Tribune Magazine,* 3 June 1979, 49–52, 54.

7. *Chicago Tribune,* 30 December 1979, Arts section, p. 1.

8. *Chicago Tribune,* 2 August 1979, 1.

9. In one such instance, 7,000 people lined up outside the employment office of a steel company in East Chicago, Indiana, only to discover that the announcement of positions there had been premature (see *Chicago Sun-Times,* 22 January 1981, 3). These reports were commonplace, and it was not until nearly five years later that there was a sense of a resurging economy. At that time a *New York Times* article reported the flow of population from the "rust belt" to the sun belt was declining, the state of Michigan had just balanced its books for the first time in ten years, and that a cautious optimism was finally possible (19 November 1985, 1).

10. *Chicago Tribune,* 10 July 1980, section 1, p. 3.

11. *Chicago Tribune,* 6 March 1981, section 3, p. 2.

12. John Irving, *The World According to Garp* (New York: Pocket Books, 1979), 251–52.

13. *Chicago Tribune,* 15 April 1979, section 6, p. 3.

14. Ibid.

15. *Chicago Tribune,* 12 May 1980, section 2, p. 7.

16. Todd Gitlin, *Inside Prime Time* (New York: Pantheon, 1983), 81.

17. Samuel G. Freedman, "Serious Drama, Old and New, Will Take Center Stage," *New York Times,* 9 September 1984, section H, pp. 5, 18; Arthur Holmberg, "Playwrights Who Take a Dim View of Business," *New York Times,* 2 December 1984, section H, pp. 3, 24.

18. Nelson Algren, *Chicago: City on the Make* (Garden City, NY: Doubleday, 1951), 67–68.

19. *Chicago Sun-Times,* 9 February 1980, p. 6.

Chapter 2

1. Roger Parloff, "Zoo Story," *New York,* 7 May 1979, 62–65.

2. See *New York Times,* 16 November 1977 and *Chicago Sun-Times,* 27 December 1978, 7, 26.

3. In a curious move toward democratizing the selection process,

however, it was later documented that the selling of positions enabled even those without important connections to be referred to the program. Payments of up to $150 made to employees of the state employment service were investigated by a local grand jury (see *Chicago Tribune,* 28 July 1979, section 1, pp. 1, 5).

4. William Mirengoff, Lester Rindler, Harry Greenspan, and Scott Seablom, *CETA: Assessment of Public Service Employment Programs* (Washington, D.C.: National Academy of Sciences, 1980), 5.

One of the most interesting controversies I discovered in this regard was the clamor over the hiring of Jeanne Ehrlichman (wife of the former White House official) as the education director of the Seattle Symphony. After she was found to be properly qualified and eligible, however, the furor subsided (detailed in James C. Hyatt, "Do Artists Perform True Public Service? Paychecks Say Yes," *Wall Street Journal,* 15 December 1975, 15).

5. Such issues did not escape the attention of the press during the Works Progress Administration (WPA) era, either. For example, a *Chicago Tribune* article dated 17 August 1936 was entitled "WPA Sculptors Lift Chisels to a 2½ Hour Day." Similarly, a *Chicago Herald Examiner* article reported: "Politicians have found a happy hunting ground for patronage. It enabled the ward and district bosses to enlarge and strengthen their vote-getting machines, and . . . it provided thousands of 'soft spots' for the so-called 'faithful.' " And further, a letter from a U.S. Senator to the assistant director of the [Visual] Art Project indicates that networks were similarly cultivated in order to secure positions; in part it reads, "A very splendid young man, [name and Chicago address], is desirous of obtaining a position with the WPA National Art Project in Chicago. [Individual's name] whom I have known for years is a really splendid chap. He has studied art for the past few years and has his heart and soul in continuing in that career. Personally, I want to help him obtain his success. Believe me, I shall deem it a distinct personal favor if you can have your Director in Chicago place him on one of your projects." (D. Worth Clark to Thomas C. Parker, 23 January 1939: Record Group 69 [Records of Works Progress Administration/Federal Arts Projects], State Series, Illinois, Box 1238). This document is part of the material I personally selected from the collection of administrative records in the National Archives, Washington, D.C., during research conducted in January 1979. All further WPA material cited is from this collection, unless otherwise noted.

6. James J. Kilpatrick, "CETA—No Miracles, Fat Budget," *Chicago Sun-Times,* 29 September 1978, 56.

7. Andy Meisler, "While You're Up, Get Me a Grant," *New West,* 19 June 1978, 84.

8. "Casey," in *Chicago Tribune,* 19 February 1979.

9. Mirengoff et al., *CETA,* 3.

10. William Mirengoff and Lester Rindler, *The Comprehensive Employment and Training Act: Impact on People, Places, Programs* (Washington, D.C.: National Academy of Sciences, 1976), 5.

11. Ibid., 218.

12. Ibid., 17.

13. Ibid., 7.

14. Department of Labor, *Employment and Training Report to the President 1978* (Washington, D.C.: Government Printing Office, 1978), 40.

15. Similar kinds of problems are discussed in a very general sense in William Mirengoff and Lester Rindler, *CETA: Manpower Programs Under Local Control* (Washington, D.C.: National Academy of Sciences, 1978); and in Mirengoff et al., *CETA*.

16. "Transitioning" was a commonly used term in CETA projects for the successful movement from public sector subsidy to private sector employment.

17. *National Endowment for the Arts Bulletin on Federal Programs and the Arts,* 21 September 1978, 4; emphasis in the original.

18. A. L. Nellum and Associates, *Putting the Arts to Work,* Resource Book for U.S. Department of Labor Conference (Washington, D.C.: U.S. Department of Labor, 1979).

19. Mirengoff et al., *CETA,* 142. This estimate is probably low, because it is based on 1977 data, which is before CETA-arts support peaked. When these data were reported, arts support represented 7,000 PSE positions. Later estimates ranged from 10,000 positions (see A. L. Nellum and Associates, *Artswork,* Resource Book for U.S. Department of Labor Conference [Washington, D.C.: U.S. Department of Labor, 1980]), to as much as a $300 million expenditure for 16,000 artists and arts-related workers (California Arts Council, *State of the Arts,* no. 18, November, 1980).

However, it is virtually impossible to get concise data in this area because of a crucial problem: CETA was a decentralized program and required the collection of information by funding title only, not by specific occupational categories. My attempts to obtain information regarding cultural workers from both the local and national offices were repeatedly stymied; such records simply do not exist. Furthermore, even important aggregate statistics can be interestingly contradictory. Data I received from the Department of Labor indicated that both total CETA outlays and PSE outlays peaked in 1978, although the number of participants who were employed was greatest in 1979. A massive report prepared for the Department of Labor likewise fails to clarify matters. It maintains that the largest number of prime sponsors provided funding in cultural areas in 1979, but asserts just two pages later that 1978 marked the height of PSE projects in cultural fields (Morgan Management Systems, *The CETA Arts and Humanities Experience* [Columbia, MD: Report prepared for U.S. Department of Labor, 1981], 62, 64). Another statement in this report is to be wisely heeded: "Documentation in this field is incompletely compiled and imperfectly extrapolated" (p. ix).

20. The major city department responsible for the administration and management of CETA funds, called a "prime sponsor."

21. The difference in background, personal style, and sense of priorities could probably not have been more striking than in the contrast between the second and third CCFA directors. The former had a personal interest in art, but her background also included administering a variety of public-service oriented programs such as a National Teachers Corps project, summer youth projects, and welfare programs. Her expertise overlapped remarkably with that of the director of AIR; in fact, the two had been colleagues in the Department of Manpower. Both had had extensive experience with the management of governmental programs and personal knowledge of the inner workings of city government. The third director, however, undertook the position as her first full-time professional job, although she was approximately middle-aged. As the socialite wife of a judge, her activities were more commonly reported in women's page columns than in departmental newsletters.

22. Letter to CCFA director, 9 October 1978.

23. Memo from AIR director to all AIR staff, 7 December 1979.

24. Kai Erikson has alerted us to expect such things in *Wayward Puritans* (New York: Wiley, 1966).

Chapter 3

1. Peter L. Berger, *Invitation to Sociology* (Garden City, NY: Anchor, 1963), 41.

2. George Becker's discussion of the historical image of artists and its active public promotion is especially interesting; see *The Mad Genius Controversy* (Beverly Hills, CA: Sage, 1978).

3. See National Endowment for the Arts, "Selected Characteristics of Artists: 1970," Research Report no. 10. Washington, D.C.: National Endowment for the Arts, 18.

4. Ibid., p. i.

5. Judith Adler, *Artists in Offices: An Ethnography of An Academic Art Scene* (New Brunswick, NJ: Transaction, 1979); Howard S. Becker "Art As Collective Action," *American Sociological Review* 39 (1974): 767–76.

6. Howard S. Becker, *Art Worlds* (Berkeley, CA: University of California Press, 1982); Gary A. Fine, "Popular Culture and Social Interaction: Production, Consumption, and Usage," *Journal of Popular Culture* 11 (1977): 453–66; Charles Kadushin, "Networks and Circles in the Production of Culture," *American Behavioral Scientist* 19 (1976): 769–84.

7. William J. Baumol and William G. Bowen, *Performing Arts— The Economic Dilemma* (New York: Twentieth Century Fund, 1966); Cultural Assistance Center, *Public and Private Support for the Arts in New York City* (New York: Cultural Assistance Center, 1980).

8. See such contemporaneous publications as the New York artists' newspaper entitled *Artworkers News,* and resource books from conferences sponsored by the Department of Labor entitled *Putting the Arts to*

Work and *Artswork* (A. L. Nellum and Associates [Washington, D.C.: Department of Labor, 1979, 1980]).

9. *National Enquirer,* 27 June 1978, 27.

10. Nellum and Associates, *Putting the Arts to Work,* 3–12.

11. For example, the book which summarized the activities of the New York project was entitled *Artists Project: On the Identification and Utilization of Largely Untapped Resources* (New York: Cultural Council Foundation, 1980). This imagery clearly drew from economics, not aesthetics.

12. Jeremy Bentham, *The Theory of Legislation,* edited by R. Hildreth (London: Trubner, 1871).

13. Rockefeller Brothers Fund, *The Performing Arts: Problems and Prospects; Rockefeller Panel Report on the Future of Theatre, Dance, Music in America* (New York: McGraw-Hill, 1965).

14. See Cultural Assistance Center, *Public and Private Support;* Charles Simpson, *SoHo: The Artist in the City* (Chicago: University of Chicago Press, 1981); and Sharon Zukin, *Loft Living: Culture and Capital in Urban Change* (Baltimore: Johns Hopkins, 1982) for discussions of the contributions of artists to economic development. In addition, the image of the artist as an explorer of new physical as well as thematic territories, leading to the subsequent occupation by other groups, is portrayed in the following: "The artists and poets patrons seeing and hearing their reports / bought vast tracts of the Adirondacks very cheaply / and began to build elaborate camps there thus inventing / the wilderness as luxury" (E. L. Doctorow, *Loon Lake* [New York: Random House, 1980], 46).

15. U.S. Congress. House Education and Labor Committee on Manpower Compensation, Health, and Safety. Oversight Hearing, Testimony on CETA, 8 November 1976.

16. Chicago Council On Fine Arts, "A Survey of Arts and Cultural Activities in Chicago," (Chicago: Chicago Council on Fine Arts, 1977), 4.

17. Ruttenberg, Friedman, Kilgallon, Gutchess and Associates Inc. (for the Human Resources Development Institute, Inc., AFL-CIO), *Survey of Employment, Underemployment and Unemployment in the Performing Arts* (Washington, D.C.: Human Resources Development Institute, 1977), 2–3.

18. Baumol and Bowen, *Performing Arts.*

19. Ibid., 382–85.

20. Dick Netzer, *The Subsidized Muse* (Cambridge: Cambridge University Press, 1978), 16.

21. This does not, of course, preclude considering the various ways in which CETA-arts projects were politicized. At times the arts commanded a degree of attention which far outweighed their comparatively small portion of CETA, state, and local budgets. One observer noted that the arts were being used as highly visible "scapegoats"; for example, legislators would threaten to withdraw support from state arts councils if they felt the public was pressuring them to cut back on overall expendi-

tures. Such threats could demonstrate the legislators' "sincerity" in acceding to the commonweal. And, in many cases, supporters of the arts were less able to apply political pressure on behalf of their cause than were other, better-connected constituencies (see Daniel Grant, "Budget Cutters Using the Arts as a 'Scapegoat,'" *Artworkers News,* May 1980, 5–7). At other times, the amount of overall CETA support was teasingly played with. For example, 1,300 CETA jobs in Chicago were preserved by the personal intervention of President Carter as he tried to capture the endorsement of Chicago's mayor for his re-election bid (*Chicago Tribune,* 16 October 1979, 1). It is no mistake that a similar article was entitled "Carter Woos Coy Byrne" (*Chicago Sun-Times,* 16 October 1979, 1), for CETA positions could reasily be used to court favor and to appease. When the mayor failed to respond favorably to this offer (she did not endorse the president), a later report declared "U.S. Funds Dangled to Spite Byrne" (*Chicago Tribune,* 21 November 1979, 3); having had the initial gift spurned, the president used the threat of withdrawing other monies from this area as a punishment for nonsupport.

22. From a poem by an AIR participant; *AIR Newsletter* 1, no. 9 (August 1978).

23. The average earnings in artistic fields are quite low. In 1972 the average income in the arts category utilized by the U.S. Census was $8,200, yet the average for the entire non-farm population was $8,630. And, the situation of artists is probably even more serious than this indicates: the category the census uses includes a number of occupations often considered beyond the traditional arts fields, such as newspaper reporters and book publishers. Second, these average earnings are obviously inflated by the large salaries of certain celebrities. And finally, thirty percent of the arts category is considered to be comprised of professionals, while only fifteen percent of the national work force is so classified. Therefore, we would expect a *larger* than average income for a group with such a proportionately higher segment of professionals in their ranks (Netzer, *Subsidized Muse,* 10–12). Data reported by a study conducted for the Author's Guild Foundation in New York confirms this. Authors who were included in their sample had published at least one book. The median income they reported from their writing was $4,775 in 1979. However, their median personal income from all sources was $27,000. Thus even "successful" writers had to supplement what they could expect to make from directly pursuing their chosen profession (Paul Kingston, Jonathon R. Cole and Robert K. Merton, *The Columbia University Survey of American Authors: A Summary of Findings* [New York: Author's Guild, Inc., 1981]).

Furthermore, in the decade from 1971 to 1980, unemployment for all artistic categories consistently exceeded the rates for other professional and technical categories. Actors registered an incredible average rate of thirty-five percent unemployment, ranging from thirty-one to forty-eight percent per year (*Artist Employment and Unemployment 1971–1980,*

Research Division Report no. 16 [Washington, D.C.: National Endowment for the Arts, 1982], 13). Interestingly, during the same time period the artistic workforce increased by forty-six percent (Ibid., 7).

24. The centrality of this concern is long-standing, as is the desire for the provision of relief; viz. the following letter from an artist employed on the WPA Federal Art Project:

> Without the aid of the Federal Art Project the artist is forced back into the existence in which he has starved and frozen for centuries. This mode of living is romantic and poetic only in literature and the opera. There is nothing romantic and poetic about an empty stomach or a palette bare of paint; nor is there anything poetic in having a good inspiration for a painting and no canvas on which to visualize it . . . the old belief that the artist has to struggle in order to produce great art is a fallacy. With supplies furnished, and the certain knowledge of the government check ready for them, the Project artists have been able to create works of art with their minds free from financial care and their stomachs full.
> (Letter from John Fountain Nichols to Holger Cahill, 20 December 1938; Record Group 69, State Series, Illinois, Box 1239)

25. Many reports from other cities were received by the AIR office, including those from New York, San Francisco, Cincinnati, Atlanta, and Seattle. In each case an extremely large pool was available, offering a wide selection of individuals for each position.

26. Some would argue that the adverse economic conditions under which many artists live are distinctly voluntary in nature. That is, they have willfully "chosen" to be poor and could enter jobs of a more middle-class nature if they so desired. It must be conceded that the AIR participants were generally middle-class in origin and in many of their expectations, but not so in their current income level. And, their educational backgrounds could probably be adapted to a number of occupational settings. The central point, however, is that they had indeed chosen to pursue professions which typically do not provide large financial rewards to great numbers of practitioners. What they "could do" and what they "wanted to do" were distinctly separate. There is some similarity between this kind of choice and what is discussed by Peter and Brigitte Berger as "the Blueing of America"; that is, the transformation of hippie dropouts into a new blue-collar class. They note that some middle-class individuals have deliberately chosen to be downwardly mobile, providing new opportunities for minority group members who had previously had very limited access to middle-level positions (in Peter L. Berger, *Facing Up to Modernity* [New York: Basic Books, 1977]). While those identifying themselves as artists or hippies might have the paper credentials with which to enter "respectable" society, this objective evidence has to be corroborated by a certain personal style and a willingness to participate in "straight" society for it to be successfully activated.

27. This and other descriptive characteristics of this population will be examined in greater detail in the following chapter.

28. See Robert K. Merton, *Social Theory and Social Structure,* rev. ed. (Glencoe, IL: The Free Press, 1957), 370.

29. Edwin H. Sutherland, *Principles of Criminology* (Philadelphia: J. B. Lippincott, 1947); Richard A. Cloward and Lloyd E. Ohlin, *Delinquency and Opportunity* (New York: The Free Press, 1960).

30. AIR assistant director in *AIR Newsletter* 2, no. 3 (January 1979).

31. Cloward and Ohlin, *Delinquency,* 301–2.

32. The acquisition by AIR of the distinction of being an Actors Equity company was an unintended by-product of an interesting conflictual situation at the end of the first program year. Through a carefully agreed upon solution, the theatre component was declared an Equity company, although prior union membership was not necessary for individuals to be considered for an AIR position, and participants were not required to join during their AIR tenure if they did not wish to do so. This incident will be discussed in detail later.

33. For a discussion of the importance of access to such indices of professionalization as union membership and of structural over sociopsychological factors in the acquisition of professional identity, see Charles Kadushin, "The Professional Self-Concept of Music Students," *American Journal of Sociology* 75 (1969): 389–404.

34. See, for example, Elliot Liebow, *Tally's Corner* (Boston: Little, Brown and Company, 1967); and William Ryan, *Blaming the Victim* (New York: Vintage, 1971).

35. The presumed psychological distinctiveness of artists has been the focus of investigators ranging from such theorists as Freud and Rank to the more experimental administrators of the Rorschach test. See Miguel Prados, "Rorschach Studies on Artists and Painters," *Rorschach Exchange* 8 (1944): 178–84 for the "confirmation" of a distinctive artist personality; see Vytautas Kavolis, "A Role Theory of Artistic Interest," *Journal of Social Psychology* 60 (1963): 31–37 for an attempt to apply role theory in an explanation of the artist as a social "type." More contemporary studies in both psychology and sociology tend to de-emphasize the delineation of a distinctive personality type, however. Instead, they rely on a situational analysis whereby aspects of "personality" can be called out in specific situations and expressed through artistic creations. See Thomas Munro, "The Psychology of Art: Past, Present, Future," *Journal of Aesthetics and Art Criticism* 21 (1963): 263–82 for an example of this trend.

Chapter 4

1. Headline, *Chicago Sun-Times,* 22 January 1978, 8.

2. This figure is derived from the number of individuals who applied in the music category and the number of available slots to absorb them. Writers exhibited a similarly high ratio of qualified applicants to

available jobs: twenty-six for each position. The other disciplines ranged from between nine and fourteen applicants per position.

3. Monthly salaries averaged $750, $767, and $800 for the three respective program years. For most of the AIR participants this was more income than they were accustomed to on a regular basis, and this was certainly the case for income derived from art-related work. During a session on "The Artist as Worker" within the 1980 CETA-arts conference ("Artswork") sponsored by the Department of Labor, the leader stated that an originally unintended consequence of the CETA employment of artists was that they would become active consumers. With a regular salary they would be able to afford apartments and new clothes, and they would be able to qualify for major credit cards. Then, rather than lose this newly acquired standard of living, they might go into some other kind of work to support their "consuming habit." The conclusion that this Department of Labor representative drew was that his bureau would then no longer have to worry about this segment of a generally problematic occupational group.

This sequence of reasoning is similar to a point made by Howard S. Becker and Anselm Strauss. In their discussion of career routes and career switching by adults, they stated: "The 'fine artist' may be committed to artistic ideals but seize upon whatever jobs are at hand to help him toward creative goals. When he takes a job in order to live, he thereby risks committing himself to an alternative career; and artists and writers do, indeed get weaned away from their art in just this way" ("Careers, Personality, and Adult Socialization," *American Journal of Sociology* 62 [1956]: 253–63, 260).

This is also similar to what Becker has specified as "commitment by default"; that is, a path of behavior which is followed from the unintentional accretion of "side bets," making it increasingly unprofitable to diverge from a particular course of action (see "Notes on the Concept of Commitment," *American Journal of Sociology* 46 [1960]: 32–40). While AIR might not have provided many artists the specific opportunity to develop an alternative career route, it did offer them the opportunity to experience what it could mean to draw a regular salary that was unlikely from their artistic careers.

Of course, much of this discussion must be tempered by the following considerations. First, the AIR salary was not that large and would scarcely underwrite a luxurious life-style. There may have been an initial flurry of buying activity at the beginning of AIR tenures, but this probably tapered off in time. And this leads to a second point: many of these individuals had had to postpone basic purchases for a long time. After some of this catching up had been done, most artists gave indications of living on only part of their salary. The rest was generally "squirreled away" for those future times when an income would not be so regular.

4. *Artists Project: On the Identification and Utilization of Largely Untapped Resources* (New York: Cultural Council Foundation, 1980), 22.

5. Letter from CCFA director to Office of Manpower, 27 June 1978.

6. Letter dated 3 May 1978.

7. National Endowment for the Arts, "A Bulletin on Federal Economic Programs and the Arts," 21 September 1978, p. 5; emphasis in the original.

8. Included in this panel were representatives from the arts council, the Office of Manpower, and the Office of the Budget.

9. Letter from AIR director to Manpower director, 21 September 1977.

10. A composer working in a classical mode was included the first year, and a classically trained performer was included in a theatre ensemble during year three. However, these were the only exceptions to this general pattern.

11. AIR received letters of complaint from applicants who were angry at not being accepted into the program. Oftentimes they discussed their individual qualifications and indicated what a mistake it had been that they had not been chosen. Others, however, pinpointed difficulties which were relevant to entire groups of AIR hopefuls. For example, a representative of the Chicago Opera Repertory Theatre wrote the following: "Only jazz and blues musicians were chosen . . . [whereas] according to . . . guidelines the positions for musicians were to be as evenly distributed among the various aspects of music as possible . . . As much as [a] program such as the Artists-in-Residence [program] is needed it does not seem to run with any sense of honesty or integrity" (Letter to AIR director, 27 October 1977).

The response given to this criticism read in part: "The musicians in the program are predominantly jazz and blues artists because the Music Panel determined that these musicians were most appropriate to the public service programs defined by City agencies" (Letter from AIR director, 4 November 1977).

12. Memo from AIR director to new employees, August 1978.

13. Letter to CCFA director, 20 October 1977.

14. Interview conducted with AIR writers by Sarah E. Lauzen, February 1980.

15. There is every reason to believe that the "horses" who were chosen and those who were not closely resembled each other. For example, when the groups of "hired" and "not hired" artists in each discipline were compared on such factors as age, education, income and income source in the year preceding AIR employment, there were no distinct differences between them (this was done in 1977–78 and 1978–79). There was in fact a high ratio of *qualified* applicants to available jobs; as already indicated, this was particularly true the first program year and less so in subsequent years. AIR was thereby in a position to select those "horses" most able to serve its needs; such criteria as "attitude" and past and present public service commitment were highlighted in order to pick the desired individuals out of a densely composed herd. Also, it should be clear from information reported in this chapter and in previous ones that

the characteristics of the AIR pool directly reflected the situation for artists generally; they were, thus, more typical than atypical of many of their fellow artists.

16. Richard Friedman, *Physical Culture* (Chicago: Yellow Press, 1979), 96.

17. This was a critical need within certain artistic disciplines and at times delayed projects unless the artists themselves were willing to "front" the money with no guarantee of speedy reimbursement. As the artistic director for dance stated: "If the dancers are to prepare programs of an aesthetically high caliber, they must present an attractive and finished presence. We will make our own costumes when we can. We will attempt to minimize costs and adapt creatively to what we do get. We are not asking for a $3,000 expense account at Capezio's. But we will need costumes, and we need to know how to approach these needs" (Letter to CCFA director, 12 October 1977). This must have been one of the least typical problems experienced by CETA participants.

18. These questions regarding the nature of public art form the basis of chapter 9.

19. *AIR Newsletter* 1, no. 3 (April 1978).

20. Memo from AIR director, 2 July 1979.

21. Anthony Adler, *Strange Food and Orchestras,* Script, 1979, 34; a play written and produced during an AIR tenure.

22. AIR was different in two distinct ways from most other CETA-sponsored arts programs around the country. First, it was one of two large-scale employment schemes; only in New York City were comparably large numbers employed under the aegis of one organization. Under the sponsorship of the Cultural Council Foundation (CCF), 325 artists were hired there (these were 1979–80 figures). And second, only in these two programs was there an emphasis on assembling new groups rather than being incorporated directly under already existing organizational frameworks (i.e., either cultural or community service institutions). In New York, 100 of the CCF artists were employed by such subcontractors, leaving 225 working in the part of the program most similar to AIR.

Therefore, CETA artists in Chicago and New York may have experienced somewhat atypical employment conditions. Yet, if one of the central purposes here is to discern the fit between artistic and organizational imperatives, these groups had one distinct advantage. They were originally structured with the distinctive needs of the artists in mind. For the purposes of drawing more general conclusions, then, we might keep in mind that working in either of these two large-scale organizations was potentially less problematic than working for either small-scale CETA sponsors or other large-scale organizations. In the case of the former, the range of programs they could sponsor was more restricted, and they were less stable as organizations than AIR. In the case of other large-scale organizations, the distinctive needs of artists would probably not be so self-consciously considered in such settings. The problems AIR artists experi-

enced were therefore probably similar to, and possibly less extreme than, those they would be experiencing in other organizational settings.

23. These will all be discussed in greater detail in later chapters.

24. Video, it will be noted, decreased in size the second year and then increased again in the third year. Its contraction and expansion can be explained only with extended discussion, which will be provided later; most important to note here is the contraction of this component in the second year.

25. This was accomplished only by assuring the school system that AIR-sponsored activities would only supplement, not duplicate or encroach upon, their established programs. This was strategically important in order to gain entrance into the area. However, it also guaranteed that AIR activities would be marginal to the rest of the school program, its importance auxiliary rather than central, and its practitioners subsidiary to the authority of the regular teachers. This created an additional element of uncertainty and instability for AIR and is similar to Burton Clark's discussion of an adult education program's attempt to gain legitimacy and develop more of a peer relationship in regard to a regular school program (see *Adult Education in Transition: A Study of Institutional Insecurity* [Berkeley, CA: University of California, 1968]). He stated, "Peripheral programs within multiprogram organizations typically have low status and little power and, in consequence, are insecure" (p. 148). AIR did what it had to do in order to initially get its foot in the door; however, these same tactics made it more difficult to improve its position from point of entry, or to secure a more permanent place.

Chapter 5

1. Max Weber, *The Protestant Ethic and the Spirit of Capitalism,* translated by Talcott Parsons. (New York: Scribner's, [1904] 1958), 181–83.

2. These concerns parallel those of the negotiated order approach to organizational analysis. See David R. Maines, "Social Organization and Social Structure in Symbolic Interactionist Thought," *Annual Review of Sociology* 3 (1977): 235–59, and "In Search of Mesostructure: Studies in the Negotiated Order," *Urban Life* 11 (1982): 267–79; Peter Manning, *Police Work* (Cambridge, MA: MIT, 1977), and "Producing Drama: Symbolic Communication and the Police," *Symbolic Interaction* 5 (1982): 223–41; and Anselm Strauss, *Negotiations* (San Francisco: Jossey-Bass, 1978). This approach rejects the organizational-chart point of view in favor of examining the ongoing evolution of structure and individuals' experiences of it. In addition, what employees bring with them into a situation is deemed important.

3. John W. Meyer and Brian Rowan, "Institutionalized Organizations: Formal Structure as Myth and Ceremony," *American Journal of Sociology* 83 (1977): 341.

4. Paul DiMaggio and Walter W. Powell, "The Iron Cage Revisited: Institutional Isomorphism and Collective Rationality in Organizational Fields," *American Sociological Review* 48 (1983): 154–56.

5. Brian Rowan, "Organizational Structure and the Institutional Environment: The Case of Public Schools," *Administrative Science Quarterly* 27 (1982): 259–79.

6. At least one organizational study does document similar characteristics. John Maniha and Charles Perrow described a youth commission set up to study conditions affecting the youth in a particular community and to make recommendations to the city council; it was not, however, to assume an action role. The gradual development of this latter role was their subject. As they stated, "Organizations are usually defined as rational systems for coordinating the efforts of individuals towards a goal or goals . . . [We] present one case history where an organization had every reason not to be born, and had no goals to guide it. It was used by other organizations for its own ends, but in the process it became an organization with a mission of its own, in spite of itself, and even while its members denied it was becoming an action group" ("The Reluctant Organization and the Aggressive Environment," *Administrative Science Quarterly* 10 [1965]: 238).

7. Studies of total institutions such as prisons and mental hospitals are an exception to this.

8. This is an excellent example of the very general way in which AIR sought to appear more legitimate. This development parallels the notion of coercive isomorphism (the idea that organizations tend to become the same secondary to political influences and the problem of legitimacy), whereas other innovations such as its more careful choice of personnel (to be discussed shortly) reflect mimetic isomorphism resulting from standard responses to uncertainty (DiMaggio and Powell, "Iron Cage," 150).

9. AIR director quoted in Michael VerMeulen, "Art of Politics/Politics of Art," *The New Art Examiner* 5 (December 1977): 13.

10. Letter to members of the writing panel, 24 October 1977.

11. Burton Clark discussed the similar development of a service orientation in his study of an adult education program. Applying a concept originally descriptive of individual orientations, he offered the following explanation, "Marginality, diffuse roles, and the pressures of the enrollment economy [i.e., only those courses would be offered for which there was sufficient demand] lay the basis for a strong 'other-directed' orientation on the part of adult education administrators. . . . They tend to face outward, toward clientele and critics, not inward toward traditional rules and their own conception of right and wrong" (*Adult Education in Transition: A Study of Institutional Insecurity* [Berkeley, CA: University of California, 1968], 106–7).

12. Transcription of a videotape recorded 19 May 1978; verbal emphasis in the original.

13. *AIR Newsletter* 1, no. 7 (June 1978); emphasis added.

14. AIR director in *AIR Newsletter* 2, no. 5 (June 1979).

15. AIR director, quoted in VerMeulen, "Art of Politics," 13.

16. James Thompson, *Organizations in Action* (New York: McGraw-Hill, 1967), 104.

17. Philip Selznick, *TVA and the Grass Roots* (New York: Harper and Row, 1966), 256.

18. This part of the discussion of some of the typical features of bureaucracies is informed by Peter Blau, *Bureaucracy in Modern Society* (New York: Random House, 1956), and, of course, Max Weber, *The Theory of Social and Economic Organization,* translated by A. M. Henderson and Talcott Parsons (New York: Oxford University, 1947).

19. This coalescence between the "latent culture" brought into the program by some artistic sections and the manifest culture of the program itself (see Howard S. Becker and Blanche Geer, "Latent Culture: A Note on the Theory of Latent Social Roles," *Administrative Science Quarterly* 5 [1960]: 304–13) as a factor contributing to success will be discussed further in chapter 9.

20. Transcription of a videotape recorded 31 October 1977.

21. In addition to the frustrations expressed in this quotation, some artists reacted with anger at feeling actively managed according to misguided standards:

> The need to constantly negotiate one's position thru the intricate bureaucracies make it like being on welfare. Instead of using clerical standards of acceptability, why not look at what the AIR's have done??? Perfect time sheets and work summaries and sign-in and out sheets and proper attendance at training sessions duz not mean that the AIR has actually *completed* the projects which are supposed to comprise the job! My projects have deadlines and I work hard and I meet them. It is draining to have to keep negotiating one's position this way. I'm no welfare swindle-suspectee! I've been hired to do a job and until there is some evidence that I'm not doing it or that people are dissatisfied by my performance, why not just let me get on with it? I resent a surveillance system that has no way of reviewing the work I'm actually doing!
>
> (35-year-old video artist; end-of-the-year survey, 1980)

22. Given the current state of the academic world, tenure protects those who have it not so much from political interference, but primarily from current economic realities. With academic departments in many academic disciplines being close to fully tenured, there is little or no possibility for others' entering into—and staying in—such positions. As one observer noted, "Now almost no one is moving, and tenure has become the whole objective, the end of all intellectual growth. . . . There is a growing army of embittered, unemployable intellectuals in our midst" (Duncan Robertson, "My Turn: The Overprotected Professors," *Newsweek,* 15 February 1982, 17).

The situation for CETA artists was somewhat different. Since they

were not accustomed to alternatives where they would more likely be guaranteed tenure, eighteen months in these programs was more than could be expected in typical artistic pursuits. This time could therefore be defined as an opportunity, with one eye also continually focused on the career outside the program. The sense of defeat currently experienced by many young academics did not, then, have as much basis for developing for these young artists. Because they do not expect as much in the way of job security, they were not as surprised or disappointed when it wasn't available.

This problem is also raised at the beginning of chapter 7.

23. See the similar discussion in chapter 2.

24. This will be discussed in detail in chapter 8.

Chapter 6

1. Daniel Katz and Robert Kahn, *The Social Psychology of Organizations* (New York: Wiley, 1966); Philip Selznick, *TVA and the Grass Roots* (New York: Harper and Row, 1966); and James Thompson, *Organizations in Action* (New York: McGraw-Hill, 1967) are a few of the better known, "early" representatives. The population ecology approach and its concerns with organizational growth and decline, its emphasis on opposition and survival within a competitive field, and its focus on the interaction between organizational form and environmental conditions, has considerably extended this central notion. See Howard Aldrich, *Organizations and Environments* (Englewood Cliffs, NJ: Prentice-Hall, 1979); John Freeman, "Organizational Life-Cycle and Natural Selection Processes," in B. M. Staw and L. L. Cummings, *Research in Organizational Behavior* (Greenwich, CT: JAI, 1982), 1–32; Michael Hannan and John Freeman, "The Population Ecology of Organizations," *American Journal of Sociology* 82 (1977): 929–64; and John Kasarda and Charles Bidwell, "A Human Ecological Theory of Organizational Structuring," in M. Micklin and H. M. Choldin, *Sociological Human Ecology* (New York: Academic, 1984).

2. See Katz and Kahn, *Social Psychology of Organizations,* especially chapter 2.

3. Burton Clark, *Adult Education in Transition: A Study of Institutional Insecurity* (Berkeley, CA: University of California, 1968), 106–7, 150.

4. Helen Grace, *The Development of a Child Psychiatric Treatment Program* (Cambridge, MA: Schenkman, 1974), 52, 197, 209.

5. Selznick, *TVA,* p. xiii.

6. Robert Michels, *Political Parties,* translated by Eden and Cedar Paul (New York: Free Press, [1915] 1949).

7. In the popular culture sphere, Todd Gitlin's study of the television industry similarly notes the reliance on quantitative measures, in this case audience ratings of pilot shows. Even though these are not necessarily good predictors of program success or failure, they are *something*

concrete to refer to in an otherwise unpredictable environment where executives often must rely on intuition rather than "objective" data (see *Inside Prime Time* [New York: Pantheon, 1983], especially 31–46). This is a further illustration of Paul DiMaggio and Walter W. Powell's idea of "mimetic isomorphism," although elements of coercive isomorphism are reflected in AIR's conduct as well (see "The Iron Cage Revisited: Institutional Isomorphism and Collective Rationality in Organizational Fields," *American Sociological Review* 48 [1983]: 147–60).

8. This will be addressed more specifically later in this section.

9. Interview with AIR writer conducted by Sarah E. Lauzen, February 1980.

10. For example, the program's efforts to court favor with the city culminated in an official proclamation by the mayor establishing "AIR Day" (23 July 1979), with the sponsorship of performances at a downtown public plaza. No other arts group which received CETA funding garnered similar recognition.

11. National Endowment for the Arts, "A Bulletin on Federal Economic Programs and the Arts," 21 September 1978, 4.

12. A. L. Nellum and Associates, *Putting the Arts to Work,* Resource Book for U.S. Department of Labor Conference (Washington, D.C.: Department of Labor, 1979), 5–16. Many not-for-profit organizations did in fact experience considerable difficulties from this dual expansion of budgets and expectations. As a result, "feeling dismal" was how one administrator described the situation at her theatre on 1 October 1981—the first day in seven years it was without CETA-funded employees. An immediate indication of the extent of the loss was the increased responsibility top administrators were having to assume for routine office tasks. Many such groups were forced to expand their volunteer and student internship programs, providing less reliable help than was the case with full-time, paid employees.

Although these problems might have been foreordained, few CETA-sponsored organizations were adequately prepared to deal with such changed circumstances.

13. Letter to *Chicago Sun-Times,* 23 January 1978.

14. Letter from AIR director to selection panel member dated 19 March 1979.

15. Harold Haydon, "Chicago Gives Its Artists Public Service Jobs," *Chicago Sun-Times,* 14 April 1978, 70.

16. One of the photographers provided a sophisticated understanding of some of the problems AIR incurred by exposing the work of its artists to the review of established critics, while at the same time operating under the limitations of the artists available to it:

> Artistically, it [AIR] can encourage mediocrity without intending to—it combines aspects of being in school with aspects of the "real world" to a negative effect. In a school situation, assignments are given *but* work is not

publicly exhibited that has met those assignments unless it has sufficient quality (usually). In the "real world," no assignments are made *until* work has sufficient merit to receive public exhibition. Within the program, assignments are made and the work is *guaranteed* public exhibition more or less—especially this applies for Art Bank. While it is admirable that the City should attempt to create a publicly owned body of art, it is not necessarily using the work of mature artists and therefore work of lasting value. It is a catch-22 situation since one of the intents of the program is to give "meaningful" employment to artists—but, because of the program's economic structure, its artists are mainly young "beginners" of promise and talent who do not necessarily have maturity in their work yet.

(35-year-old female; end-of-the-year survey, 1980)

17. Grace's 1974 case study of the development of a child psychiatric treatment unit documents a similar conservative trend initiated in order to enhance organizational survival. First, it carefully selected personnel, preferring untrained workers for their malleability. It was feared that professionally trained individuals would be too committed to professional standards and treatment goals, which would interfere with the kind of program being structured. Second, it retreated from its initially progressive treatment goal of working with severely disturbed, aggressive children to choosing instead a small number of withdrawn children. Political capital was gained by dealing with individuals not often defined as treatable. Only modest treatment goals were set, due to the severity of their conditions, and they were easy to manage, unlike energetic, acting-out children. By purposely choosing such a client population, it at least *appeared* as if something was being done.

18. *Chicago Sun-Times,* 10 March 1979, 6.

19. *Chicago Tribune,* 2 August 1979, 1.

20. *Chicago Defender,* 7 November 1979, 3.

21. *Chicago Tribune,* 31 January 1980, 3.

22. See *Chicago Tribune,* 15 April 1979, section 1, p. 10.

23. The anger was complemented by worries regarding how far down the AIR administrative ladder the dismissals would extend.

24. See *Chicago Sun-Times,* 29 September 1979, 8; *Chicago Sun-Times,* 14 November 1979, 20.

25. *Chicago Tribune,* 12 July 1981, section 1, p. 6.

26. CETA PSE programs were discontinued at the end of fiscal year 1981. By Winter-Spring 1982, only one CETA title existed which provided employment for a minimal number of employees. The On-the-Job Training program provided full or partial wage reimbursement to organizations during the time it takes to train new, low-income employees. There were few positions funded by this program, and it also had a relatively short duration, ending on 30 September 1983.

27. Narrative description of CETA: Mayor's Office of Manpower, 1978; letters from Human Resources Development Institute to AIR director, 11 September 1978 and 4 October 1978.

28. *Employment and Training Reporter* 10, no. 4 (December 1978). AIR was somewhat atypical in this respect. Observers of CETA programs generally concluded that organized labor influenced and supported these programs (see William Mirengoff and Lester Rindler, *CETA: Manpower Programs Under Local Control* [Washington, D.C.: National Academy of Sciences, 1978], 164). And, a survey I conducted of CETA-arts projects in a number of major cities in September 1978 confirmed either (1) an inattentive stance when small numbers of artists were employed and diffused throughout the community within grass-roots type organizations (e.g., Los Angeles and Philadelphia); or (2) a co-operative stance, whereby unions helped to establish or promote CETA programs, viewing them as expanding job opportunities for artists or expanding the potential audience for all performers, privately as well as publicly funded (the situations in Seattle, Cincinnati, Atlanta, and Rochester all provided examples of this type of relationship).

In addition, the WPA projects had a firm commitment: "We're for labor, first, last, and all the time . . . [WPA] is labor—don't forget that" (Harry Hopkins quoted in Hallie Flanagan, *Arena* [Rahway, NJ: Quinn and Boden, 1940], 35). See, also, William McDonald, *Federal Relief Administration and the Arts* (Columbus, OH: Ohio State University Press, 1969), 52–56, 601–11; and Jane DeHart Mathews, *The Federal Theatre: Plays, Relief, and Politics* (Princeton, NJ: Princeton University, 1967), 302–3.

29. Letter to CCFA director dated 16 August 1978.

30. Letter dated 8 August 1978.

31. Pickets and the leveling of fines against Equity actors in the company had been threatened.

32. Approximately thirty percent of the theatre component.

33. John W. Meyer and Brian Rowan, "Institutional Organizations: Formal Structure as Myth and Ceremony," *American Journal of Sociology* 83 (1977): 349.

Chapter 7

1. In Clarence J. Wittler, "Some Social Trends in WPA Drama," (Ph.D. diss., Catholic University, 1939), 75.

2. It is the closeness in time which make these two periods such likely comparison points. Yet there have been similarly bleak market conditions in eras far removed from our own. For example, educated young men in Restoration France found their numbers too great to be absorbed into an administrative and political structure largely manned by older individuals. The material and psychological discontent which resulted came to characterize a generation as *le mal de siecle*. See Lewis A. Coser, *Masters of Sociological Thought* (New York: Harcourt Brace Jovanovich, 1977), 32.

3. Transcription of a videotape recorded 31 October 1977.

4. See, especially, Herbert Marcuse, *Counterrevolution and Revolt* (Boston: Beacon, 1972); "Art As a Form of Reality," in *On the Future of*

Art (New York: Viking, 1970), 123–34; and *Eros and Civilization* (Boston: Beacon, 1966).

5. See, for example, J. W. Getzels and M. Csikszentmihalyi, "On the Roles, Values, and Performance of Future Artists: A Conceptual and Empirical Exploration," *Sociological Quarterly* 9 (1968): 516–30; Mason Griff, "The Recruitment and Socialization of Artists," in *The Sociology of Art and Literature,* edited by Milton C. Albrecht, James H. Barnett, and Mason Griff (New York: Praeger, 1970), 145–58; Charles Kadushin, "The Professional Self-Concept of Music Students," *American Journal of Sociology* 75 (1969): 389–404; and Anselm Strauss, "The Art School and Its Students: A Study and an Interpretation," in Albrecht et al., *Sociology of Art,* 159–77.

6. Howard S. Becker, *Outsiders* (Glencoe, IL: The Free Press. 1963).

7. Robert Faulkner, *Hollywood Studio Musicians: Their Work and Careers in the Recording Industry* (Chicago: Aldine-Atherton, 1971).

8. Ibid., 183.

9. End-of-the-year survey, 1980; emphases in the original.

10. End-of-the-year survey, 1980.

11. See James Thompson, *Organizations in Action* (New York: McGraw-Hill, 1967). Interestingly, studies of organizations producing cultural goods routinely address these concerns, e.g., Lewis A. Coser, Charles Kadushin, and Walter Powell, *Books: The Culture and Commerce of Publishing* (New York: Basic, 1982); Simon Frith, *Sound Effects* (New York: Pantheon, 1981); and Todd Gitlin, *Inside Prime Time* (New York: Pantheon, 1983).

12. It needs to be noted that this and other "survival tactics"—for example, the drift toward the workshop format—had a largely unintentional component to them. That is, crucial organizational changes in AIR were not necessarily deliberately derived and executed; to an extent they were the result of drifting toward what seemed to be advantageous and pulling away from what was known to be causing problems. Oftentimes solutions resulted from testing the waters and pulling back quickly when it was not comfortable or safe to stay in. As Herbert Simon has alerted us in his *Administrative Behavior* (New York: Macmillan, 1945) and in *Models of Man, Social and Rational* (New York: Wiley, 1957), the alternatives which developed resulted from knowledge gained sequentially; AIR did not have all the information it might have optimally desired on which to act. As an organization it did what it could and felt it had to do; in Simon's terms, it used a "satisficing," not maximizing set of criteria on which to base its decisions.

13. Incidentally, only a portion of the 1979 respondents could have experienced year one firsthand, and the 1980 respondents could be aware of what went on initially only through the transmission of "folk" knowledge from former participants.

14. End-of-the-year survey, 1979.

15. 28-year-old actor; end-of-the-year survey, 1980.

16. End-of-the-year survey, 1980.

17. *AIR Newsletter* 2, no. 4 (March 1979).

18. Erikson's definition reads as follows: "Societies . . . are apt to give them [young people] a *moratorium,* a span of time after which they have ceased being children, but before their deeds and works count toward a future identity" (*Young Man Luther* [New York: Norton, 1962], 43, emphasis in the original).

19. End-of-the-year survey, 1980.

20. Interestingly, although about one-third of the actors in the program belonged to Equity when they entered AIR, only three or four took advantage of the favorable position program participation brought them by joining during their tenure.

21. End-of-the-year survey, 1980.

22. This information was reported as "A Portrait of the Artist" in chapter 4.

23. In 1979, there were seventeen "no responses," and eleven responses which were so idiosyncratic as to be uncodeable. In 1980, the comparable figures were eleven and seven.

24. End-of-the-year survey, 1980.

25. Ibid.

26. *AIR Newsletter* 2, no. 3 (January 1979); emphasis added.

27. 36-year-old actress; 36-year-old female; 35-year-old female video artist: end-of-the-year survey, 1980.

28. End-of-the-year survey, 1979.

29. Kadushin, "Music Students," 398.

30. Ibid., 403.

31. End-of-the-year survey, 1979.

32. Ibid.; emphasis in the original.

33. 27-year-old male; end-of-the-year survey, 1980.

34. See Howard S. Becker, "Art As Collective Action," *American Sociological Review* 39 (1974): 767–76; Gary A. Fine, "Popular Culture and Social Interaction: Production, Consumption, and Usage," *Journal of Popular Culture* 11 (1977): 453–66; and Charles Kadushin, "Networks and Circles in the Production of Culture," *American Behavioral Scientist* 19 (1976): 769–84.

35. End-of-the-year survey, 1979.

36. To use Kadushin's terms as defined in "Music Students."

37. End-of-the-year survey, 1979.

38. Ibid.

39. Ibid.

40. Ibid.

41. End-of-the-year survey, 1980.

42. End-of-the-year survey, 1979.

43. Ibid.

44. Ibid.

45. End-of-the-year survey, 1980.
46. Ibid.
47. Vol. 2, no. 4 (February 1979).

Chapter 8

1. See Rosabeth Kanter, *Men and Women of the Corporation* (New York: Basic, 1977); and Paul Willis, *Learning to Labor: How Working Class Kids Get Working Class Jobs* (New York: Columbia University, [1977] 1981).

2. Judith Adler, *Artists in Offices: An Ethnography of an Academic Art Scene* (New Brunswick, NJ: Transaction, 1979), 53.

3. Richard Friedman, *Physical Culture* (Chicago: Yellow Press, 1979), 97.

4. See Hannah Arendt, *The Human Condition* (Chicago: University of Chicago, 1958), 79–135. Intellectuals comprise the only other group to which this distinction readily applies. Employed as researchers or teachers in academic settings, this urge to return to their own work often seems paramount.

5. Jerre Mangione, *The Dream and the Deal: The Federal Writers' Project, 1935–1943* (New York: Avon, 1972), 138.

6. Quoted in William McDonald, *Federal Relief Administration and the Arts* (Columbus, OH: Ohio State University Press, 1969), 701.

7. Statement on "Extra Employment and Professional Activity," 2 October 1978.

8. 27-year-old male; end-of-the-year survey, 1979.

9. Memo dated 14 March 1979; emphasis in the original. This demand was bolstered by the threat of docking pay for continued violations.

10. Francis V. O'Connor, *Federal Support for the Visual Arts: The New Deal and Now* (Boston: New York Graphic Society, 1969), 96.

11. The John Reed Clubs were named after the American journalist who had been a correspondent during World War I and the author of a book on the Russian revolution entitled *Ten Days That Shook the World;* he was also one of the founders of the U.S. Communist Labor Party. These groups attracted writers and artists through their sponsorship of art classes, lectures and exhibitions, and they published a regular magazine. The clubs had affiliate members in a number of major cities and routinely organized discussions on propaganda, aesthetics, and the role of the artist. See Gerald Monroe, "The Artists Union of New York" (Ed.D. diss., New York University, 1971), especially chapter 2.

12. Ibid., 35, 196; and see Warren Susman, "The Thirties," in *The Development of an American Culture,* 179–218, edited by Stanley Cohen and Lorman Ratner (Englewood Cliffs, NJ: Prentice-Hall, 1970), 207.

13. In Daniel Aaron, "Thirty Years Later: Memories of the First American Writers' Congress," *American Scholar* 35 (1966): 504. The events of this time period continue to be subject to reinterpretation and to

spark controversy; see, for example, Hilton Kramer's scathing review of *Artists Against War and Fascism: Papers of the First American Artists' Congress,* Introduction by Mathew Baigell and Julia Williams (New Brunswick, NJ: Rutgers University Press, 1986) in *The New York Times Book Review,* 27 April 1986, 19. This era is recalled as either the "glory days" or as an abomination, largely depending upon one's contemporary political sympathies.

14. Richard Christiansen, "Turmoil Expands as CETA Funds Shrink," *Chicago Tribune,* 10 December 1978, Arts and Fun Section, p. 6.

15. *Artworkers News,* October 1979, p. 1.

16. Letter to Ray Marshall from "Chicago Delegation to 'Putting the Arts to Work,'" August 1979.

17. For example, the conference which generated the letter to the secretary of labor was attended only by AIR administrative staff and not by any artists "from the ranks." The document included the supportive signatures of four AIR representatives.

18. Circular, January 1979.

19. Ibid.

20. See *Chicago Defender,* 19 September, 1 October, and 30 October 1979; also, *Chicago Tribune,* 15 September 1979.

21. Cultural Council Foundation Artists Project, *On the Identification and Utilization of Largely Untapped Resources* (New York: Cultural Council Foundation, 1980), 22.

22. Richard Goldstein, "Lilacs Out of a Dead Land," *Village Voice,* 17 April 1979, 42.

23. See Nancy Marmer, "Art and Politics '77," *Art in America* 65 (1977): 64–66; and Therese Schwartz, "The Politicalization of the Avant-Garde," *Art in America* 59 (1971): 97–106.

24. Conference organizers compared this to similar congresses held in the 1930s. The most forceful statement of purpose for this gathering was made by author Toni Morrison in her keynote address when she pointedly rejected individual response in favor of collective definitions and actions: "We need protection in the form of a structure: an accessible organization that is truly representative of the diverse interests of all writers . . . We have to stop loving our horror stories . . . A went mad, B died in penury, C drank herself to death, D was blacklisted, E committed suicide . . . All those stories mean is that solitude, competitiveness, and grief are the inevitable lot of a writer only when there is no organization or network to which he can turn."

25. Brochure from the Peace Museum, November 1981.

26. Lucy R. Lippard, "They've Got FBEyes for You," *Village Voice,* 4 November 1981, 114. The renewal of political participation by artists (e.g., in protesting U.S. involvement in Central America and apartheid in South Africa) is now much more the rule than the exception (see also Lippard's collected essays *Get the Message? A Decade of Art for Social Change* [New York: E. P. Dutton, 1984] regarding the political

involvement of artists throughout the 1970s. While she persuasively doc-
uments such activity, it is clear that it has moved from a marginal to a
more central position within the art community.

27. See Richard McKinzie, *The New Deal For Artists* (Princeton,
NJ: Princeton University, 1973); Mangione, *The Dream and the Deal;*
Monroe, "The Artists Union"; Lincoln Rothschild, "Artists' Organiza-
tions of the Depression Decade," in *The New Deal Art Projects: An An-
thology of Memoirs,* edited by Francis V. O'Connor (Washington, D.C.:
Smithsonian Institution, 1972), 198–221; and Robert Wolff, "Chicago
and the Artists' Union," in O'Connor, *New Deal Art Projects,* 239–42.
News clippings of the time are particularly interesting, picturing as they
do artists walking the picket lines as we are accustomed to seeing other
groups of workers doing. For example, in a story in the *Chicago Herald
Examiner,* 25 August 1936, such a scene is pictured: male and female artists
are marching with signs displaying slogans like "We Demand Prevailing
Wage Scale: $2.00 per hour," and "Employ Artists on the Basis of Need."
The headline on the article reads, incidentally, "Art for Cash Only! Art
Strikers Resume War." Similar pictures and stories can be found in *The
Chicago Evening American* and *The Chicago Daily News,* both dated 14 Au-
gust 1936.

28. Robin Guest, *This Unfinished Reach,* Script, play written and
produced in AIR program, 1979, p. 13.

29. Ibid., 45.

30. AIR presented a number of theatrical and musical productions
portraying the experiences of American minority groups, particularly
blacks. The explanation for this lies partially in the racial composition of
AIR's audiences. Since it primarily served minority audiences, it tried to
gear itself to the perceived needs and interests of these groups. And, the
proportion of minority group members comprising AIR's staff was signifi-
cant as well. In 1978–79, twenty-eight percent of the artists were from
racial minorities, and this segment increased to thirty-four percent in
1979–80.

31. Quoted in Phil Cohran, *The World of Paul Laurence Dunbar,*
Playscript, 1979.

32. Sasha Dalton, *Runnin' With the 8 Ball,* Playscript, 1978, p. 14.

33. The one exception to this pattern was a revue entitled *Passages*
which examined the black experience from colonial times to the present.
However, the work generated controversy and was curtailed. A full dis-
cussion of this work and the response to it will be presented in the chapter
on censorship and control.

34. Elizabeth Jackson, *3 Horns With Ease,* Playscript, 1979, p. 4.

35. The corresponding titles were: *To Save a Kinsman: Ida B. Wells
in the Case of Steve Green; This Unfinished Reach;* and *Strange Food and
Orchestras.*

36. Press release, 4 May 1979.

37. There were two notable exceptions to the predominance of in-

dividual over social themes in AIR theatrical productions. One example was a production entitled *Excerpts from Our Lives: A Womanshow*. Here, individual experiences of high school students were collected to address the common themes of women's concerns. This production was conceived and directed by the actress who had supervised a controversial production of a drug-related play (to be discussed in the following chapter). Another example of an activity concerned with social issues was the Youth Repertory Theatre, which worked with a company of teenagers referred by a social-service agency. They presented plays reflecting contemporary social problems such as youth gangs. Because this unit was gaining momentum just as my AIR tenure was ending, it is beyond the scope of this discussion.

38. To be discussed in additional detail in the next chapter.

39. See Malcolm Goldstein, *The Political Stage: American Drama and Theatre of the Great Depression* (New York: Oxford University, 1974); Morgan Himmelstein, *Drama Was a Weapon* (New Brunswick, NJ: Rutgers University, 1963); Jane DeHart Mathews, *The Federal Theatre, 1935–1939: Plays, Relief, and Politics* (Princeton, NJ: Princeton University, 1967); John O'Connor and Lorraine Brown, eds., *Free, Adult, Uncensored: The Living History of the Federal Theatre Project* (Washington, D.C.: New Republic, 1978); Clarence Wittler, "Some Social Trends in WPA Drama" (Ph.D. diss., Catholic University, 1939).

40. See McDonald, *Federal Relief;* McKinzie, *New Deal for Artists;* Milton Meltzer, *Violins and Shovels: The WPA Arts Projects* (New York: Delacorte, 1976); Francis O'Connor, *Art for the Millions* (Boston: New York Graphic Society, 1973); and Francis O'Connor, *The New Deal Art Projects.*

41. *Chicago Sun-Times,* 22 January 1978, 41.

Chapter 9

1. *AIR Newsletter* 2, no. 4 (February 1979).

2. Transcription of a videotape recorded 11 October 1977.

3. Ibid.; verbal emphasis in the original.

4. Ibid.

5. Ibid.

6. *National Enquirer,* 27 June 1978, 27; *Chicago Tribune,* 26 January 1978, 1.

7. This meteorological disaster eventually had a negative political impact on the mayor when he was later blamed for inept and inadequate snow removal efforts.

8. As has been noted, mayoral interest in the program's activities had a distinctive history; the mayor's wife had headed the sponsoring arts council prior to her marriage and had in fact been one of the initiators of AIR.

9. Howard S. Becker and Blanche Geer, "Latent Culture: A Note

on the Theory of Latent Social Roles," *Administrative Science Quarterly* 5 (1960): 306.

10. Ibid.

11. Ibid., 307.

12. For discussions of the role of conventions in both expediting artistic production and limiting it to within certain boundaries, see Howard S. Becker, "Art As Collective Action," *American Sociological Review* 39 (1974): 767–76, and *Art Worlds* (Berkeley, CA: University of California, 1982); also, Vera Zolberg, "Displayed Art and Performed Art: Selective Innovation and the Structure of Artistic Media," *Sociological Quarterly* 21 (1980): 219–31.

13. The workshop and residency format generally included didactic or recreational material, tapping only a portion of the artists' actual abilities; this directly reflected the program's priorities in gearing its efforts to those who were artistically "unsophisticated."

14. Here, however, there was no corresponding formal affiliation with professional unions as with theatre and music.

15. Photography, writing, visual arts, and film demonstrated a mixture of characteristics and fell somewhere between these extremes illustrated by theatre and video.

16. Transcription of a videotape recorded 4 November 1977.

17. Ibid.

18. The actual salary that year was $750 per month, or $9,000 a year.

19. Transcription of a videotape recorded 4 November 1977.

20. This artist earlier had referred to an elderly alderman, many of whose close associates had been sent to jail on charges of corruption.

21. Transcription of a videotape recorded 11 October 1977.

22. Transcription of a videotape recorded 9 March 1978.

23. Transcription of a videotape recorded 8 March 1978.

24. Ibid.

25. Transcription of a videotape recorded 14 April 1978.

26. The CHA program was multidisciplinary and had a director who oversaw all its artists and their activities.

27. Transcription of a videotape recorded 9 March 1978.

28. Ibid.

29. Transcription of a videotape recorded 14 April 1978.

30. Ibid.

31. All the CHA sites in which AIR operated were located in predominantly black communities whereas the AIR staff was racially mixed.

32. Summary statement, 5 July 1978.

33. Transcription of a videotape recorded 9 March 1978.

34. Transcription of a videotape recorded 14 April 1978.

35. Interestingly, no official document, including a lengthy summary statement of the unit's activities, mentioned these issues of public art: the role of the public artist, the entertainment versus cathartic/

problem-solving potential of art, and the dilemma over whites transmitting culture to blacks.

Chapter 10

1. George Seldes, "The People and the Arts," *Scribner's Magazine,* May 1937, 80.

2. Joseph Ben-David and Teresa Sullivan, "Sociology of Science," *Annual Review of Sociology* 1 (1975): 203–22, especially 203.

3. John Manfredi, *The Social Limits of Art* (Amherst, MA: University of Massachusetts, 1982), 3–4.

4. See Robert Meier, "Perspectives on the Concept of Social Control," *Annual Review of Sociology* 8 (1982): 35–55 for a discussion of social control as both result and process.

5. William Baumol and William Bowen, *Performing Arts: The Economic Dilemma* (New York: Twentieth Century Fund, 1966), 374.

6. Dick Netzer, *The Subsidized Muse* (Cambridge: Cambridge University, 1978), 36.

7. A. L. Nellum and Associates, *Putting the Arts to Work,* Resource Book for U.S. Department of Labor Conference (Washington, D.C.: U.S. Department of Labor, 1979), 19–20.

8. Marcia Bystryn, "Art Galleries As Gatekeepers," *Social Research* 45 (1978): 390–408; Lewis Coser, "Publishers As Gatekeepers of Ideas," *The Annals of the American Academy of Political and Social Science* 421 (1975): 14–22; Diana Crane, "The Gatekeepers of Science: Some Factors Affecting the Selection of Articles for Scientific Journals," *American Sociologist* 2 (1967): 195–201; Paul DiMaggio, "Market Structure, the Creative Process and Popular Culture: Toward an Organizational Reinterpretation of Mass-Culture Theory," *Journal of Popular Culture* 11 (1977): 436–52; Harriet Zuckerman and Robert Merton, "Patterns of Evaluation in Science: Institutionalization, Structure and Function of the Referee System," *Minerva* 9 (1971): 66–100.

9. Thomas Moore, *The Economics of the American Theatre* (Durham, NC: Duke University, 1968), 126. The control dimensions of both real and anticipated budget cuts are important although somewhat tangential concerns here. Their role in helping to shape the nature of artistic production is exemplified by the cuts in the NEA budget which were proposed since the beginning of the Reagan administration. Segments of the program supporting nontraditional arts programming were specifically targeted for the severest cuts, for example, activities of minority artists, service to audiences relatively unexposed to art, and work of a socially or politically critical nature. The Reagan administration has supported a return to traditional standards of artistic excellence, which means that experimental and critical artistic work will probably continue to lose ideological and monetary favor. See a symposium on each of the NEA programs: Richard Goldstein, "Artists: An Endangered Species," *Village*

Voice, 13 May 1982, 39–46; also, "A James Watt for the Arts?" *Village Voice,* 10 February 1982, 47.

10. Cesar Grana, *Bohemian Versus Bourgeois* (New York: Harper and Row, 1967).

11. See Judith Adler, *Artists in Offices: An Ethnography of an Academic Art Scene* (New Brunswick, NJ: Transaction, 1979); and Robert Faulkner, *Hollywood Studio Musicians: Their Work and Careers in the Recording Industry* (Chicago: Aldine-Atherton, 1971), and *Music on Demand: Composers and Careers in the Hollywood Film Industry* (New Brunswick, NJ: Transaction, 1982).

12. A. L. Nellum and Associates, *Putting the Arts to Work,* Resource Book for U.S. Department of Labor Conference (Washington, D.C.: U.S. Department of Labor, 1979), 20.

13. Michael Useem, "Government Patronage of Science and Art in America," *American Behavioral Scientist* 19 (1976): 785–804.

14. Hans Haacke, "Working Conditions," *Artforum* 19 (1981): 57.

15. Paul DiMaggio and Michael Useem, "Cultural Property and Public Policy: Emerging Tensions in Government Support for the Arts," *Social Research* 45 (1978): 356–89; Herbert Marcuse, *Counterrevolution and Revolt* (Boston: Beacon, 1972), *One-Dimensional Man* (Boston: Beacon, 1964), and "Art As a Form of Reality," in *On the Future of Art* (New York: Viking, 1970), 123–34; and C. Wright Mills, "The Cultural Apparatus," in *Power, Politics and People: The Collected Essays of C. Wright Mills* (New York: Oxford University, 1967), 405–22.

16. Quoted in Gerald Monroe, "The Artists Union of New York" (Ed.D. diss., New York University, 1971), 10–11.

17. Letter dated 28 July 1936: Record Group 69, Regional and State Correspondence, Box 24.

18. Ibid., letter to national director dated 6 August 1936.

19. Ibid., letter from Illinois state director to national assistant director, no date, 1937.

20. William McDonald, *Federal Relief Administration and the Arts* (Columbus, OH: Ohio State University Press, 1969), 698. How to impose discipline upon workers often accustomed to more independent functioning is an interesting problem. And, it is no accident that determining how to structure the arts projects was especially difficult since they incorporated professionals into a program designed primarily for nonprofessional workers. There is a great deal of continuity between the WPA and CETA projects in confronting these problems, although CETA (specifically represented here by AIR) became quite accomplished in choosing participants who would be receptive to discipline. The following statement by an artistic director concerns a writer who was not being recommended for retention in the program and illustrates one of those instances where participant and program goals did not mesh, an occurrence much less frequent as AIR matured as an organization: "[Name of artist] seemed to be more interested in her own work and its acceptance than in the

shared goals of the AIR writers" (memo to AIR director, August 1979). As a result, this individual was terminated when her initial appointment time had expired.

21. Jerre Mangione, *The Dream and the Deal: The Federal Writers' Project, 1935–1943* (New York: Avon, 1972), 217–20.

22. Howard S. Becker, "Art As Collective Action," *American Sociological Review* 39 (1974): 767–76.

23. See Vera Zolberg, "Displayed Art and Performed Art: Selective Innovation and the Structure of Artistic Media," *Sociological Quarterly* 21 (1980): 219–31 for a discussion of similar concerns. Additionally, the choice of symphonic music was a particularly cautious one since there would be no text to analyze. As Simon Frith has pointed out in regard to contemporary rock music, "there are no obvious ways to pin down the subversiveness of groups' *music*" (*Sound Effects* [New York: Pantheon, 1981], 56), although Senate hearings held in 1985 proposed a critical examination of lyrics and explored the possibility of regulating expression in this field (see Jon Pareles, "Should Lyrics of Rock Songs Be Sanitized?" *New York Times,* 13 October 1985, Arts and Leisure, pp. 1, 5).

24. Hallie Flanagan, *Arena* (Rahway, NJ: Quinn and Boden, 1940), 289.

25: The political persecution of the arts projects, their participants and leaders by Martin Dies (chairman of the House Committee on Un-American Activities—HUACO) and Clifton Woodrum (chairman of the House Appropriations Committee) has been well documented; see, for example, Flanagan, *Arena;* Malcolm Goldstein, *The Political Stage: American Drama and Theatre of the Great Depression* (New York: Oxford University, 1974); Mangione, *The Dream and the Deal;* and Jane DeHart Mathews, *The Federal Theatre, 1935–1939: Plays, Relief and Politics* (Princeton, NJ: Princeton University, 1967).

26. *Chicago Daily News,* 23 December 1935, 1.

27. "Unemployed Arts," *Fortune,* May 1937, 114.

28. See Richard McKinzie, *The New Deal for Artists* (Princeton, NJ: Princeton University, 1973), 55; and Karal Ann Marling, *Wall-To-Wall America: A Cultural History of Post-Office Murals in the Great Depression* (Minneapolis: University of Minnesota Press, 1982), 84–85, 312.

29. Kathleen Lombardo, *To Save a Kinsman: Ida B. Wells in the Case of Steve Green,* Script, play written and produced in AIR program, 1979, p. 45.

30. Eva Cockcroft, "The Norwich Murals: A Case Study of CETA and Public Art," *Artworkers News,* May 1980, 14.

31. The term "censorship" is a troublesome one, which is complicated considerably when qualified by the phrase "implicit censorship." The latter is somewhat of a contradiction, given that censorship most typically refers to an actual intervention to modify, destroy, or prevent the distribution of already completed works. Because of this difficulty, I can only follow Cockcroft's lead in a distinguishing two types of reg-

ulatory devices. In the discussion that follows, "censorship" is used only to refer to those instances in which a product was actively restricted in some way. The more neutral term "implicit controls," which refers more specifically to modification in process or compelling adherence to organizational guidelines, is used in all other cases.

32. Transcription of a videotape recorded 11 October 1977.

33. Haacke, "Working Conditions," 58.

34. Republican Senator from Delaware, 1938, quoted in Mathews, *The Federal Theatre,* 177.

35. Transcription of hearing proceedings, John Sefick versus The City of Chicago, Chicago Council on Fine Arts, S. Marie Cummings and Rose Farina. U.S. District Court, Court of Hon. Marvin E. Aspen, 26 November 1979, p. 34.

36. Press release, 30 November 1979.

37. Hearing transcript, 1979, p. 109.

38. Ibid., 16.

39. Ibid., 135.

40. Ibid., 137; emphasis added.

41. Peter Bachrach and Morton J. Baratz, "Two Faces of Power," *American Political Science Review* 41 (1962): 947–52.

42. Ibid., 952; emphasis in the original.

43. E. A. Ross, "Art," *American Journal of Sociology* 3 (1897): 70.

44. See, for example, Richard Cloward and Frances Piven, *Regulating the Poor: The Functions of Public Relief* (New York: Pantheon, 1971).

45. Flanagan, *Arena,* 3.

46. Ibid., 134–35.

47. Quoted in McKinzie, *The New Deal,* 57.

48. Flanagan, *Arena,* 87, 237, 268, 312.

49. Ibid., 152.

50. Quoted in ibid., 150.

51. McDonald, *Federal Relief,* 316.

52. Ibid., 688–90, 825.

53. Ibid., 688–90.

54. Quoted in ibid., 689.

55. The other primary differences were that the WPA was created by an executive order while CETA was mandated by legislation, and the WPA was originally geared toward providing relief rather than job training.

56. This was comically portrayed in a *Saturday Evening Post* cartoon which pictured a sculptor in a studio surrounded by his work—all elephants, of varying sizes. He complains to a visitor, "I applied for relief, but the administration won't give me any until I change my subjects" (6 August 1936, p. 70).

57. This was demonstrated in detail in the preceding chapter. In addition, the specter of boosterism did indeed arise toward the end of the WPA projects. As the country became more involved in the war, these projects were not only drastically cut in size but were released from na-

tional to state control. As Monty Penkower notes, the previous "Federalization" of the projects had insulated the production of written work from tampering for personal ends by local officials to a certain extent (*The Federal Writers' Project* [Urbana, IL: University of Illinois, 1977], 50). A problem endemic to CETA was therefore somewhat presaged in the latter part of the WPA's history.

58. The expression of doubt that "things" generally were not as good as they used to be was facilitated by the continual invocation of the phrase, "If Mayor Daley were alive . . . [such and such wouldn't be the way it is now]." This was taken to tragicomic lengths in regard to the blizzard of 1979. Not only did many people express doubts that the snow-clearing process would not have been so inept "if Mayor Daley were alive . . ."; but, many went on to stretch the conjecture to include the possibility that the snow *itself* would not have happened, "if Mayor Daley were alive." It was this supposed omnipotence of leadership that succeeding administrations had to contend with; to be successful in this task required a mixture of sacred and profane elements.

Epilogue

1. 28-year-old actor; end-of-the-year survey, 1979.

Methodological Afterword

1. Narrative description of AIR, August 1977.
2. Albert Camus, *The Plague* (New York: Vintage, 1972), 280–81.

Index